BASIC ANATOMY
for the
MANGA ARTIST

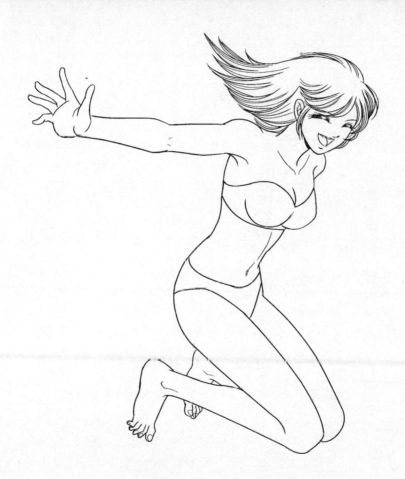

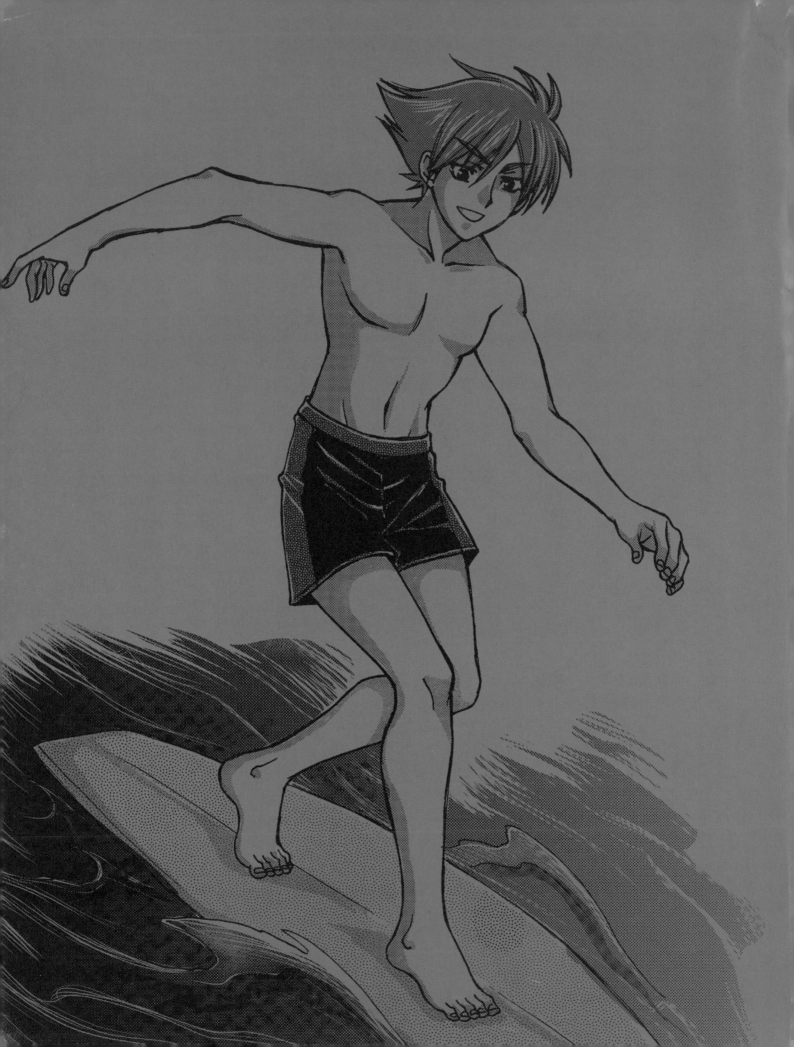

BASIC ANATOMY
for the
MANGA ARTIST

Everything You Need to Start Drawing Authentic Manga Characters

CHRISTOPHER HART

Watson-Guptill Publications / New York

Contributing artists: Yuu Sanau, Makiko Kanada, Rhea, Morgan Long, Roberta Pares

Library of Congress Cataloging-in-Publication Data
Hart, Christopher, 1957-
 Basic anatomy for the manga artist : everything you need to start drawing authentic manga characters / Christopher
Hart. -- 1st ed.
 p. cm.
 Includes index.
 ISBN 978-0-8230-4770-3 (pbk.)
 1. Comic books, strips, etc.—Japan—Technique. 2. Cartoon characters—Japan. 3. Figure drawing—Technique. I. Title.
II. Title: Everything you need to start drawing authentic manga characters.
 NC1764.5.J3H36915 2011
 741.5'1—dc22
 2010038623

Design by Melissa F. Chang
Front cover art by Roberta Pares

Printed in China

10 9 8 7 6 5 4 3 2 1

First Edition

For Candace Raney, my longtime editor.
I hope this makes up for all the times
I've interrupted your morning muffin
and latte with my phone calls.

CONTENTS

INTRODUCTION

The ability to represent the human head and figure is essential for those who want to draw manga. And yet it's often the main sticking point for most aspiring artists. Finally, there's one source you can turn to for the answers you've been seeking. In this book, you'll learn about manga proportions, posture, poses, and shortcuts used by the pros to check that their drawings are on track. You'll also see how to draw the clothed figure.

Why an anatomy book designed specifically for manga? Why not just get any old book on anatomy? Because manga is a distinct style, with important unique characteristics. *Basic Anatomy for the Manga Artist* contains instructions specifically designed for drawing idealized heads and bodies in the authentic Japanese style of manga. In addition, this book tells you exactly which muscles to emphasize when drawing the human body. Most books don't, and as a result, you can't tell which muscles to define and which to omit.

There's a complete section on the muscles that provides all the technical information you could want, but there's also an extensive material on how to simplify the body to make drawing easy. This isn't just a technical book; it's also very practical. And unlike so many books on anatomy, this one features many step-by-step sequences that will allow you to practice your newfound knowledge of anatomy on original, appealing manga characters.

So if you want to improve your manga and don't know where to begin, this is a great place to start. If you're a beginner, this book can help you build a solid foundation. If you're already experienced in drawing, this book can raise your game to the next level. It's a must-have reference that will serve you throughout your adventures as a manga artist.

1: BASIC HEAD ELEMENTS

Although this is a book that's primarily about drawing the manga figure, let's begin with a review of the head for two important reasons: First, this is an anatomy book, and there's practical anatomical information here about the head that you can use right away in your drawings. Second, if you're going to raise your skill level in one area (drawing the body), it makes sense to also raise your skill level in a related area (drawing the head) so that your abilities don't become lopsided.

So we'll start off with a look at the skull. It's the basic framework of the head. Your face doesn't resemble a skull because of all the muscle, fat, and ligaments over it, which round it out into, roughly, an egg shape. But the basic underlying elements of the skull still have their effect. You'll see, for example, that the cheekbones provide the width of the face, the size of the forehead relative to the chin is huge, and so forth.

THE SKULL

The skull answers many common questions about why the head looks the way it does. For example, why do people tend to have an overbite? It's because the maxilla (the upper jawbone, which houses the upper teeth) overlaps the mandible (lower jawbone). We can see that in the drawing to the right.

Why do manga characters have such big eyes? Just look at how large the eye sockets are on an average human skull. Why do manga character have such cute faces? Notice the extraordinary width of the cheekbones. And manga characters also typically have small chins, as is reflective of the skull structure. All these things contribute to cuteness.

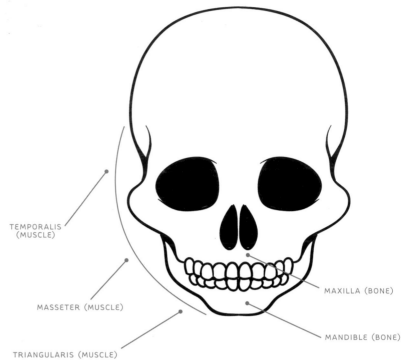

TEMPORALIS (MUSCLE)

MASSETER (MUSCLE)

TRIANGULARIS (MUSCLE)

MAXILLA (BONE)

MANDIBLE (BONE)

The sunken areas of the skull are padded with the three major facial muscles, noted here. The maxilla and mandible are also indicated.

Profile

There are a couple of important things to notice about the skull in the side view that are sometimes overlooked, even by more experienced artists. Check out these points to avoid the common pitfalls.

First, there's a lot of mass behind the center of the head (behind the jaw), and the back of the head is round, not flat. Conversely, the front of the face is fairly flat. It's the nose and chin that "pull the face forward."

Second, the eye in profile becomes more slender than in the front view. You can't draw a front-view eye in a side view—unless you're a cubist artist, in which case, god help us all.

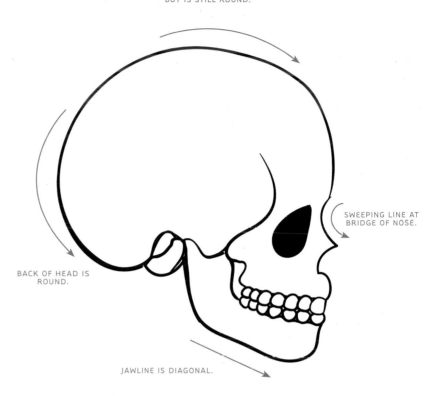

TOP OF HEAD APPEARS ALMOST FLAT BUT IS STILL ROUND.

SWEEPING LINE AT BRIDGE OF NOSE.

BACK OF HEAD IS ROUND.

JAWLINE IS DIAGONAL.

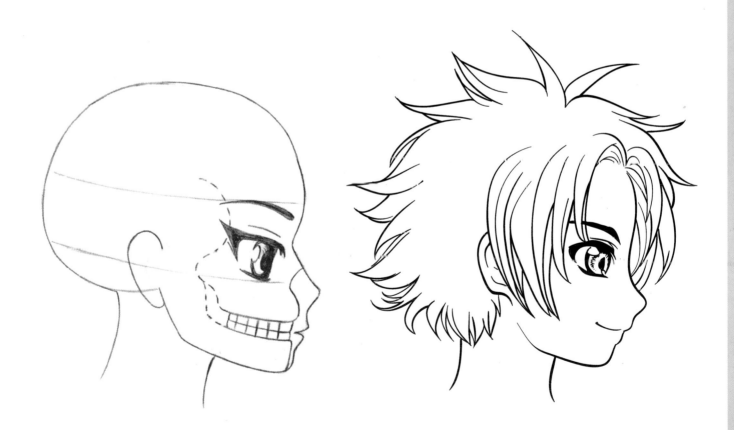

With the basic structural concepts out of the way, we can proceed to the construction of the individual facial features, starting with the eyes. To show you the complete progression, the eyes here start in only ink but finish in full color. However, the information is completely applicable to those of you who are working in pencil. Where it calls for an ink line, simply use a dark pencil line.

Where it calls for color, simply use a medium-gray pencil tone.

To maintain symmetry between the two eyes (keeping them evenly aligned with each other) don't finish one eye before you complete the other. Go back and forth between the two so that you complete both at the same time. Also, complete the black outlines first.

Male Eyes

The upper lids are *always* thicker and heavier than the lower lids. The eyebrows should be curved. And note that the heavy outline of the "eyeball" is really the outline of the iris. You can cut off some of the top of the spherical iris with the eyelid for a more intense look, which works especially well on male characters.

Note that there are no individual eyelashes on male characters; rather, the upper eyelids are simply thick and drawn with a pointed outer edge. The pupils are small here. You can make them large, medium, or small, but larger pupils are generally reserved for younger characters. At this stage, the pupils look odd, floating in the middle of the irises. Don't worry, the "shines" that we'll add in the last step will "attach" the pupils to the upper eyelid and eliminate that deer-in-the-headlights stare.

Add color or gray tone to fill in the irises.

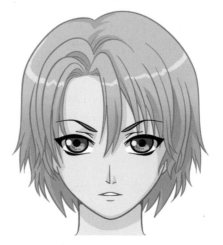

There's a large shine in the upper left and a less brilliant shine at bottom right of each iris. Shines are often placed diagonally opposite each other for a dynamic look. I add my eye shines by using a touch of white paint.

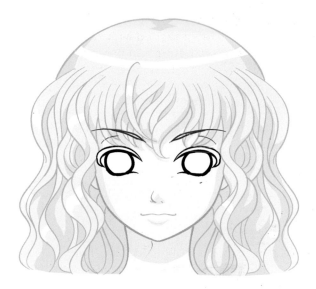

The upper and bottom eyelids are used as brackets to "hold" the spherical eyeballs in place.

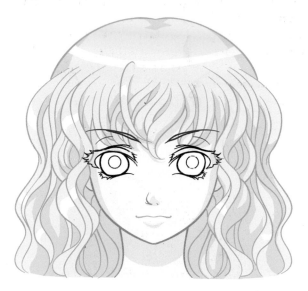

For female characters, add substantial eyelashes as well as pupils at this stage.

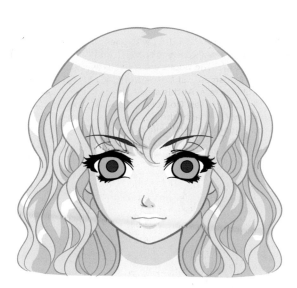

Fill in the irises with color or gray tone. Darken in the eyelashes—very dark.

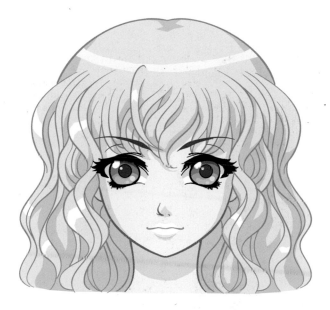

The large white shines serve to "connect" the pupils to the upper eyelashes through the irises. Several additional, minor shines appear on the pupils and lower parts of the irises.

Manga noses aren't terribly realistic but are stylized instead. That doesn't mean that when drawing noses anything goes. The placement of the feature still needs to be correct, or the proportions of the entire face will look out of balance. And there are established conventions for drawing noses in manga that should be respected or else the nose may not read as being from the manga genre. So let's focus on the most popular styles of noses. From these, you can improvise, adjust, and create your own types if you desire.

Male Nose Styles

Side Nose

Very common on both male and female characters, this nose is often drawn pointed. It angles off to one side, and there are no nostrils.

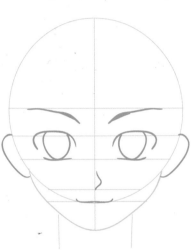

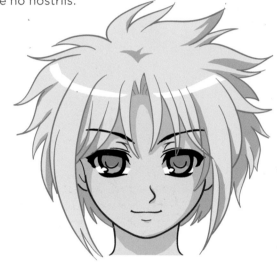

Long Shadow

This style is mainly seen on *bishounen* (handsome male characters). The bridge of the nose is long and very thin, with a sliver of a shadow.

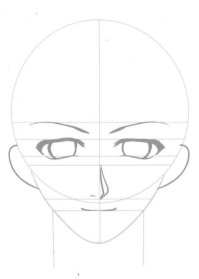

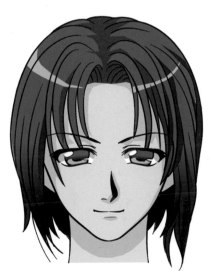

Double Shadow

This type is great for villains and intense characters. Draw a regular nose with a long side shadow. Then add a second smaller shadow inside the first shadow.

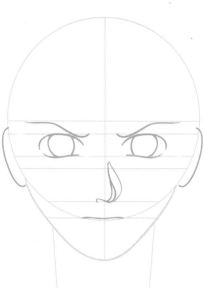

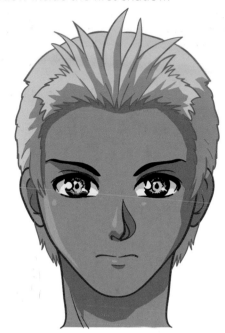

Downward-Slanting Nostrils

On these nostrils, drawn in a slightly "down" direction, note the subtle shading at the tip of nose. You can use light-gray pencil tone for this or a color accent. Don't draw "holes" for the nostrils here.

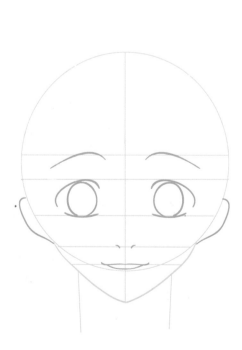

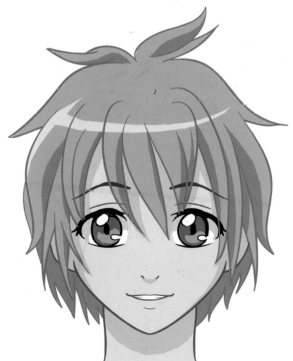

Empty Shadow

This style shows no bridge of the nose. The nose is small and placed low on the face, close to the mouth.

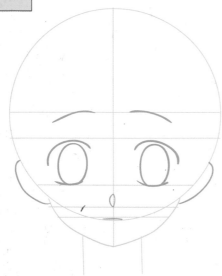

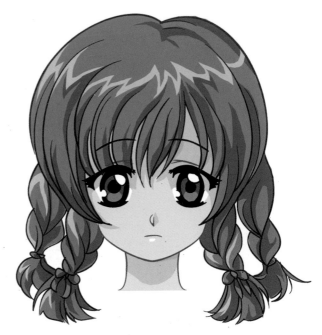

Petite Type

A short line indicates the bridge of the nose. At the bottom of this is a small half-circle shape. It's a great nose for cute, innocent, and charming characters.

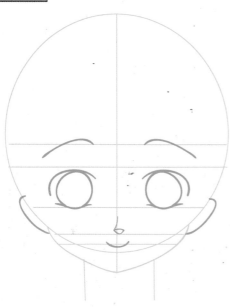

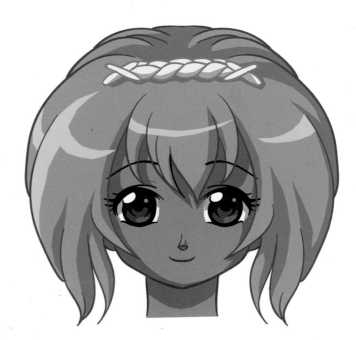

Upward-Slanting Nostrils

These nostrils are drawn in a slight "up" direction. Draw short lines, not small circles. Place the nostrils close together to make the nose appear delicate. Note the light shading at the tip of the nose; you van use light-gray pencil tone for this or a color accent, as you see here.

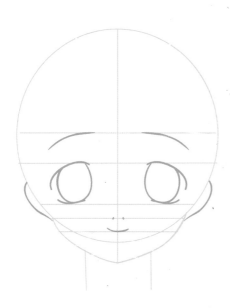

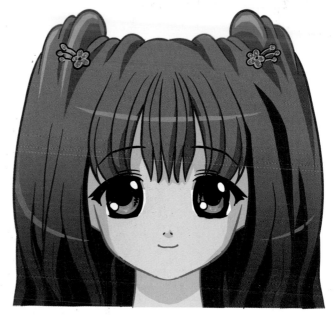

Full Nose

This style is just what it sounds like. The entire nose is shown—the bridge and the two nostrils. The bridge must "face" either left or right to remain visible. (In this example, it faces to our right.)

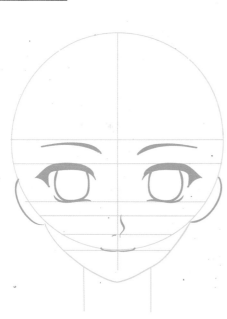

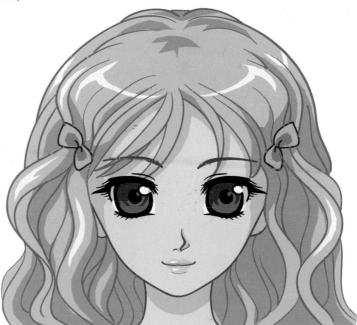

Is the mouth just one line, as one would see in a simple smile? Or is it an upside-down U, as one would see in a frown? At its basic level, perhaps it is that easy. But as your skills as an artist improve, you'll need to draw the mouth in more complex ways and at angles other than a simple front view. For this, a review of the structure of the mouth is helpful.

The teeth do not go straight across the face but protrude or curve outward along the jaw to form a semicircle. The lips are elastic and stretch across the teeth, covering them. That's why the lips are usually drawn as a curved (rather than a straight) line.

These rules aren't cast in stone; however, the mouth examples here are classic types used in modern manga graphic novels with great frequency. They will work well in your artwork, once you are familiar with them, or you can adapt them to create your own style.

INDIVIDUAL TEETH VS. "UNINTERRUPTED" TEETH

Individual teeth (below) look too busy. This will be especially true when the drawings are reduced to the size of a typical manga graphic novel panel. Plus, all that inking takes away from the look of brilliant white teeth.

Uninterrupted teeth lines that flow across the mouth create a more pleasing look; plus, the larger patches of uninterrupted white produce that desirable, brilliant glow or lustrous shine.

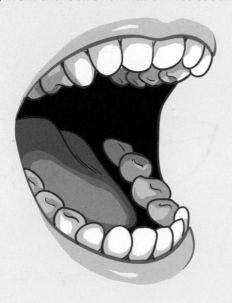

Front View

Manga smiles don't have crease lines at the edges to emphasize the expression. As a result, the shape of the smile itself must do all of the work. Average readers don't realize how meticulously *mangaka* (manga artists) labor over the shape of the mouth to make sure it reflects a cheerful smile or other expression. Follow these insider tips to add to your skill set.

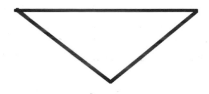

The basic shape of the smile is an upside-down triangle.

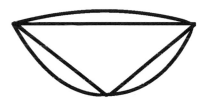

Using the triangle as your guide, draw a smile around it, connecting all of the points.

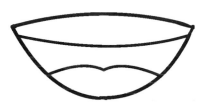

Add top teeth and a tongue for the smile. In general the bottom row of teeth is left out.

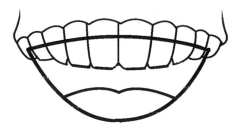

If you compare the previous version with one that shows the individual teeth, you can see how much more attractive the mouth is when the teeth are merged into a single slab of white.

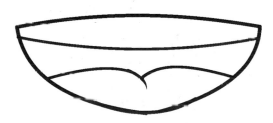

Bigger, wider mouths are used for male characters.

The dotted line represents the center line—the actual center of the mouth, where the two front teeth would theoretically go. Since this is a 3/4 view, the center line appears off to one side.

Using the triangle shape again, draw around it, attaching curved lines to all three corners and widening it out at the bottom.

Add teeth and a tongue, and define a few minor ridges to the back teeth.

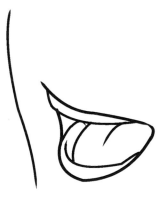

Again, the dotted line indicates the center of the face, this time in a "down" angle (i.e., when viewed from above).

Note the curve to the bottom row of teeth, as well. Showing the bottom row is a classic look you'll want to use when drawing a character in a down angle.

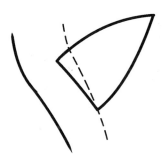

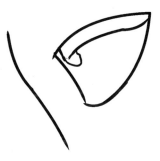

In the "up" angle (when the character is viewed from below), the center line falls in relatively the same spot as in the down angle.

Note that you can see a touch of the inside of the teeth on the far side of the mouth in the up angle when in the 3/4 view.

Side View

The smiling mouth doesn't require that the upper lip curve upward. It's the bottom lip that must sweep dramatically in an upward curve.

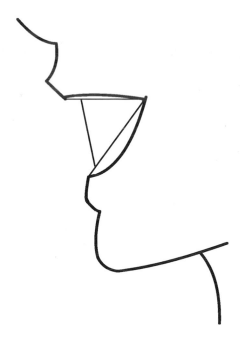

Just as with the front view, in the side view draw the smile around a triangle shape. Enlarge it slightly at the bottom.

It's a nice stylistic touch to leave the top and bottom lip lines unconnected.

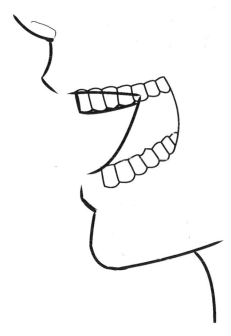

Note that, due to the way the mouth is built, the bottom teeth are usually unseen in this angle.

On a realistically drawn human head, the tops of the ears usually line up with the eyebrows and the bottoms line up with the bottom of the nose; however, in most styles of manga—and particularly in shoujo—the eyes are so large and exaggerated that using these guidelines would create ears that are gigantic. Therefore, manga ears generally do not reach the height of the eyebrows.

Front View

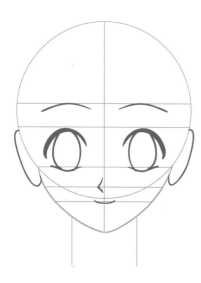 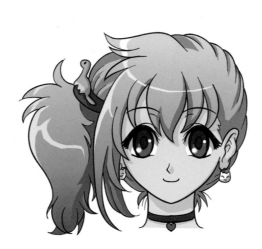 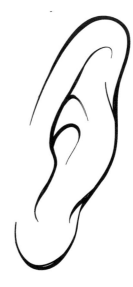

3/4 View

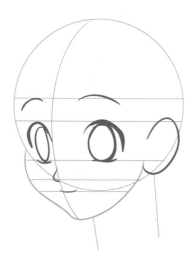 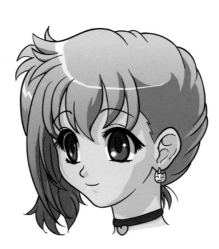 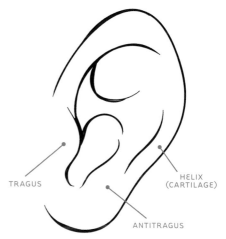

TRAGUS

HELIX (CARTILAGE)

ANTITRAGUS

Side View

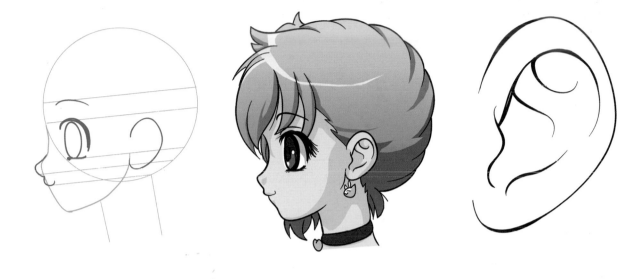

3/4 Rear View

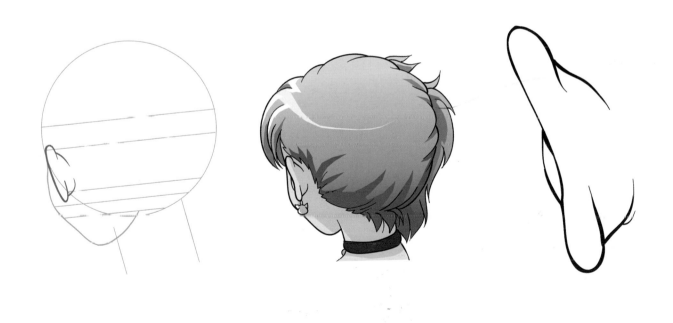

Think of the basic head shape as a starting point. To create specific characters, you can add mass to—or subtract it from—the basic foundation, like a sculptor with a block of clay. The next few pages offer a few ideas that you can use as a springboard when creating your own manga characters.

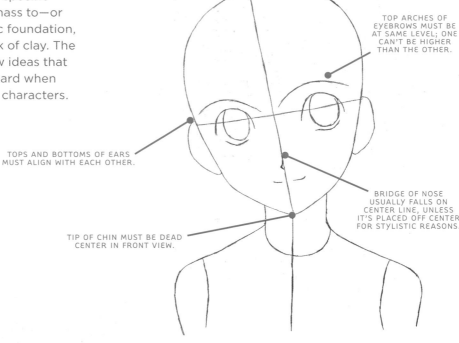

TOP ARCHES OF EYEBROWS MUST BE AT SAME LEVEL; ONE CAN'T BE HIGHER THAN THE OTHER.

TOPS AND BOTTOMS OF EARS MUST ALIGN WITH EACH OTHER.

BRIDGE OF NOSE USUALLY FALLS ON CENTER LINE, UNLESS IT'S PLACED OFF CENTER FOR STYLISTIC REASONS.

TIP OF CHIN MUST BE DEAD CENTER IN FRONT VIEW.

Schoolgirl

The front view is often the first angle a beginning artist tackles and the one most favored until more confidence and skills are developed. This may be because the overall head shape is easiest to draw from this angle. And yet, the front view is actually one of the hardest views to draw. The reason is symmetry. The features must line up to appear perfectly even. If one eye or one ear is a little bit higher than the other, the face looks lopsided. If the nose is not perfectly centered, the face looks wrong. When you started out, you probably didn't notice symmetry as scrupulously as you do now—now, in a pose like this, you realize that symmetry is *required*. As you raise the level of your game, you can be a little more demanding in the way the features line up, symmetrically, in the front view.

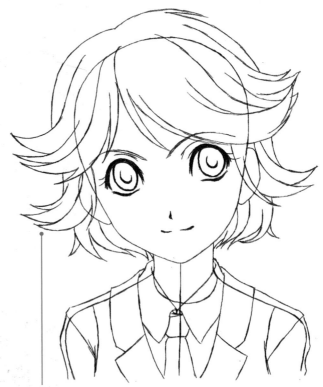

"BRUSH-AWAY" LOOK IS PRETTY STYLE FOR GIRLS WITH SHORT HAIR.

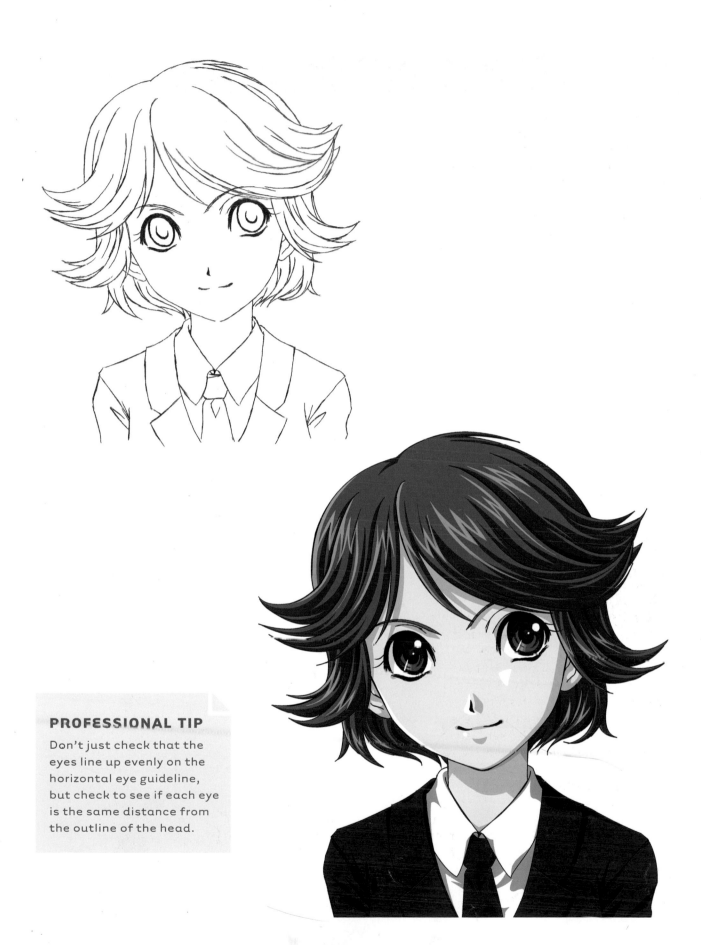

PROFESSIONAL TIP

Don't just check that the eyes line up evenly on the horizontal eye guideline, but check to see if each eye is the same distance from the outline of the head.

Introspective Teen

Mass has been removed from the chin area of this character, seen in the 3/4 view. This creates a weak chin and a larger-looking top of the head. The overall effect is to make the character appear young and soft-spoken. To complete the look, he has a brushed-forward hairstyle. But the most unique aspect of the design here is the eye, which is quite narrow and horizontal. This is typical of bishounen (male teen idol) characters; the eyes on female characters are often less narrow.

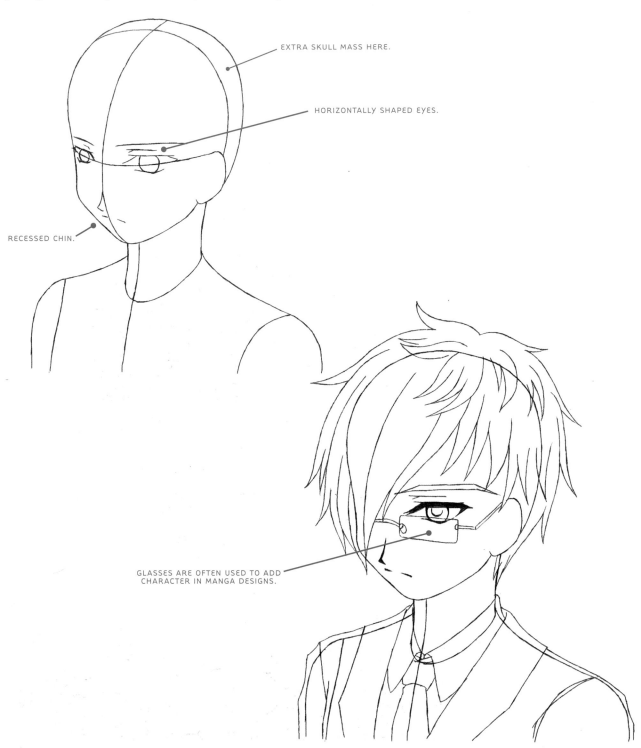

EXTRA SKULL MASS HERE.

HORIZONTALLY SHAPED EYES.

RECESSED CHIN.

GLASSES ARE OFTEN USED TO ADD CHARACTER IN MANGA DESIGNS.

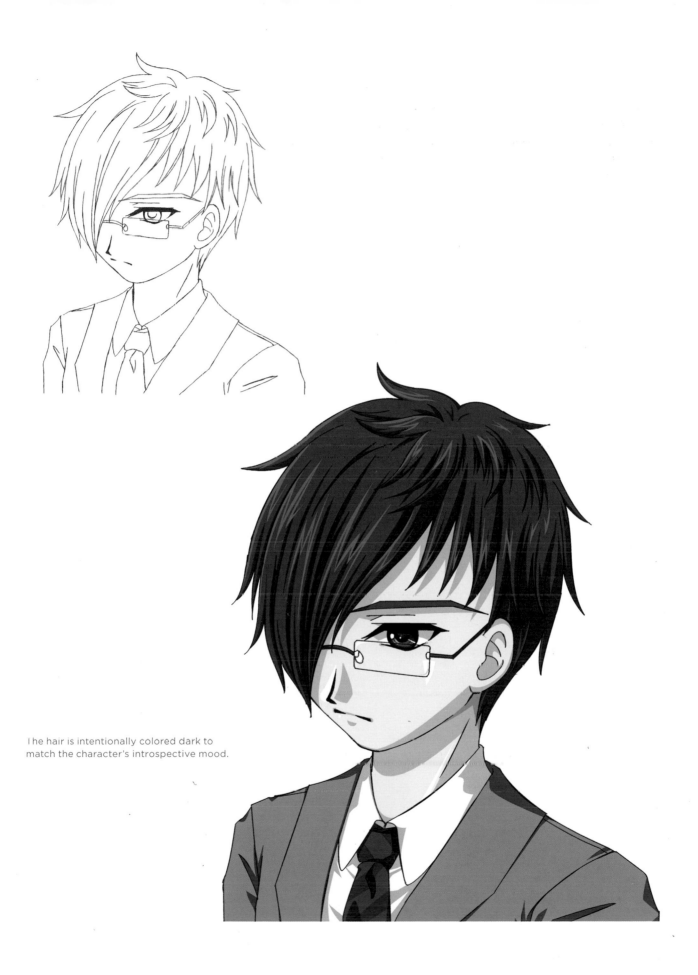

The hair is intentionally colored dark to match the character's introspective mood.

Charming Girl with Curls

Many professionally drawn manga characters give the beginner pause, as they think, "I'll never be able to draw like *that*!" But I'm here to tell you, "Yes you will!" And you should aspire to. Dream big. You deserve to. You're supposed to! That's what makes us artists. But it's not just pie-in-the-sky wishing that makes it happen. There's good reason for optimism. Here's why: As you look at the final picture, it's impressive, sure. But look at the initial sketch, the foundation drawing. It's not only rather simple, but it also looks somewhat similar to many other manga constructions in this section. That means two things: First, that the structure of the drawing is basic, not complex. The complexity of the drawing comes from finishing touches with hair, eyelashes, and eye shines—things you do to "glitter up" the image.

Second, if you can draw one manga head, you have what it takes to draw the others, since they're similar in shape and contour.

Attractive characters are generally drawn with large, brilliant eyes. To emphasize the eyes, the nose and mouth are greatly reduced in size. A small, underdeveloped chin is a sign of youth. The large forehead is reminiscent of a baby's skull, and also conveys youth in a teenager.

Of particular note is the hairstyle, with large curls falling lyrically over the ears. This is a standard look in manga, seen most frequently on magical girls. These repeated curls are an elaborate but pleasing treatment. In addition, hair buns or other decorations (such as leaves or flowers), placed 45 degrees out from the top of the head, are a popular Japanese motif.

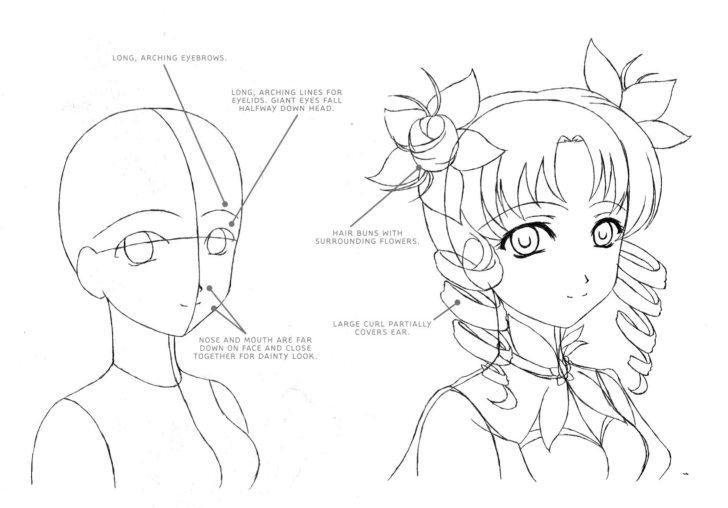

LONG, ARCHING EYEBROWS.

LONG, ARCHING LINES FOR EYELIDS. GIANT EYES FALL HALFWAY DOWN HEAD.

NOSE AND MOUTH ARE FAR DOWN ON FACE AND CLOSE TOGETHER FOR DAINTY LOOK.

HAIR BUNS WITH SURROUNDING FLOWERS.

LARGE CURL PARTIALLY COVERS EAR.

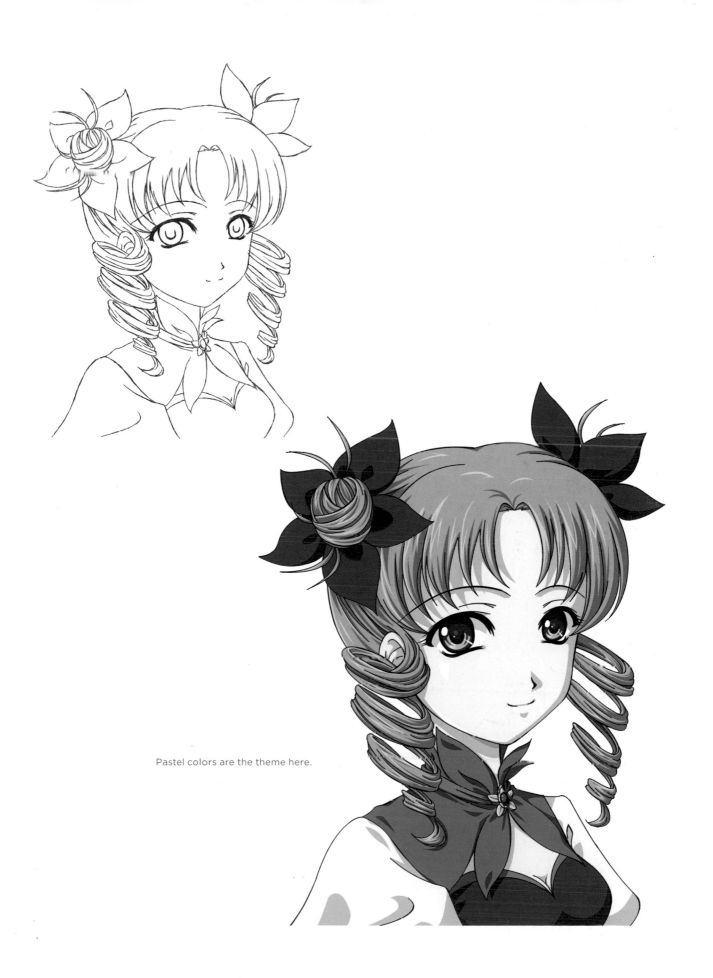

Pastel colors are the theme here.

Vampire Goth Boy

This is a good example of an underlying head shape that's completely typical in every way. As drawn, without the features, he could be turned into any one of a number of appealing shoujo teenage types. What does this mean to us? Simply that a solid, pleasing foundation is a versatile foundation. You don't have to try to accomplish too much at the outset.

One common misconception with vampire or Goth characters is that you have to begin by drawing an angular, scary skull. But as you can see, that's not necessarily the case, because today's vampires are charismatic and appealing, not grotesque and repulsive. As you can see, this one displays the popular manga convention of having characters show their playfulness by winking at the reader.

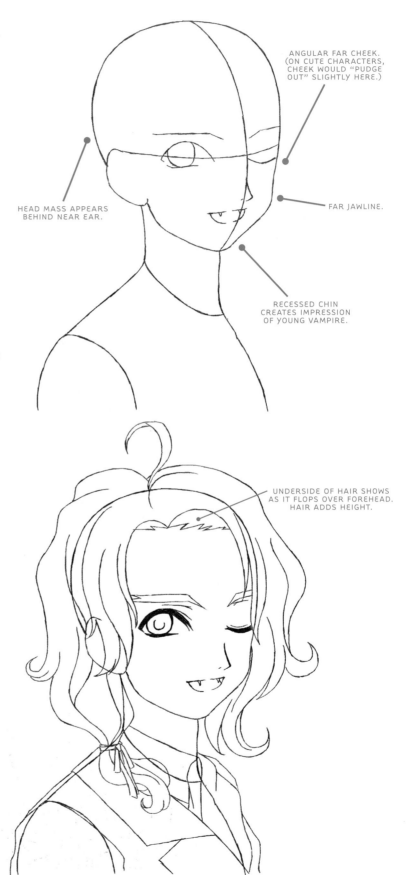

ANGULAR FAR CHEEK. (ON CUTE CHARACTERS, CHEEK WOULD "PUDGE OUT" SLIGHTLY HERE.)

HEAD MASS APPEARS BEHIND NEAR EAR.

FAR JAWLINE.

RECESSED CHIN CREATES IMPRESSION OF YOUNG VAMPIRE.

UNDERSIDE OF HAIR SHOWS AS IT FLOPS OVER FOREHEAD. HAIR ADDS HEIGHT.

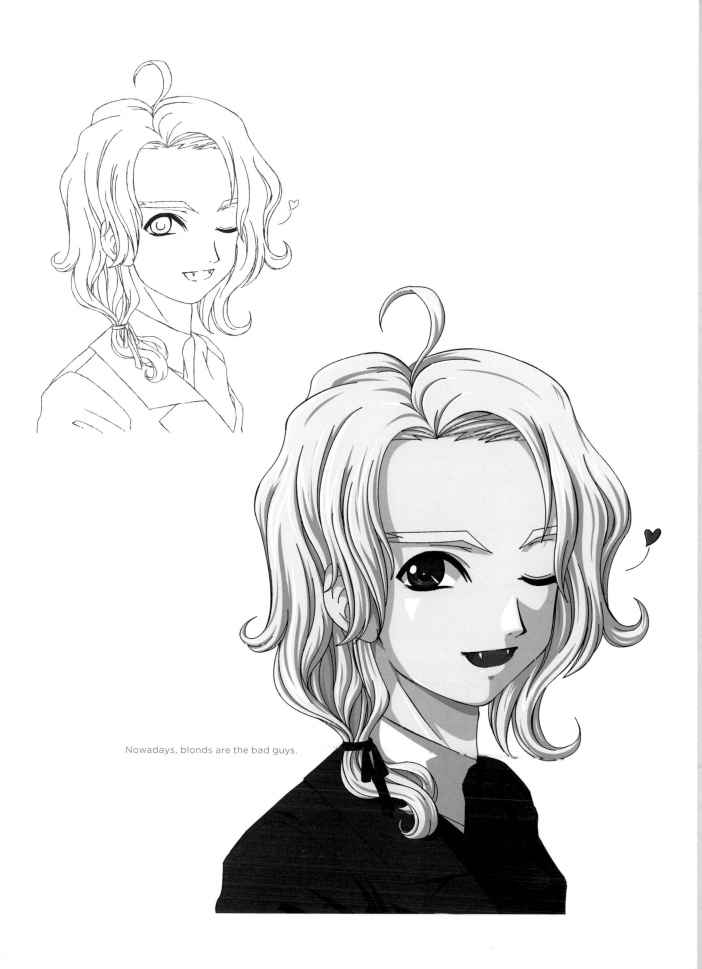

Nowadays, blonds are the bad guys.

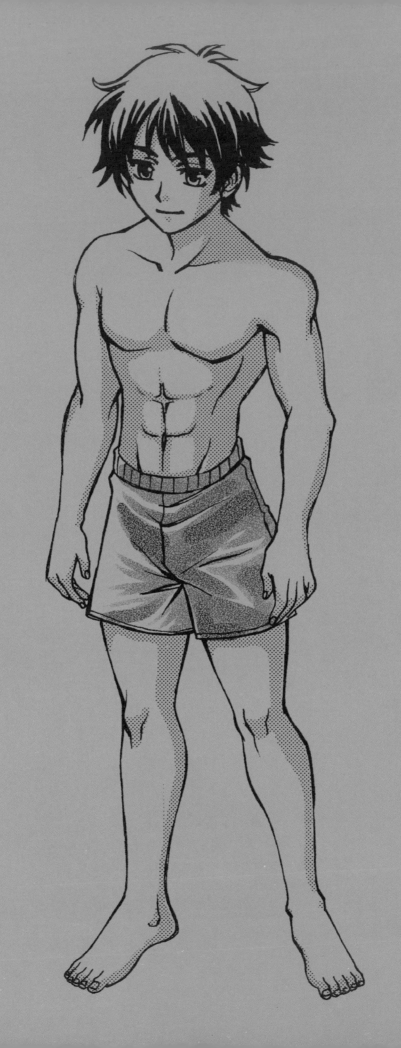

2: THE FOUNDATIONS OF THE BODY

This chapter focuses on a few different aspects of drawing the body, all from the manga artist's point of view. Each topic has been carefully chosen for its practical application. This isn't a book you just memorize; it's a book you draw with. So, whatever part of the body or whatever general concept you may be having trouble with is most likely covered here.

You may have some ingrained habits that are hard to break. That's okay. You don't have to change everything all at once. If you try one or two new ideas each week, you'll be making steady, sure progress. As you start to see your drawings take on new authority, you'll begin to embrace these new concepts that much quicker.

When I first studied life drawing in art school, my initial reaction was, Why do I have to learn about the skeleton? As far as I knew, I was never going to have to draw a skeleton; every character I was ever going to draw was going to have muscles, skin, and clothes on. As I continued, however, I came to realize that what seemed pointless at first made very practical sense. Once I began to improve, I noted five major reasons why a working familiarity with the skeleton was a benefit for comics artists: (1) The skeleton is the framework of the body and provides it with its basic angularity and shape. (2) Many of the bones "show through" to the skin surface, so you have to know where they go and in which direction they travel. (3) The various thicknesses of the bones determine the thicknesses of the body parts and limbs. (4) The proportions of the body can be measured or estimated by the length of the various bone segments. (5) The basic sections of the body are determined by the skeleton; examples of this are the hips (pelvis) and torso (rib cage).

Note that while there are slight differences between the male and female skeleton (for example, the female pelvis is wider), the basic components are the same, so we'll just use the male skeleton here to call out the main elements.

Front

When viewing the skeleton in the front angle, you can see how long the rig cage is and how wide apart the thigh joints (great trochanters) are. Note, too, that the collarbones are horizontal.

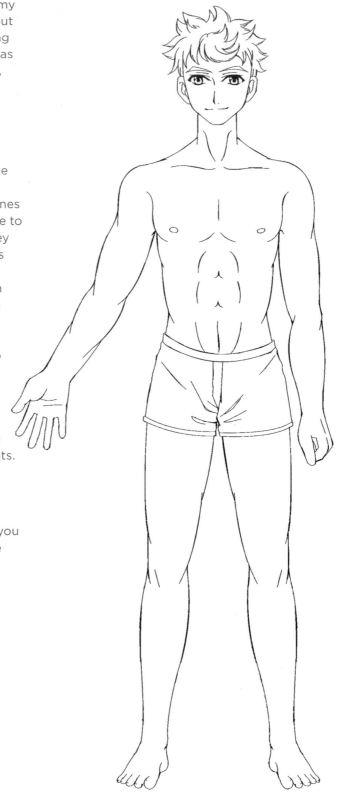

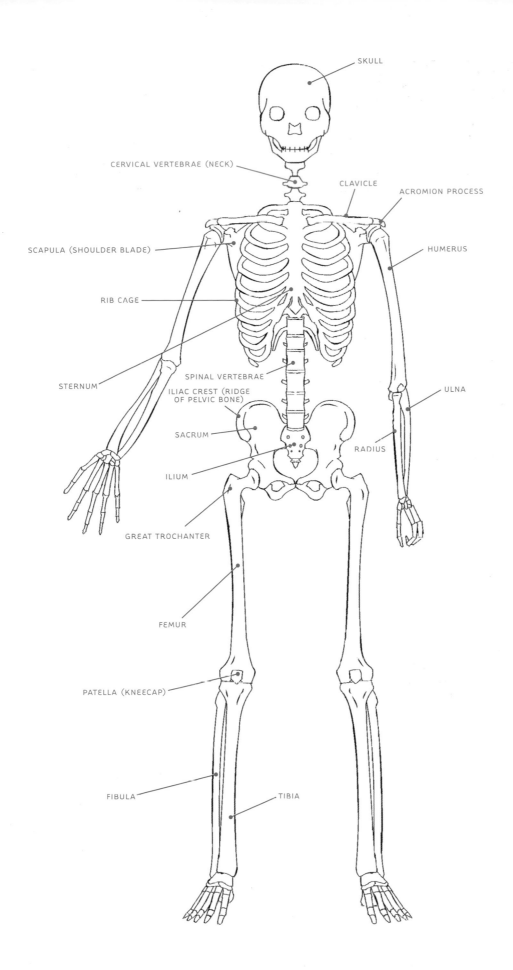

SKULL

CERVICAL VERTEBRAE (NECK)

CLAVICLE

ACROMION PROCESS

SCAPULA (SHOULDER BLADE)

HUMERUS

RIB CAGE

SPINAL VERTEBRAE

STERNUM

ULNA

ILIAC CREST (RIDGE OF PELVIC BONE)

SACRUM

RADIUS

ILIUM

GREAT TROCHANTER

FEMUR

PATELLA (KNEECAP)

FIBULA

TIBIA

Back

The shoulder blades don't attach to the rib cage or to the humerus (upper arm). In fact, the only things holding the shoulder blades in place are the ends of the collarbones (acromion process), which is why they can move around so freely along the back.

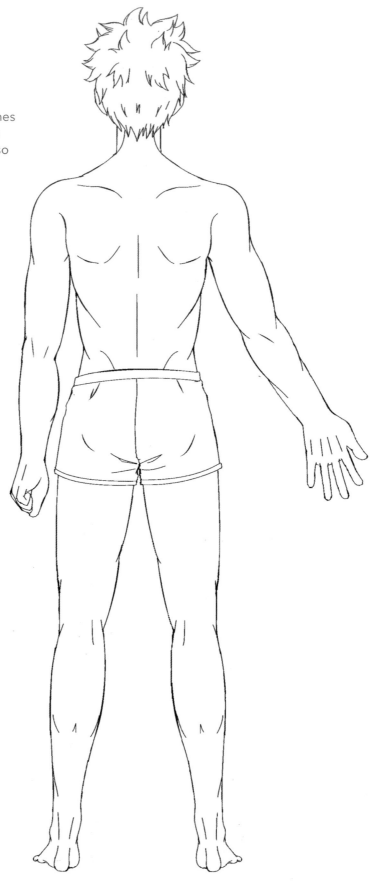

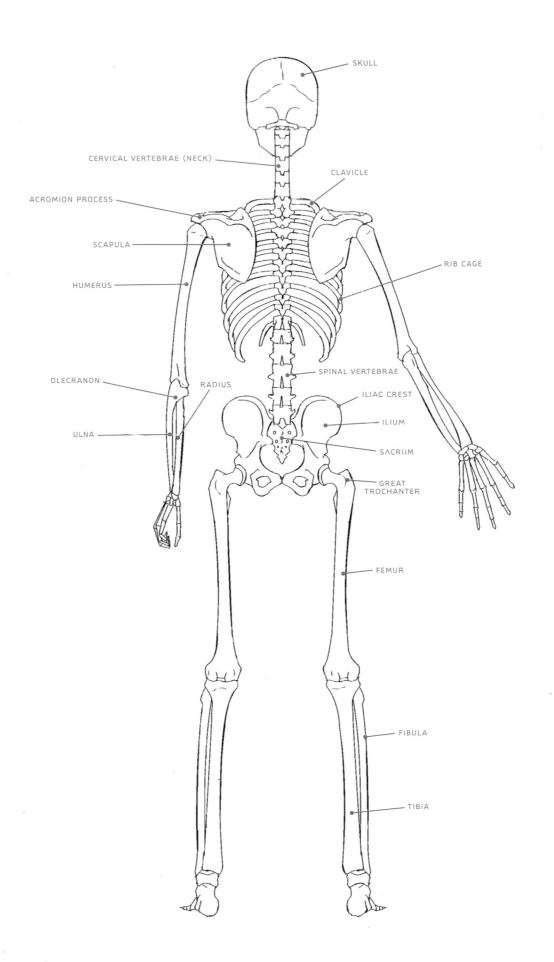

SKULL

CERVICAL VERTEBRAE (NECK)

CLAVICLE

ACROMION PROCESS

SCAPULA

RIB CAGE

HUMERUS

OLECRANON

RADIUS

SPINAL VERTEBRAE

ILIAC CREST

ILIUM

ULNA

SACRUM

GREAT
TROCHANTER

FEMUR

FIBULA

TIBIA

Now that you've examined the skeleton, you can begin to use it as the foundation for your drawings. But it would be too time-consuming to use the realistic skeleton as a foundation, so opt instead for a simplified version, like what you see on these two pages. The simplified skeleton serves as an excellent model, especially when deconstructing difficult poses. When you come across a pose that's challenging to conceptualize, and even more difficult to draw, you can often achieve success by first plotting out the figure as a simplified skeleton and then filling in the body's outline around it.

Looking at the figures with simplified skeletons, you can still see how important the skeleton is in creating a logical foundation for the build: The collarbones cause the shoulders to be far apart and on the same level. The rib cage gives the chest its width and depth. The pelvis gives the hips their mass.

Standing (Weight to One Side)

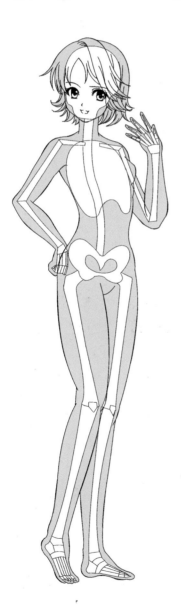

Walking

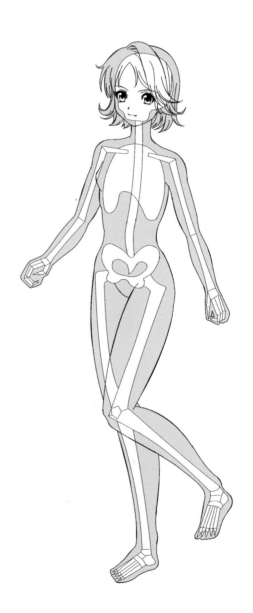

Reaching

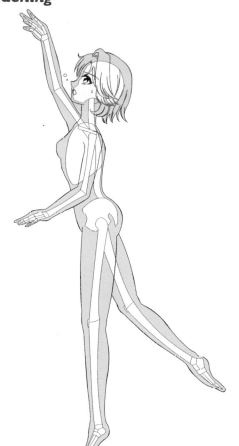

Sitting

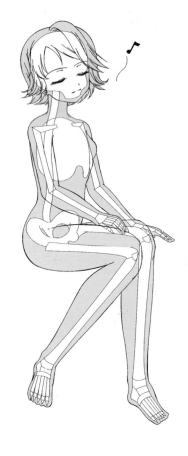

Reclining

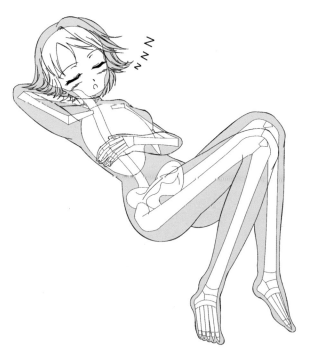

Bending

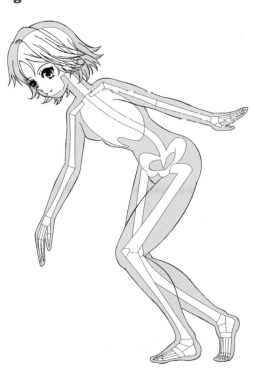

HEIGHT PROPORTIONS

We often think of height as something that is relative. In other words, a character only looks tall or short when standing alongside an object whose size the reader is already familiar with. The reader then compares the character to the size of the familiar object and deduces the height. For example, a character standing next to a large door looks short, while a character standing next to a short chair looks tall.

But this isn't the way it really works. Characters look tall, medium, or short in stature based on their own proportions, regardless of whether there is anything else to compare them to. Artists create this effect by using the character's own head as the unit of measurement to determine overall height. Generally, a cute character is 4 to 6 "heads tall." An average character is 6 to 7 heads tall. A tall character can be 8 to 9 heads tall. And superstylish characters such as bishounen and bishoujo, as well as gothic characters, can be even taller. On the other end of the spectrum, supercute chibis can be as little as three or even two heads tall!

7 Heads Tall (Average)

6 Heads Tall (Average Cute)

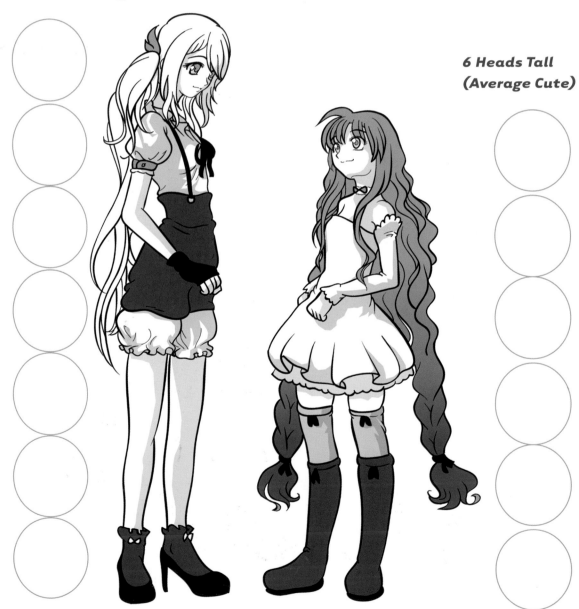

8 Heads Tall (Supertall)

5 Heads Tall (Petite)

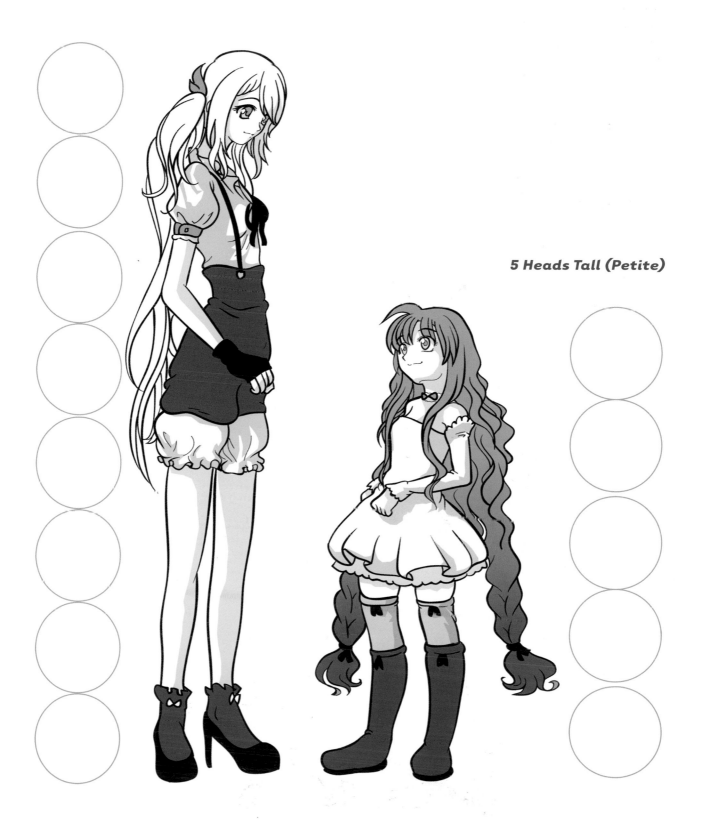

Human muscles have strange-sounding Latin names, which are hard to pronounce and even harder to remember. But don't worry—you don't have to memorize them. No one is going to give you a multiple-choice test at the end of this book, so you're off the hook! Still, it's important to label the individual muscles so that you can refer to them by name. Some artists find it helpful to memorize the names of the major muscle groups, many of which you probably already know from your workout routines; for example, there are the triceps, abdominals, and so on.

Just simply observing the various muscle groups, their basic shapes, and the way they lead into one another will improve your knowledge—and that's even before you pick up a pencil. Try drawing the figures on pages 44, 46, 48, 50, 52, and 54 (which show muscular definition at the surface of the skin) by referencing the anatomical models to the right of each figure.

Nearly every professional artist has an anatomy book on hand to use for reference, and that's another reason why memorization isn't necessary—if there's something you need to know, just pull out this book, flip to the right page, and refresh your memory. You're now taking an important step on a journey that all professional comic book artists have taken.

Male

Front

When the arms raise, it has the effect of stretching the torso slightly—but it's enough to cause the abdominals and rib muscles (serratus anterior) to become articulated.

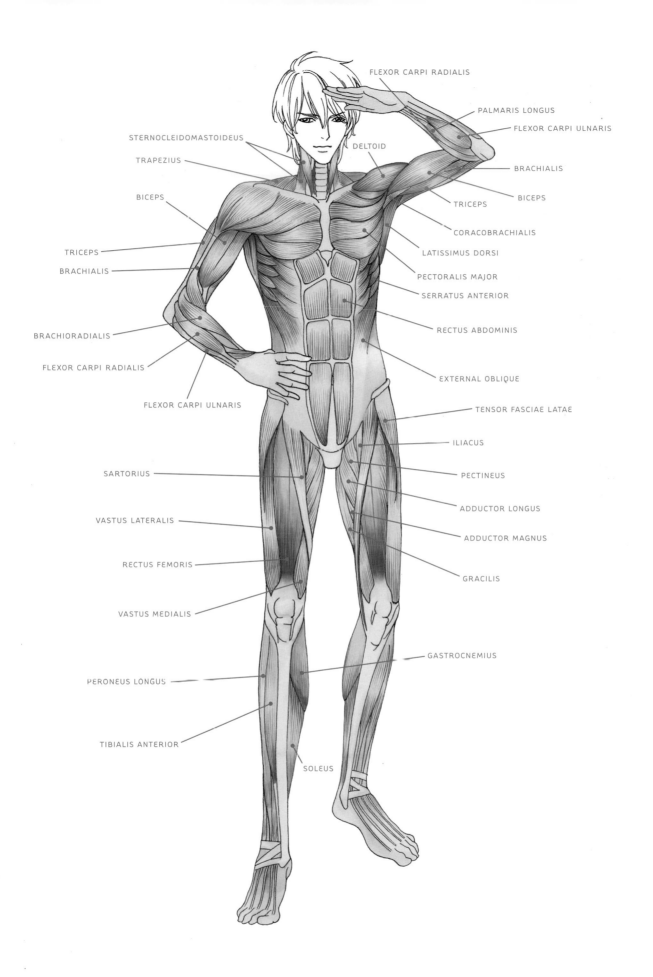

FLEXOR CARPI RADIALIS

PALMARIS LONGUS

FLEXOR CARPI ULNARIS

STERNOCLEIDOMASTOIDEUS

TRAPEZIUS

DELTOID

BRACHIALIS

BICEPS

BICEPS

TRICEPS

TRICEPS

CORACOBRACHIALIS

BRACHIALIS

LATISSIMUS DORSI

PECTORALIS MAJOR

BRACHIORADIALIS

SERRATUS ANTERIOR

FLEXOR CARPI RADIALIS

RECTUS ABDOMINIS

FLEXOR CARPI ULNARIS

EXTERNAL OBLIQUE

TENSOR FASCIAE LATAE

ILIACUS

SARTORIUS

PECTINEUS

VASTUS LATERALIS

ADDUCTOR LONGUS

ADDUCTOR MAGNUS

RECTUS FEMORIS

GRACILIS

VASTUS MEDIALIS

GASTROCNEMIUS

PERONEUS LONGUS

TIBIALIS ANTERIOR

SOLEUS

Side

Often, artists who are just beginning to study anatomy look to add as many "definition lines" to the interior of the torso and limbs as possible to indicate the individual muscles. However, as you can see here, the muscles can, in many cases, be sufficiently defined solely by articulating their shape in the outline of the figure.

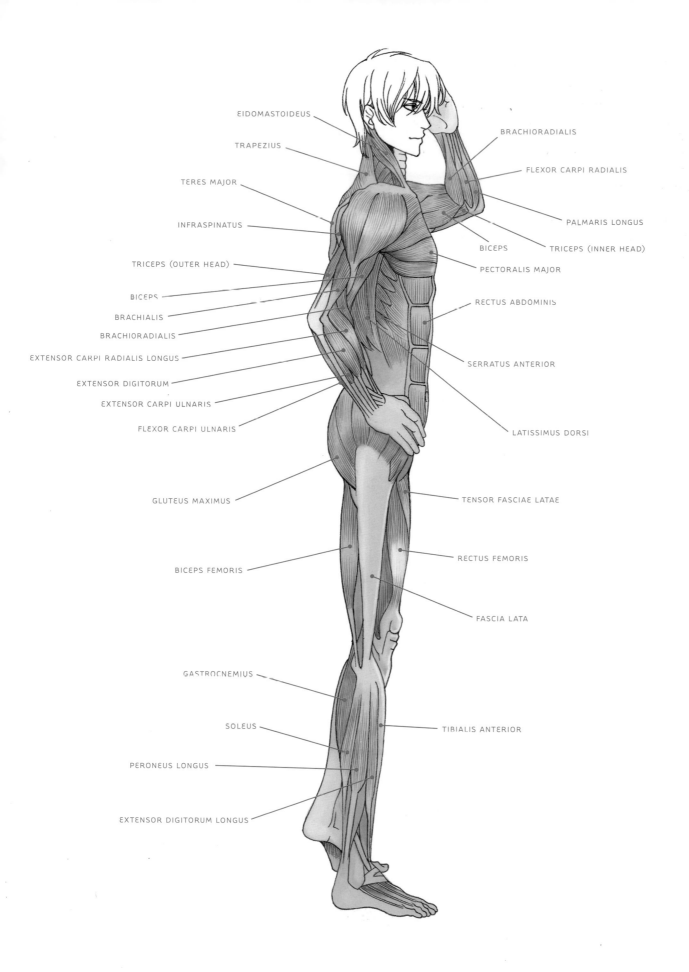

EIDOMASTOIDEUS

TRAPEZIUS

TERES MAJOR

INFRASPINATUS

TRICEPS (OUTER HEAD)

BICEPS

BRACHIALIS

BRACHIORADIALIS

EXTENSOR CARPI RADIALIS LONGUS

EXTENSOR DIGITORUM

EXTENSOR CARPI ULNARIS

FLEXOR CARPI ULNARIS

GLUTEUS MAXIMUS

BICEPS FEMORIS

GASTROCNEMIUS

SOLEUS

PERONEUS LONGUS

EXTENSOR DIGITORUM LONGUS

BRACHIORADIALIS

FLEXOR CARPI RADIALIS

PALMARIS LONGUS

BICEPS

TRICEPS (INNER HEAD)

PECTORALIS MAJOR

RECTUS ABDOMINIS

SERRATUS ANTERIOR

LATISSIMUS DORSI

TENSOR FASCIAE LATAE

RECTUS FEMORIS

FASCIA LATA

TIBIALIS ANTERIOR

Back

There are three things you'll want to watch for when drawing the back: (1) The shoulders aren't horizontal but slope, due to the trapezius muscle, which connects the shoulders to the neck. (2) The hips have width, even on men. Some beginners have a tendency to draw them too narrow, and that negatively affects the placement of the legs. And (3), the legs, even the calves, have major muscles, and therefore should not be drawn skinny, even on slender characters.

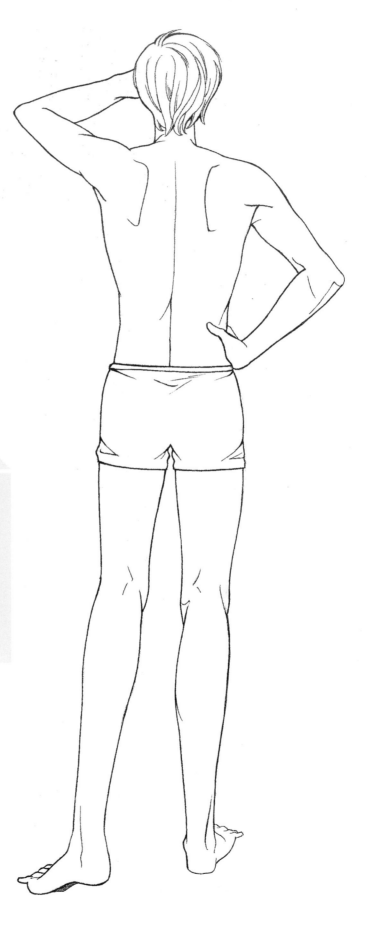

THE SHOULDER BLADES

On most slender characters, the shoulder blades (scapula) are noticeable through the skin. It's only on muscular characters that the individual muscles show on top of the shoulder blades. (We'll examine those muscles in the section on individual muscle groups, starting on page 58.)

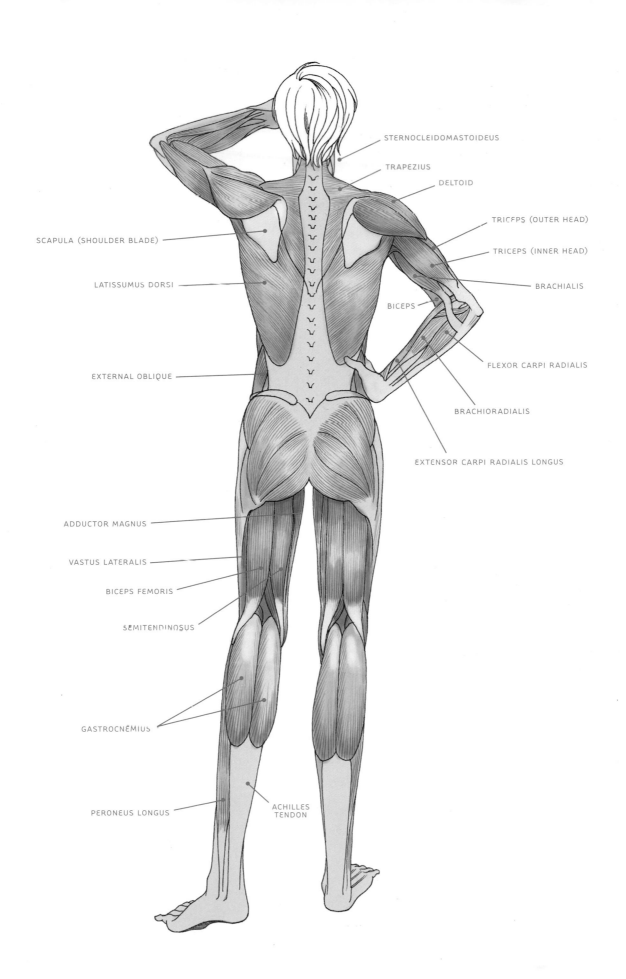

STERNOCLEIDOMASTOIDEUS

TRAPEZIUS

DELTOID

TRICEPS (OUTER HEAD)

TRICEPS (INNER HEAD)

BRACHIALIS

BICEPS

FLEXOR CARPI RADIALIS

BRACHIORADIALIS

EXTENSOR CARPI RADIALIS LONGUS

SCAPULA (SHOULDER BLADE)

LATISSUMUS DORSI

EXTERNAL OBLIQUE

ADDUCTOR MAGNUS

VASTUS LATERALIS

BICEPS FEMORIS

SEMITENDINOSUS

GASTROCNEMIUS

PERONEUS LONGUS

ACHILLES
TENDON

Female

Since the difference between the male and female figure really starts to take shape with the addition of the muscles over the skeleton, it's a good idea to also become familiar with muscle placement on women. The difference between the male and female figure is a matter of size, shape, and proportion. Generally, the female upper body shows reduced muscle mass. The rib cage is small, which limits the dimensions of the torso and creates fairly narrow shoulders. The power comes from the hips and legs.

Front

The outline of the female torso has a visual rhythm—wide, narrow, wide—that the male torso lacks. This is commonly referred to as an hourglass shape. The legs taper, and to extend that tapered effect, the feet should be fairly petite.

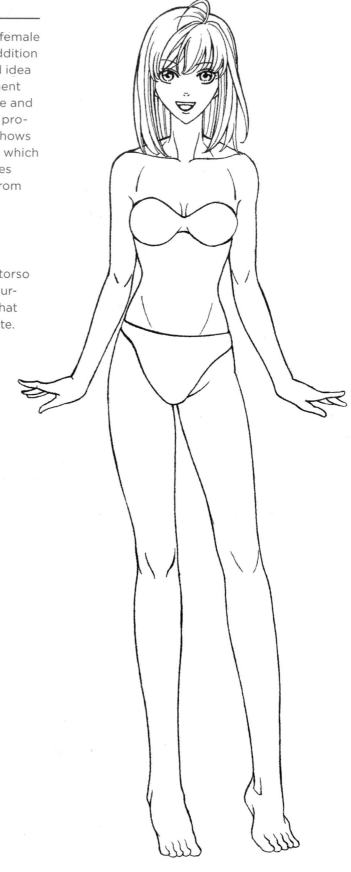

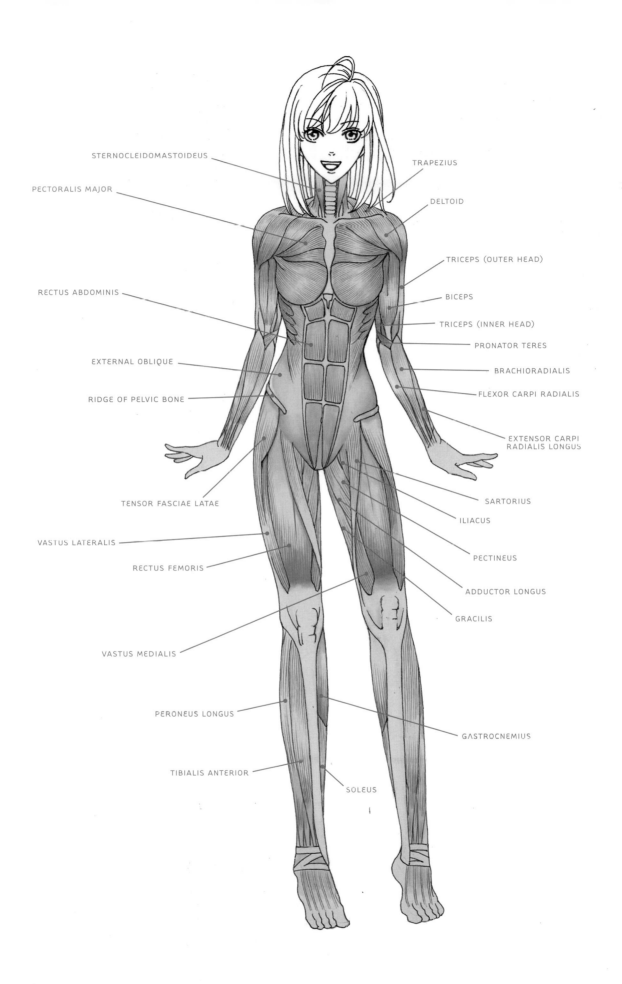

STERNOCLEIDOMASTOIDEUS

PECTORALIS MAJOR

RECTUS ABDOMINIS

EXTERNAL OBLIQUE

RIDGE OF PELVIC BONE

TENSOR FASCIAE LATAE

VASTUS LATERALIS

RECTUS FEMORIS

VASTUS MEDIALIS

PERONEUS LONGUS

TIBIALIS ANTERIOR

TRAPEZIUS

DELTOID

TRICEPS (OUTER HEAD)

BICEPS

TRICEPS (INNER HEAD)

PRONATOR TERES

BRACHIORADIALIS

FLEXOR CARPI RADIALIS

EXTENSOR CARPI RADIALIS LONGUS

SARTORIUS

ILIACUS

PECTINEUS

ADDUCTOR LONGUS

GRACILIS

GASTROCNEMIUS

SOLEUS

Side

Don't lose sight of the overall form. As you continue to concentrate on the individual muscles, whether large or small, there can be a tendency to stop paying attention to the overall pose. You could get all the muscles right but still end up with a stiff drawing. And no one wants that. So pause every now and then to reassess the fluidity of the pose. This stance in the side view shows good hip action and a natural sway in the lower back.

THE SHOULDER BLADES REDUX

The muscles that are layered on top of the shoulder blades of most female characters aren't pronounced enough to show through the surface of the body—they simply aren't large enough; therefore, the shoulder blade itself provides enough definition.

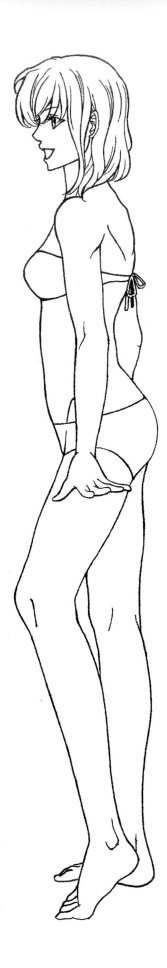

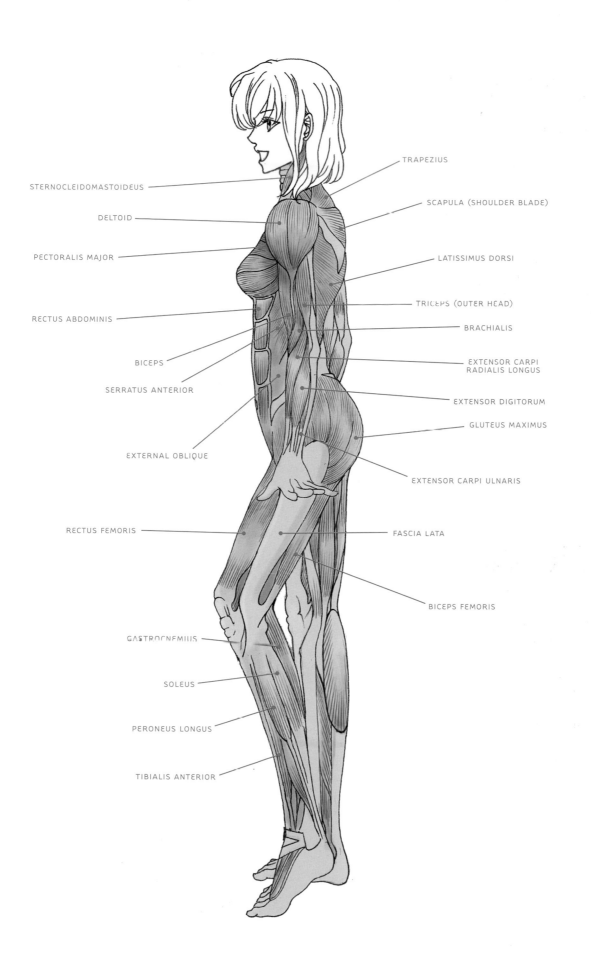

STERNOCLEIDOMASTOIDEUS

DELTOID

PECTORALIS MAJOR

RECTUS ABDOMINIS

BICEPS

SERRATUS ANTERIOR

EXTERNAL OBLIQUE

RECTUS FEMORIS

GASTROCNEMIUS

SOLEUS

PERONEUS LONGUS

TIBIALIS ANTERIOR

TRAPEZIUS

SCAPULA (SHOULDER BLADE)

LATISSIMUS DORSI

TRICEPS (OUTER HEAD)

BRACHIALIS

EXTENSOR CARPI RADIALIS LONGUS

EXTENSOR DIGITORUM

GLUTEUS MAXIMUS

EXTENSOR CARPI ULNARIS

FASCIA LATA

BICEPS FEMORIS

Back

It may seem counterintuitive, but women have wide backs. Of course the back width isn't the same as that of a man—but it should *not* be de-emphasized. The rear pose also provides the best view of the starting point of the waist, which occurs much higher up the torso than a man's waist. The female hips, being wide, are approximately the same width as the shoulders. This is a good measurement to remember when sketching. It can help you arrive at the correct proportions.

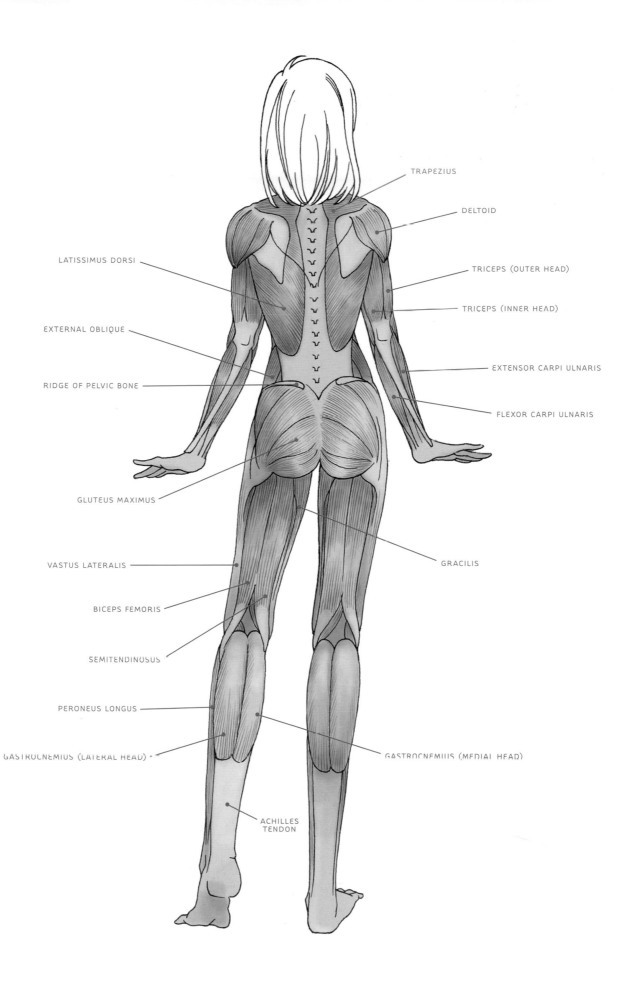

TRAPEZIUS

DELTOID

LATISSIMUS DORSI

TRICEPS (OUTER HEAD)

TRICEPS (INNER HEAD)

EXTERNAL OBLIQUE

RIDGE OF PELVIC BONE

EXTENSOR CARPI ULNARIS

FLEXOR CARPI ULNARIS

GLUTEUS MAXIMUS

GRACILIS

VASTUS LATERALIS

BICEPS FEMORIS

SEMITENDINOSUS

PERONEUS LONGUS

GASTROCNEMIUS (LATERAL HEAD)

GASTROCNEMIUS (MEDIAL HEAD)

ACHILLES
TENDON

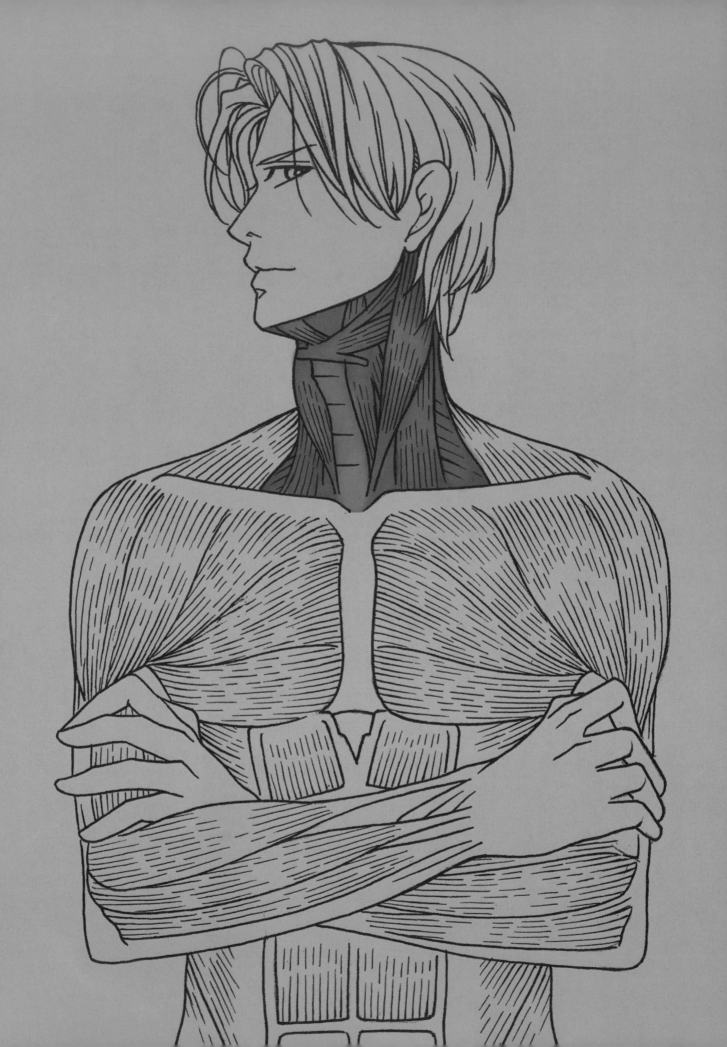

3: TOPOGRAPHIC ANATOMY

This is an important section because it shows how much muscular definition is visible on the skin's surface of the average, trim manga figure. Unless you learn which muscles "show through" to the surface of the skin and which ones don't, you can't use the muscular anatomy information very effectively.

This section also presents comparisons between the muscles in a relaxed state and in a flexed state. Most anatomy books only show the superdefined, flexed muscle groups. But what do you do when you want to draw someone who isn't flexing all the time? After reading this chapter, you'll know how much definition to add to a relaxed muscle. It's a valuable addition to your growing arsenal of manga techniques.

Many artists are surprised to learn that the neck has major muscles. They thought it only had stringy tendons. But when you look at the muscular chart of the neck, you'll immediately notice that one thick neck muscle stands out: the sternocleidomastoideus. Do not try to spell this at home. You'll drive yourself and others insane. This main neck muscle travels from the ear to the collarbone, where it forks off. This is the neck muscle with most of the definition at the skin level.

Notice, too, that fully half of the length of the neck is set down into the trapezius muscle. It's not just teetering on top of the torso but is set deep inside of it.

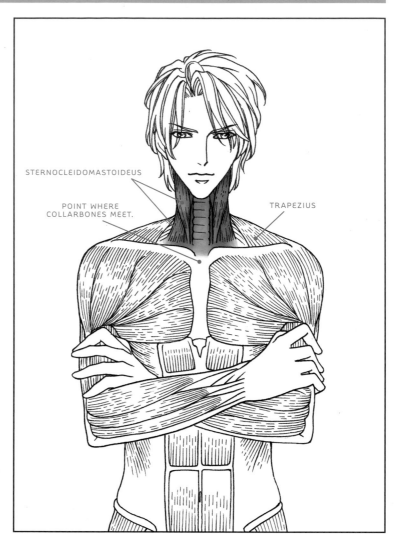

STERNOCLEIDOMASTOIDEUS

POINT WHERE COLLARBONES MEET.

TRAPEZIUS

Relaxed

Even when relaxed, both sternocleidomastoideus muscles are still apparent, especially on thin and athletic people but less so on heavier people. In this straightforward view, you can see clearly how the sternocleidomastoideus muscles travel from just beneath each ear to attach to the two collarbones where they meet, in the middle of the torso.

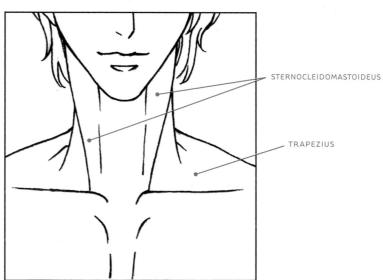

STERNOCLEIDOMASTOIDEUS

TRAPEZIUS

Flexed

When the neck turns, it flexes. This position reveals the other, smaller neck muscle, which is closer to the throat: the sternohyoideus. This muscle isn't as apparent on the surface of the skin, so use it sparingly.

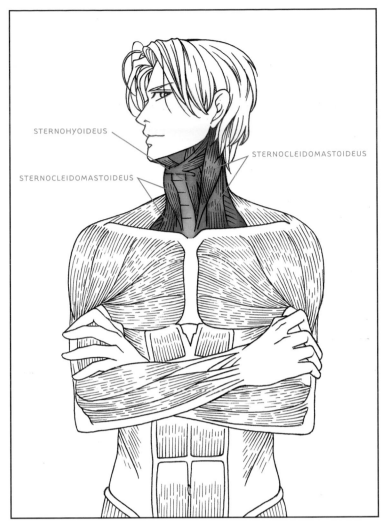

STERNOHYOIDEUS

STERNOCLEIDOMASTOIDEUS

STERNOCLEIDOMASTOIDEUS

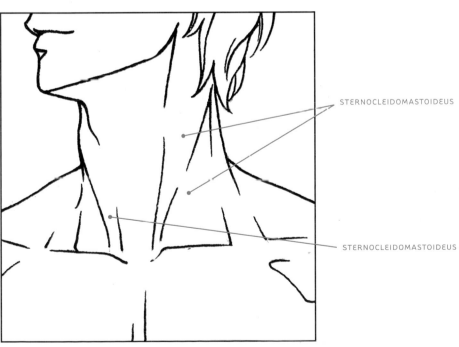

STERNOCLEIDOMASTOIDEUS

STERNOCLEIDOMASTOIDEUS

On male characters especially, a well-muscled chest equals power. It makes the stature of a character impressive in almost any pose. On female characters, developed chest muscles accentuate strong posture.

A good deal of anatomy is knowing where the muscles are positioned in relation to one another. Looking at the diagram here, you see that the chest muscles are attached horizontally across the collarbones. Running vertically down the middle of the torso, the chest muscles attach to the sternum (breastbone) in the center of the chest. On the sides, the chest muscles tilt up a bit and wind into the deltoids (shoulder muscles).

The sign of a youthful, trim, in-shape male character are "square-ish" chest muscles. You should be able to draw a straight line horizontally under the pectoral muscles.

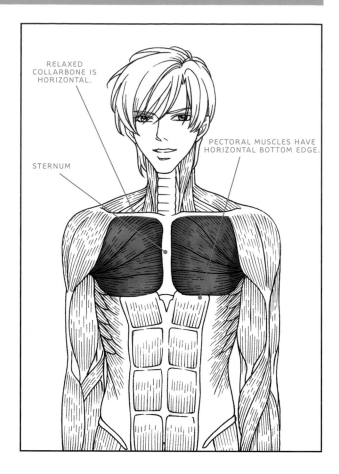

RELAXED COLLARBONE IS HORIZONTAL.

PECTORAL MUSCLES HAVE HORIZONTAL BOTTOM EDGE.

STERNUM

Relaxed

Every body type shows the muscular contour where the chest muscles (pectorals) wind into the shoulder muscles (deltoids).

When relaxed, the collarbone is horizontal and the outer ends should not tilt downward. The outer ends of the collarbones can tilt upward, but in general the collarbones should be parallel to the ground. A perfectly horizontal collarbone is one indicator of a lack of tension in the body.

UNDEFINED CHEST AREA.

CONTOUR WHERE CHEST MUSCLES (PECTORALS) WIND INTO SHOULDER MUSCLES (DELTOIDS).

Flexed

We use chest muscles all the time without realizing it, but it's during big movements—such as pushing, squeezing, and pulling—that they really stand out. When flexed, chest muscles can bunch and show striations like any other muscle; but they must have sufficient size to do so; therefore, only athletic or muscular characters' chests reveal a muscular flex like the one seen here. Note also how the collarbones crunch into a V shape when the chest flexes.

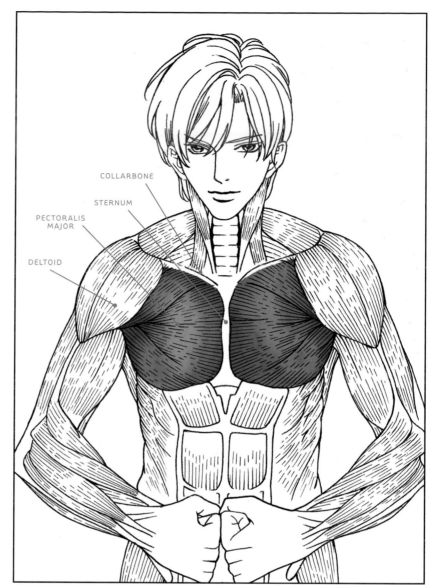

COLLARBONE

STERNUM

PECTORALIS MAJOR

DELTOID

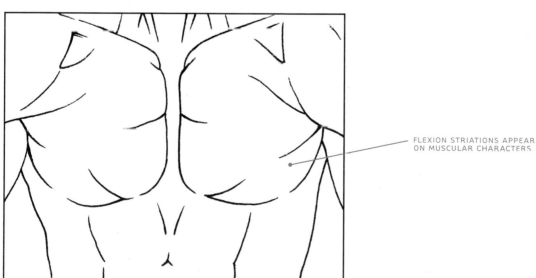

FLEXION STRIATIONS APPEAR ON MUSCULAR CHARACTERS.

A well-defined midsection gives a character the look of inner strength and power. This accent is effective for both bad guys and good guys. Women also have well-developed abdominals. But it's less attractive to articulate each individual stomach muscle. It looks very extreme. Just suggest the definition with a minimum of line work.

Abdominals are made up of four pairs of tight muscle groups running vertically down from the sternum to the pelvic region. On either side of the abdominal wall is the rib cage muscle, called the serratus anterior, and below each of these is a side muscle, called the external oblique (which adds unwanted width to the waistline!).

The shortest abdominal muscle is the top one, just below the sternum. The longest is the bottom one, just above the pelvis; this is partially blocked by clothing in the diagram here.

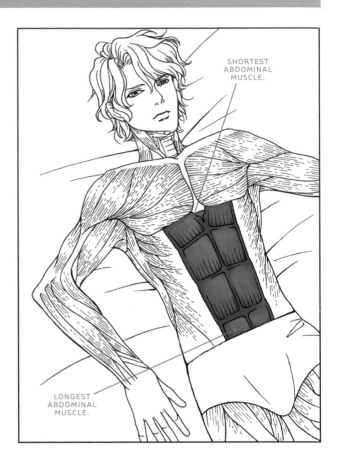

SHORTEST ABDOMINAL MUSCLE.

LONGEST ABDOMINAL MUSCLE.

Relaxed

In the relaxed position, the abdominal wall loses its highly segmented appearance on the skin surface. The center line, therefore, breaks up, too.

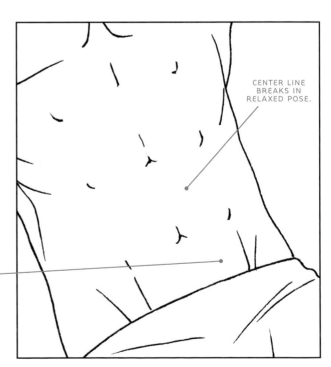

CENTER LINE BREAKS IN RELAXED POSE.

SOME OF BOTTOM (LONGEST) ABDOMINAL MUSCLE CAN BE SEEN.

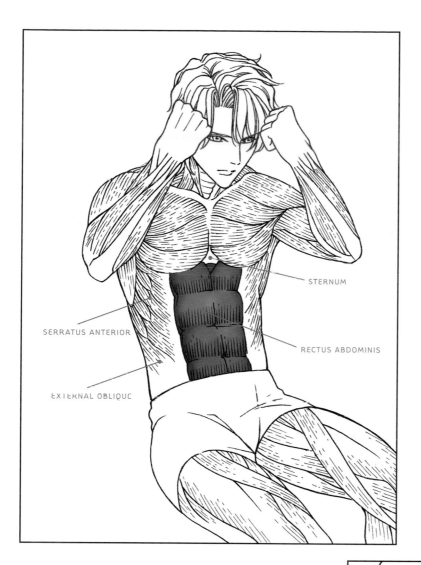

STERNUM

SERRATUS ANTERIOR

RECTUS ABDOMINIS

EXTERNAL OBLIQUE

Flexed

It's not necessary to articulate every single rib muscle in the flexed position. You can generalize. Also notice how the center line of each abdominal section is visible when the muscles are flexed.

RIBS

CENTER LINES

The main shoulder muscle is the deltoid, which is a big, round muscle that covers a lot of territory. It's capable of showing a good amount of definition, since it has three heads: front, middle, and rear. But it's still all one muscle. When drawing the definition lines, make sure they're curved, because they should appear to travel around the heaping mass of the deltoid.

Relaxed

When the deltoid is relaxed, the three heads don't show any signs of articulation. It just looks like one smooth muscle. The definition lines remain on the actual muscles below the skin, however; you just can't see them. From this angle, the deltoid looks like an upside-down teardrop. Note how the point of the teardrop lands in the middle of the upper arm, at the brachialis muscle. You can allow the lines of the brachialis to trail off without much definition, especially when a character is relaxed.

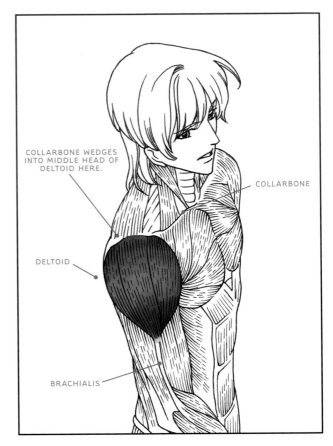

COLLARBONE WEDGES INTO MIDDLE HEAD OF DELTOID HERE.

COLLARBONE

DELTOID

BRACHIALIS

BRACHIALIS TRAILS OFF.

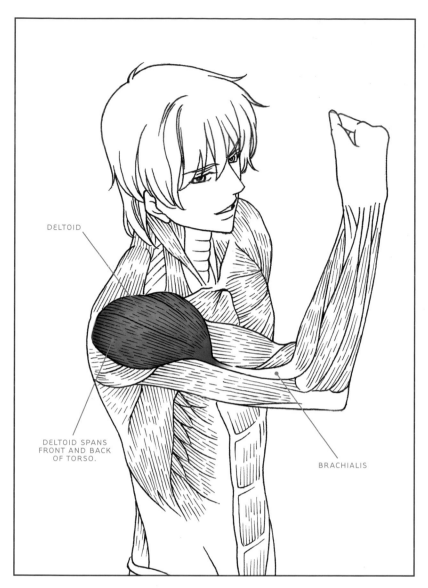

DELTOID

DELTOID SPANS
FRONT AND BACK
OF TORSO.

BRACHIALIS

Flexed

In the flexed view, you can clearly see how the deltoid muscle funnels down to meet the thin brachialis on the outside of the upper arm. The deltoid is large enough that it covers part of the front and back of the torso.

SIMPLE LINE WORK INDICATES DELTOID'S
THREE HEADS: FRONT, MIDDLE, AND REAR.

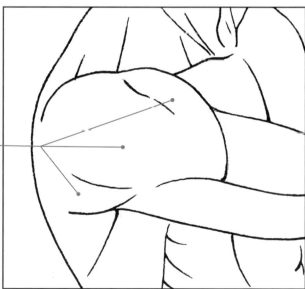

People tend to think of the upper arm as all biceps, when at least half of the arm is triceps, as well as other smaller yet still visible arm muscles.

Biceps, Relaxed

The biceps wedges into the crook of the elbow and is cut off by two forearm muscles: the brachioradialis and the pronator teres. On the outside of the upper arm, the thin brachialis muscle connects the shoulder muscles to the forearm muscles. The brachialis is important, because it separates the biceps from the triceps. Though some beginners omit this (due to lack of knowledge), pros always add it to their drawings.

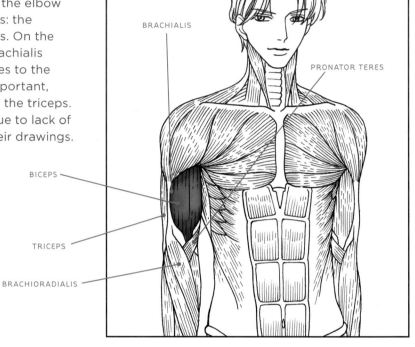

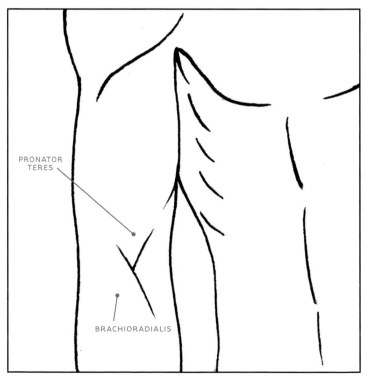

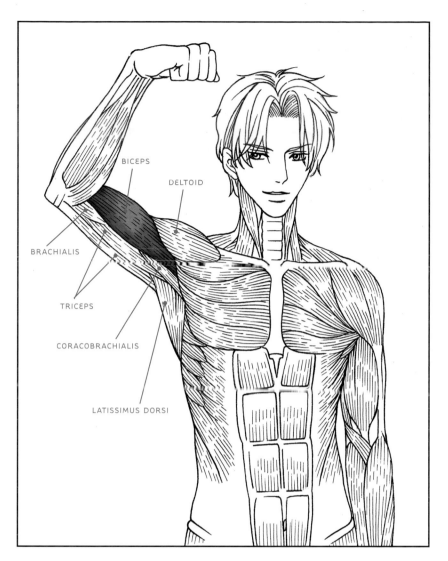

Biceps, Flexed

On the underside of the arm, the latissimus dorsi (a back muscle) wedges its way between two upper arm muscles: the triceps and the coracobrachialis.

The detail to the right is very defined here, but some artists eliminate the brachialis.

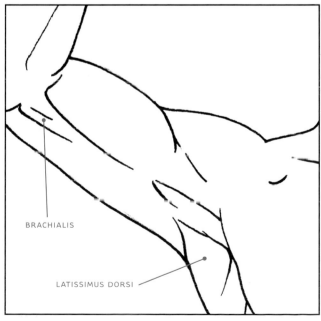

Triceps, Relaxed

When the biceps flexes, the triceps, which is on the opposite side of the arm, *relaxes*. As the arm bends at the elbow, with the forearm curling upward, the triceps is pulled, and as a result, it elongates. When stretched like that, the triceps loses definition and appears smooth.

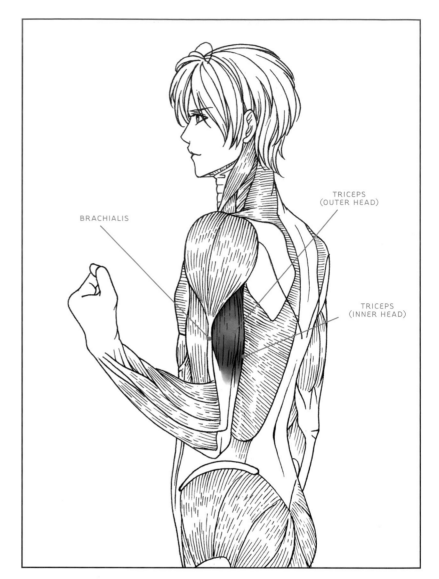

BRACHIALIS

TRICEPS (OUTER HEAD)

TRICEPS (INNER HEAD)

BRACHIALIS ADDS DEFINITION.

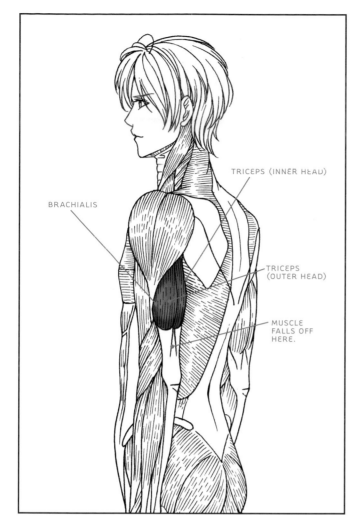

BRACHIALIS

TRICEPS (INNER HEAD)

TRICEPS (OUTER HEAD)

MUSCLE FALLS OFF HERE.

Triceps, Flexed

When the arm hangs straight down so that the biceps is relaxed, the triceps flexes, rising and hunching up. This flexing defines the two heads of the triceps (inner and outer) on the skin surface. The triceps is used primarily for pushing, pressing, striking, and throwing movements. The flexed muscle turns into tendon before reaching the elbow.

MUSCLE FALLS OFF TOWARD ELBOW.

The forearms have many thin, long muscles running from elbow to wrist. You may look at the diagrams and ask yourself if you really have to memorize all of them. This is why having diagrams of surface anatomy is so important. They show you which muscles to concentrate on for drawing and which are just for your information.

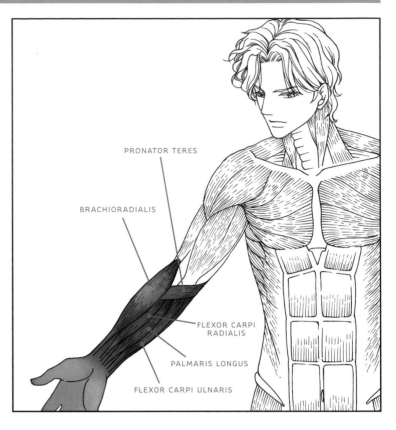

PRONATOR TERES

BRACHIORADIALIS

FLEXOR CARPI RADIALIS

PALMARIS LONGUS

FLEXOR CARPI ULNARIS

Relaxed, Anterior View

Opening up the palm relaxes the forearm muscles. Here, the prominent muscle is the brachioradialis, which takes up half the width of the forearm. Not all artists choose to articulate the forearm muscles in a relaxed pose. Most allow the outline of the forearm to suffice; however, if the muscles are articulated, it is usually near the crook of the elbow.

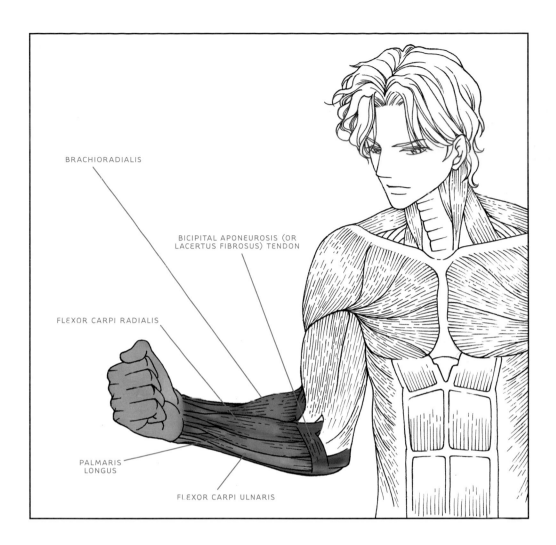

BRACHIORADIALIS

BICIPITAL APONEUROSIS (OR
LACERTUS FIBROSUS) TENDON

FLEXOR CARPI RADIALIS

PALMARIS
LONGUS

FLEXOR CARPI ULNARIS

Flexed, Anterior View

When the hand is balled into a fist, the forearm is generally tense, and the tendons will show around the wrist area. The closer to the wrist you get, the more prominent the tendons become. When the palm is held supine (facing upward) and there's no twisting or rotating of the forearm, the muscles travel in a straight line from the elbow to the wrist. Note that the muscles also taper from the elbow to the wrist.

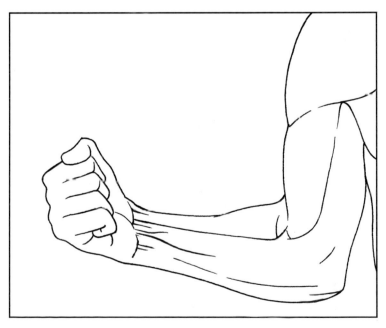

Relaxed, Posterior View

This forearm is partially relaxed because the character is holding something light, with his arm down at his side. But tension still remains in the cluster of muscles around the elbow and a bit at the wrist. And remember, you're only suggesting muscles when you're drawing surface anatomy; you're not delineating an entire group of them. Just a few light strokes may be all you need—even when your inclination may be to do more. Sometimes restraint works better than elaborate technique.

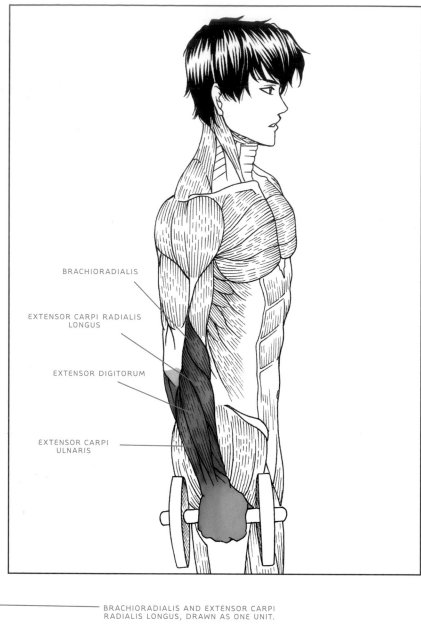

BRACHIORADIALIS

EXTENSOR CARPI RADIALIS
LONGUS

EXTENSOR DIGITORUM

EXTENSOR CARPI
ULNARIS

BRACHIORADIALIS AND EXTENSOR CARPI
RADIALIS LONGUS, DRAWN AS ONE UNIT.

OLECRANON (PROTRUDING
UPPER END OF ULNA).

VERY BEGINNING OF EXTENSOR DIGITORUM.

Flexed, Posterior View

Some of the muscles of the forearm are never articulated on surface anatomy. Examples are the abductor pollicis longus and the extensor pollicis brevis. No one ever sees them. They're called out on the diagram at right but aren't defined on the skin surface below. However, two forearm muscles are very important for artists: the extensor carpi radialis longus and the brachioradialis. They are usually visible when the forearm rotates into the palm-down (or pronate), "hammer fist," or sideways positions. In addition, the extensor digitorum communis and extensor carpi ulnaris are typically seen when the forearm is flexed. So take a close look at these two main muscles in both diagrams and commit them to memory.

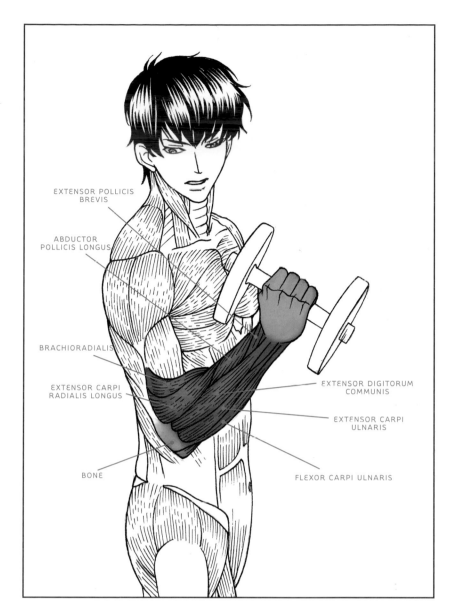

EXTENSOR POLLICIS BREVIS

ABDUCTOR POLLICIS LONGUS

BRACHIORADIALIS

EXTENSOR CARPI RADIALIS LONGUS

BONE

EXTENSOR DIGITORUM COMMUNIS

EXTENSOR CARPI ULNARIS

FLEXOR CARPI ULNARIS

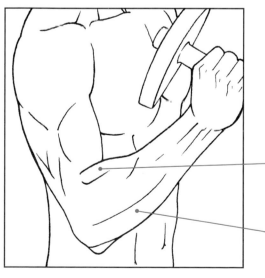

BRACHIORADIALIS AND EXTENSOR CARPI RADIALIS LONGUS WORK AS A UNIT.

DEFINITION LINE BETWEEN EXTENSOR DIGITORUM COMMUNIS AND EXTENSOR CARPI ULNARIS.

The upper back has the trapezius muscle—the one that connects the neck to the shoulders, travels down to the middle of the back, and covers the inner half of the scapula (shoulder blade).

In actuality, there are three muscles that cover each shoulder blade; however, usually the shoulder-blade muscles are not well developed unless the subject is a super-athlete; therefore, it suffices to just draw the shoulder blades.

Upper Back, Relaxed

Most characters in manga have idealized body types. You don't typically see out-of-shape manga characters. On these trim types, the spine and shoulder blades are evident, even when the back is in a relaxed state. These areas have been articulated to a high degree in these illustrations. You can show less definition omitting the diagonal ridge at the top of the shoulder blades where the shoulder muscles attach to the scapula. In these drawings, there's more definition than would normally be seen on a relaxed back. This has been done to convey the shape of the shoulder blades. Also note that the shoulder blades become more pronounced the closer they are. They become less defined as they travel out toward the arms.

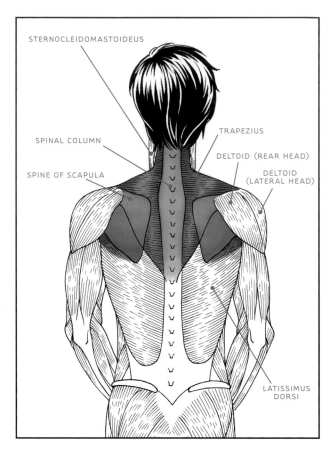

There are three muscles that cover the shoulder blade, the most prominent of which is the teres major. These muscles rarely show on people who aren't athletes.

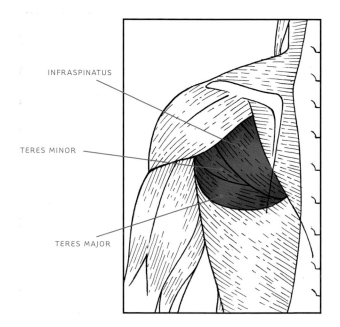

Upper Back, Flexed

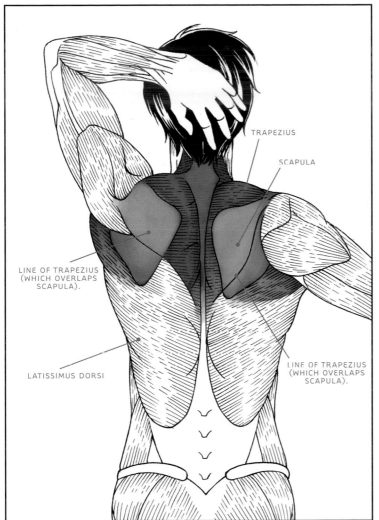

TRAPEZIUS

SCAPULA

LINE OF TRAPEZIUS
(WHICH OVERLAPS
SCAPULA).

LINE OF TRAPEZIUS
(WHICH OVERLAPS
SCAPULA).

LATISSIMUS DORSI

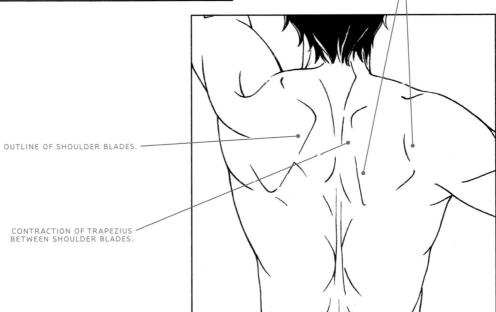

OUTLINE OF SHOULDER BLADES.

OUTLINE OF SHOULDER BLADES.

CONTRACTION OF TRAPEZIUS
BETWEEN SHOULDER BLADES.

Lower Back, Relaxed

The job of holding up the torso and the head is carried, to some extent, by the abdominal muscles, but the lower back receives the lion's share of pressure—and aches. The line of the spine is visible on the surface of the skin from the top of the neck all the way down to the lower back and pelvis. No muscles cross over the spine. The largest back muscle, the latissimus dorsi, appears as two huge slabs on either side of the back. Under it are the external obliques, which are the famous parts of the waistline that add a bit of girth as we age. Even though everybody has external obliques, some manga artists omit them on idealized characters, especially on bishounen.

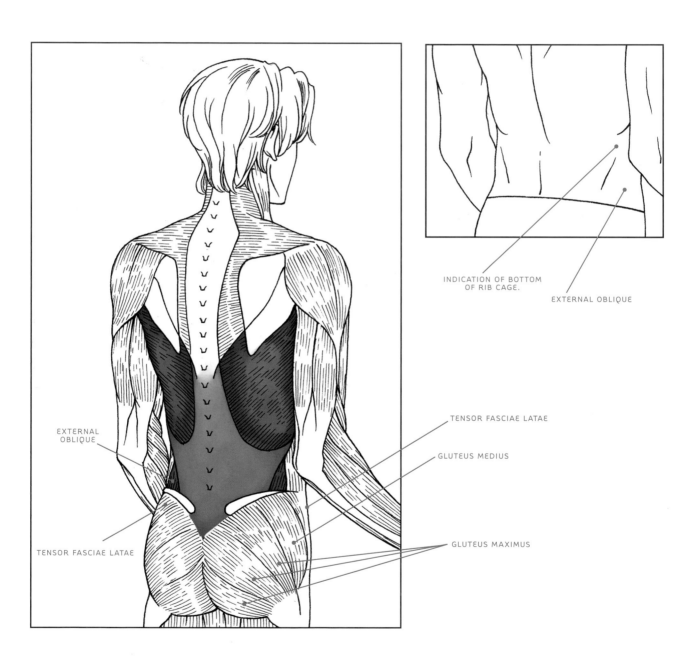

INDICATION OF BOTTOM OF RIB CAGE.

EXTERNAL OBLIQUE

EXTERNAL OBLIQUE

TENSOR FASCIAE LATAE

GLUTEUS MEDIUS

TENSOR FASCIAE LATAE

GLUTEUS MAXIMUS

Lower Back, Flexed

When the body arches back, the lower back experiences pressure and tightens up, flexing.

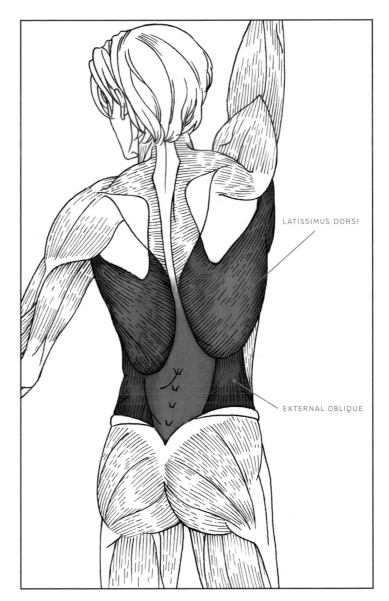

LATISSIMUS DORSI

EXTERNAL OBLIQUE

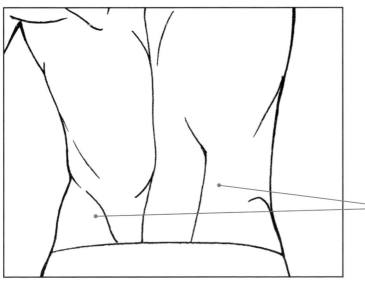

DEFINITION LINES AROUND EXTERNAL OBLIQUES AND LATISSIMUS DORSI.

Beginners often draw legs that look too straight; legs look more natural if they're drawn rounder and fuller.

Relaxed, Anterior View

Muscles that are relaxed, as a rule, are less defined; however, the one muscle that is often still articulated, even in its relaxed state, is the sartorius (the thin band that winds diagonally across the thigh from the knee to the hip). Except for that, the relaxed leg should have few interior definition lines.

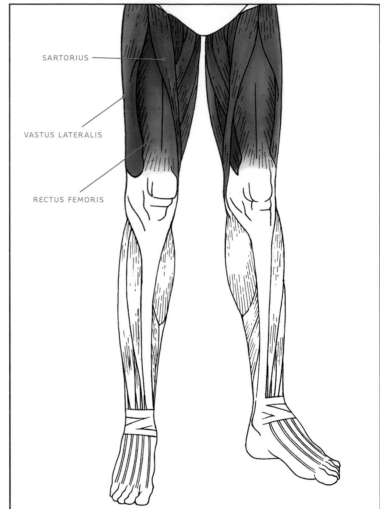

SARTORIUS

VASTUS LATERALIS

RECTUS FEMORIS

SLIGHT DEFINITION LINE NEAR
SARTORIUS ON RELAXED INNER THIGHS.

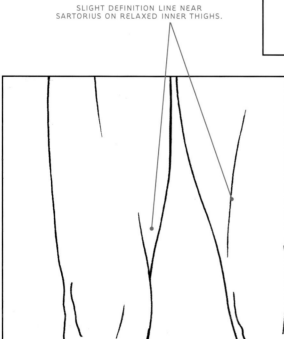

Flexed, Anterior View

There are many muscles in the upper leg that can be articulated during action poses. The most prominent of those, the vastus medialis, is defined by the thin band of the sartorius muscle, which pulls it into shape. Don't worry if there seem to be too many individual muscles to memorize and master here; you only have to articulate two or three to indicate that the leg is flexed. This drawing shows many more for illustrative purposes.

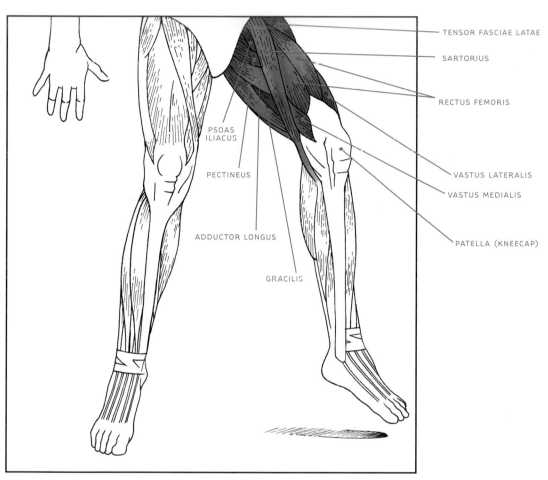

TENSOR FASCIAE LATAE

SARTORIUS

RECTUS FEMORIS

PSOAS
ILIACUS

PECTINEUS

VASTUS LATERALIS

VASTUS MEDIALIS

ADDUCTOR LONGUS

PATELLA (KNEECAP)

GRACILIS

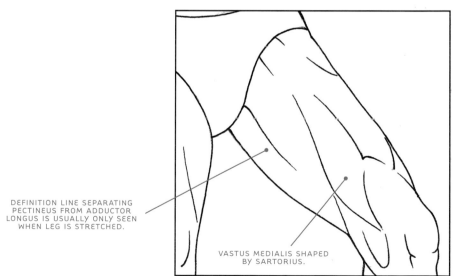

DEFINITION LINE SEPARATING
PECTINEUS FROM ADDUCTOR
LONGUS IS USUALLY ONLY SEEN
WHEN LEG IS STRETCHED.

VASTUS MEDIALIS SHAPED
BY SARTORIUS.

Relaxed, Posterior View

The rear muscles of the upper legs are composed of two major muscles: the biceps femoris and the semitendinosus. Unless flexed, they appear to form a single group of muscles and therefore don't usually need to be individually articulated.

These muscles don't transition smoothly into the gluteus maximus (the main buttocks muscle above them) but instead meet it perpendicularly. Notice, too, how the big leg muscles taper down into the small tendons at the back of the knee joint. Now you can see what causes that little pocket of space behind the knee that we all have.

Note how the placement of the muscles in the anatomical illustration at right corresponds precisely to the placement of the definition lines below.

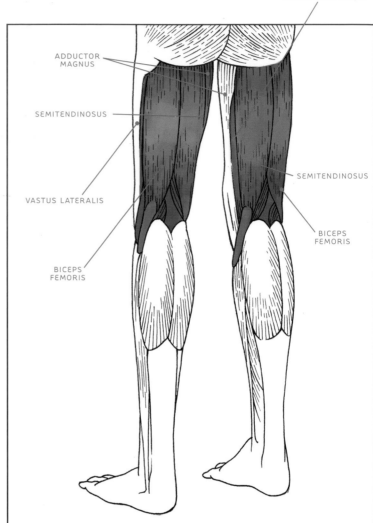

SEMIMEMBRANOSUS

ADDUCTOR MAGNUS

SEMITENDINOSUS

VASTUS LATERALIS

BICEPS FEMORIS

SEMITENDINOSUS

BICEPS FEMORIS

DEFINITION LINE BETWEEN ADDUCTOR MAGNUS AND SEMITENDINOSUS.

DEFINITION LINE WHERE VASTUS LATERALIS MEETS BICEPS FEMORIS.

INDENTATION WHERE UPPER LEG MUSCLES MEET CALF MUSCLES.

Flexed, Posterior View

The biceps femoris and the semitendinosus make a powerful pair of muscles that is sometimes referred to as the "biceps of the legs," because flexing them makes a bulge, much as the biceps in the arm does.

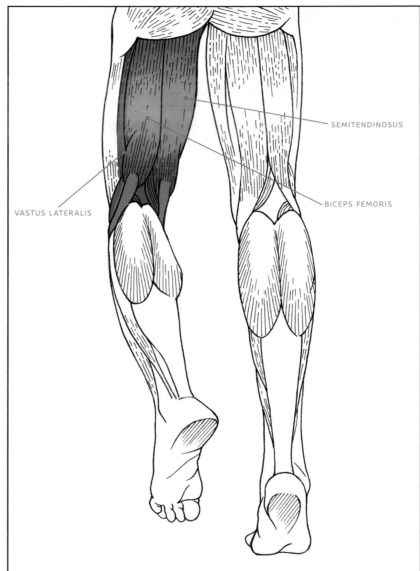

SEMITENDINOSUS

VASTUS LATERALIS

BICEPS FEMORIS

LARGE THIGH MUSCLES BULGE WHEN FLEXED.

POCKET WITH NO MUSCLE.

Don't usually pay attention to the lower leg? Drawing skinny calves can make an otherwise well-executed drawing look mediocre. But this is an easy fix. Check out the tips on these next few pages and you'll eliminate common mistakes.

Relaxed, Anterior View

In the front view, the lower leg doesn't exhibit many definition lines when the muscles aren't under exertion. Unncecessary definition lines are distracting. Don't compete with other, more important parts of the body that require significant definition lines, such as the biceps and the chest. Definition lines for a relaxed shin can be short, as in the image below, or you might choose to accent the shin bone instead.

Nonetheless, there are times when you may wish to show tension in the body—even when the legs are not under stress. An example would be if something shocks the character and his or her body tenses up, or if preparing for a fight, the entire body tenses in anticipation. Those are moments when definition lines help to underscore the anxiety of the moment.

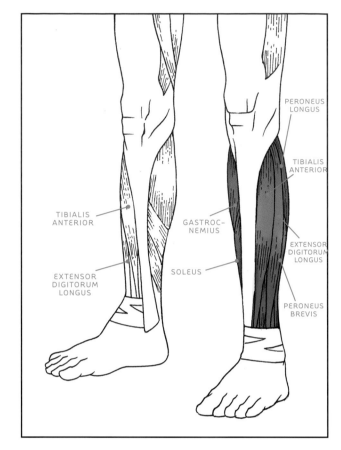

PERONEUS LONGUS

TIBIALIS ANTERIOR

TIBIALIS ANTERIOR

GASTROC-NEMIUS

EXTENSOR DIGITORUM LONGUS

EXTENSOR DIGITORUM LONGUS

SOLEUS

PERONEUS BREVIS

SHORT DEFINITION LINES FOR RELAXED MUSCLES.

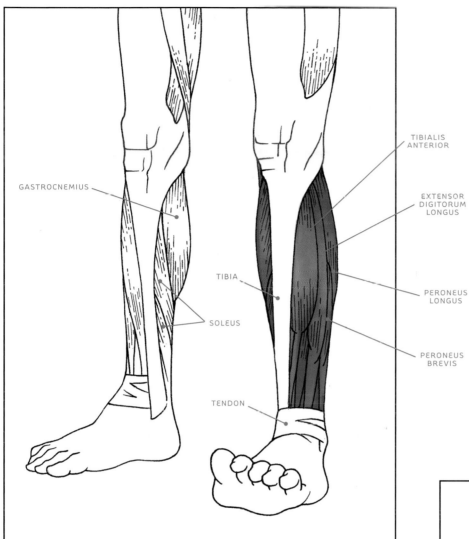

GASTROCNEMIUS

TIBIALIS
ANTERIOR

EXTENSOR
DIGITORUM
LONGUS

TIBIA

SOLEUS

PERONEUS
LONGUS

PERONEUS
BREVIS

TENDON

Flexed, Anterior View

For the sake of thoroughness, I've included a front view of the lower leg muscles when flexed. But this isn't so dynamic, because the tibia (shinbone) is so prominent that it crowds out most of the muscles and relegates them to the sides of the leg. The inner portion of the lower leg, however, has the prominent calf muscle: the gastrocnemius. On the outside, you'll see several prominent definition lines (right), owing to the longer muscles that appear there.

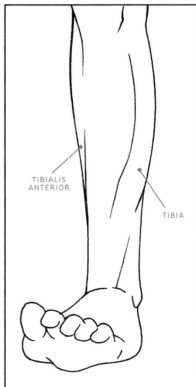

TIBIALIS
ANTERIOR

TIBIA

Relaxed, Posterior View

The prominent calf muscle, the gastrocnemius, is responsible for most of the girth of the lower leg. It looks like a three-quarter-full water balloon even when relaxed and is one of the few muscles that retains much of its roundness, even in a relaxed state. It has two distinct sections separated by a vertical split, but you don't see this on the surface of the skin when the gastrocnemius is relaxed, so there's no definition line there in the drawing below. For practical purposes, the gastrocnemius is often sketched as an oval and then adjusted at the top and bottom to show the gradual transition into the other muscles and tendons. The Achilles tendon always remains smooth.

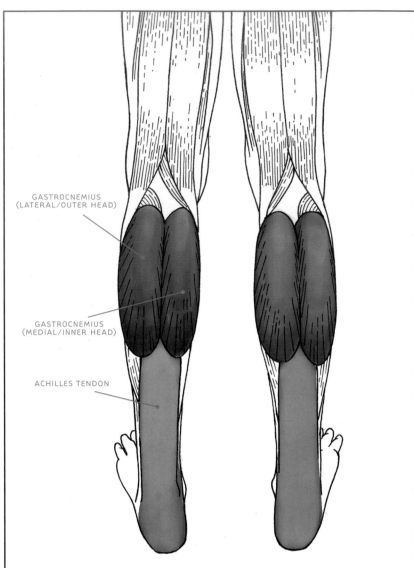

GASTROCNEMIUS
(LATERAL/OUTER HEAD)

GASTROCNEMIUS
(MEDIAL/INNER HEAD)

ACHILLES TENDON

THERE'S NO "SPLIT" SHOWN ON THE CALF
MUSCLE WHEN IT'S IN A RELAXED STATE.

Flexed, Posterior View

The calf muscles can really bunch up when flexed. The split in the gastrocnemius becomes visible when the muscle tightens up. It appears to be two different muscle groups, but actually, it's two heads of the same muscle. Fully half of the lower leg is covered by the Achilles tendon.

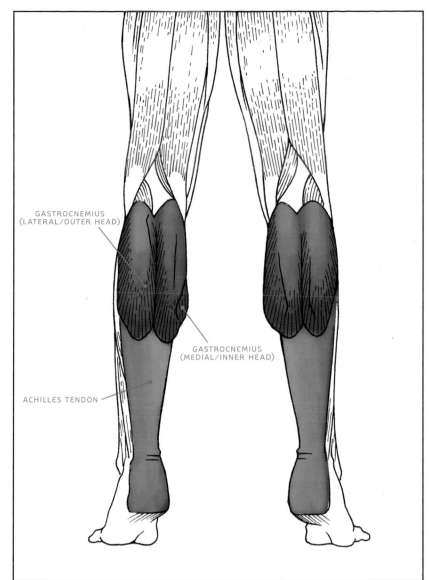

GASTROCNEMIUS (LATERAL/OUTER HEAD)

GASTROCNEMIUS (MEDIAL/INNER HEAD)

ACHILLES TENDON

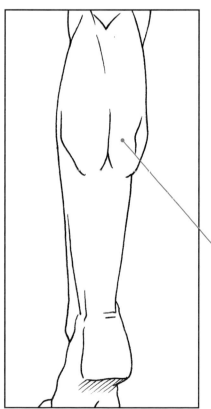

THE SPLIT LOOK OF THE GASTROCNEMIUS IS EVIDENT ONLY WHEN THE MUSCLE IS FLEXED. THE MUSCLE ACTUALLY LIFTS UP WHEN FLEXED. NOTE HOW HIGH UP ON THE LEG THE MUSCLE APPEARS. THE REST IS TENDON.

Not every muscle is superdefined on the outline of the figure, because that would result in an outline that's bumpy all over. The outline of the figure is certainly influenced by the various muscle groups, but just as important, you must be sure to draw a smooth transition between the groups, even if that requires losing some definition. Every body has a coating of fat and skin that acts as a smooth layer covering the muscles. Note how fluid the black ink outline is on these figures. The heavily muscled areas occur on the *interior* of the form.

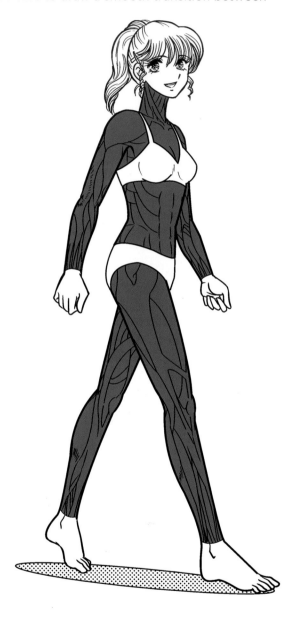

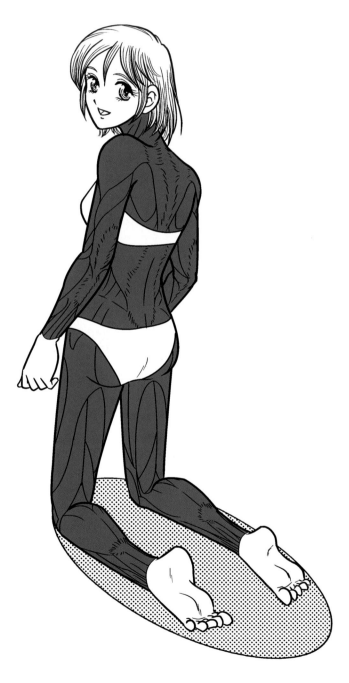

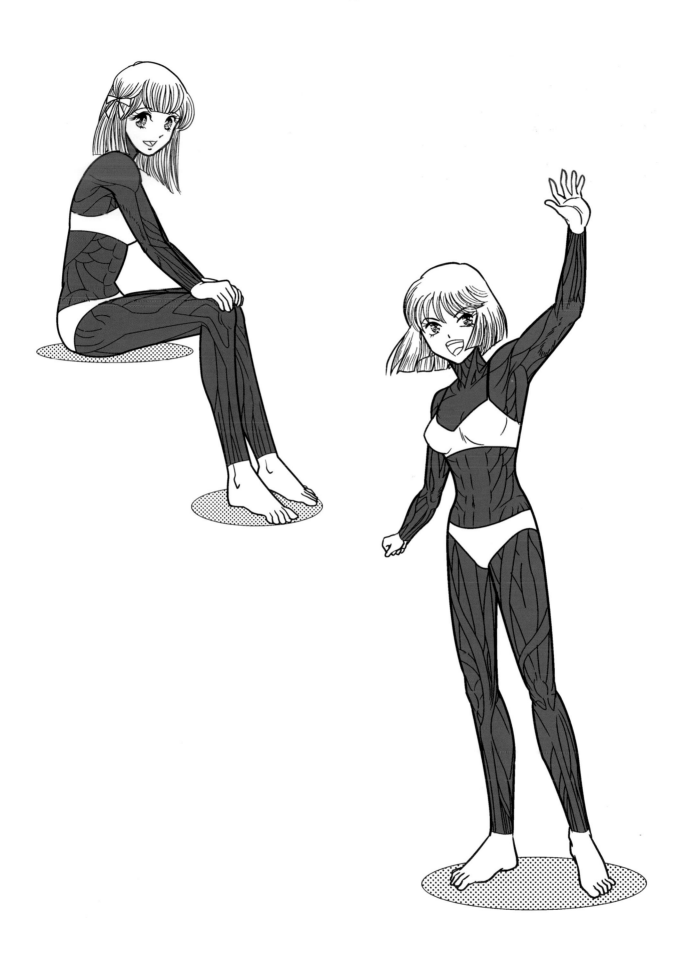

It's important to know the basic direction in which a particular muscle appears to travel: up, down, horizontally, or diagonally. When a muscle tenses up or stretches, definition lines result. If you don't know how the muscle is formed, you won't know how to draw those lines.

It's also important to be somewhat familiar with the general shapes of the muscles. For example, look at the triangular muscle (the trapezius) in the middle of the upper back below. How are you going to draw this guy holding a boulder over his head without drawing his back flexed? And how can you draw a flexed back if you don't know the shape of its major muscle? So the shapes of the muscles become integral, because they give definition to the individual body parts, making them look tense, which in turn makes an action pose look sharper.

These poses show various muscles and their general placement and shape, which can be highlighted when the muscles are flexed or stretched. It's good reference material.

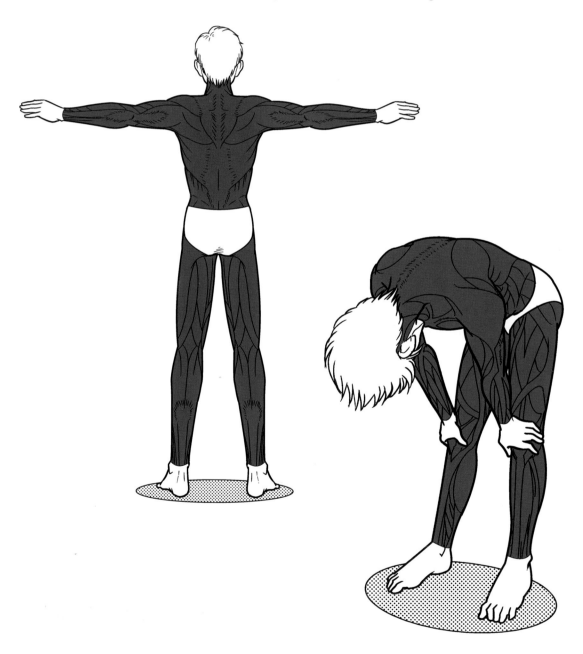

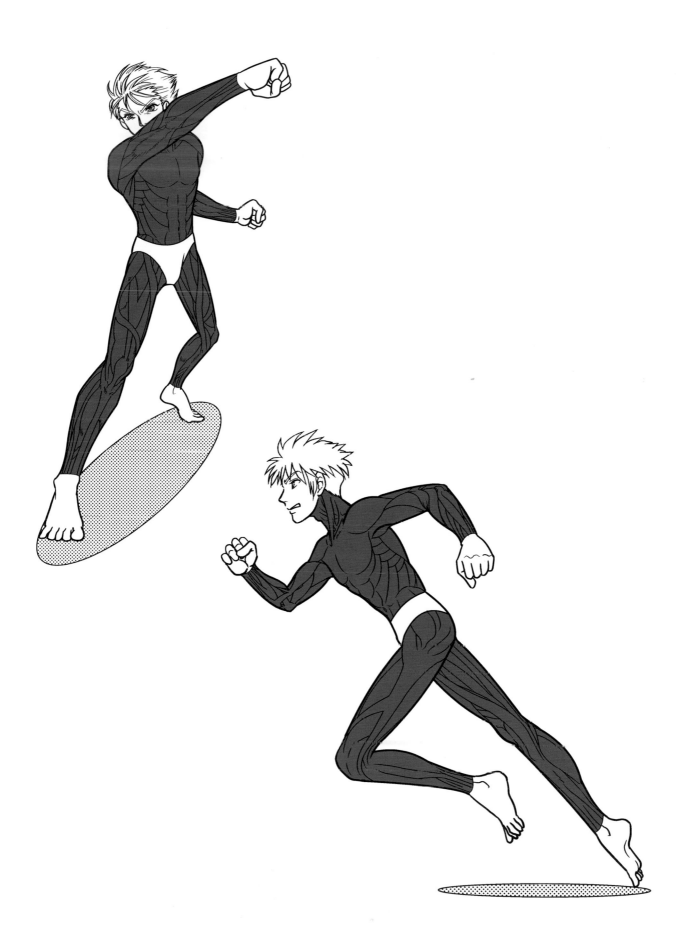

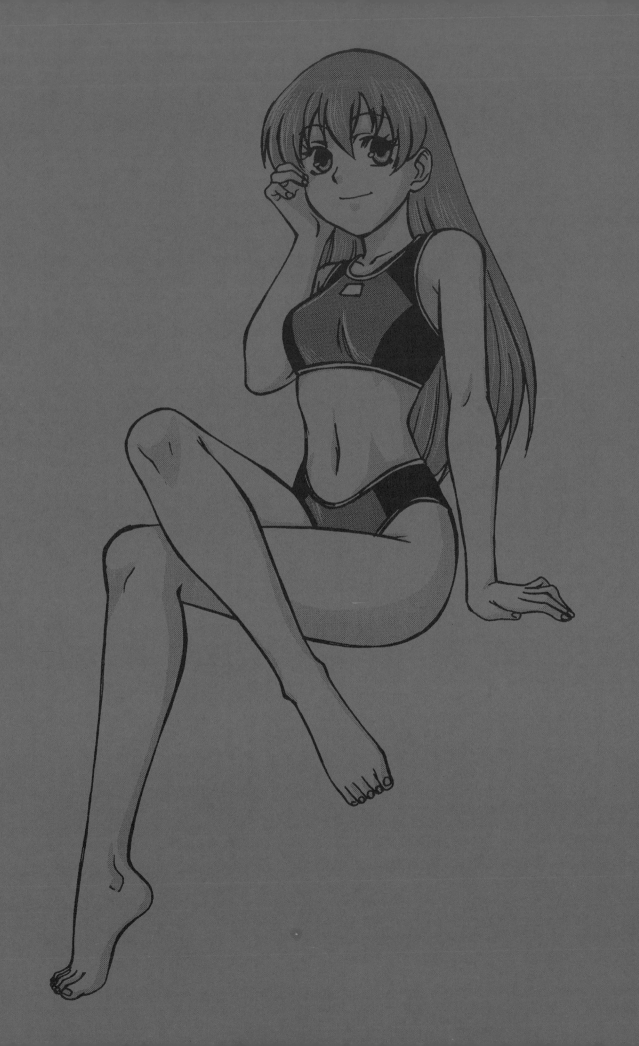

4: BODY SYMMETRY & ASYMMETRY

Most people attempt to draw symmetrical bodies, with everything in perfect alignment. But the only bodies that are perfectly symmetrical are mannequins. To make your drawings of people look lifelike, you need to add *asymmetry*—the slight imperfections and angles that add a subtle dose of realism to the human form.

The arms, elbows, legs, knees, and feet all pose specific problems for the artist, because their contours are in reality slightly uneven. But with its step-by-step progressions, this chapter will deconstruct the mysteries of these asymmetries and help you troubleshoot problems in your drawings. You no longer have to struggle or wonder how to draw those puzzling areas of the body with their subtle contours. The correct techniques are clearly spelled out specifically for the manga artist.

THE INS AND OUTS OF THE MUSCLES

Muscles generally have a bulge in the middle, even if it's subtle. And often, the shorter the muscle, the greater the bulge. Both where the muscle originates and where it ends, there is usually a depression in the muscle's height.

Because of this cresting and falling of the muscles throughout the body, there's a rhythmic sense that the outline of the body is moving up and down subtly, in a pleasing line flow. This breaks up the monotony of the outline.

To illustrate this idea of "ins and outs," let's take the arm as an example. Whether in the front, side, or rear view, the contours of the arm are evident. Some upper arm, forearm, and elbow contours are called out here, but you can see many more that are not marked.

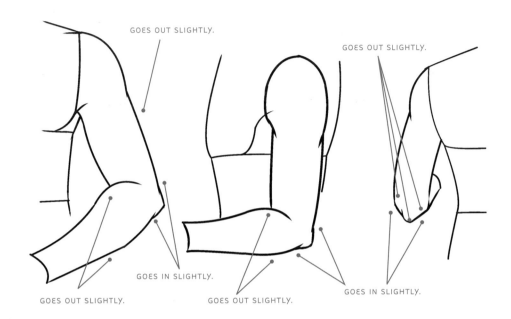

GOES OUT SLIGHTLY.

GOES OUT SLIGHTLY.

GOES IN SLIGHTLY.

GOES OUT SLIGHTLY.

GOES OUT SLIGHTLY.

GOES IN SLIGHTLY.

The female arm should be slender but should still have contours to indicate the ins and outs of the muscles.

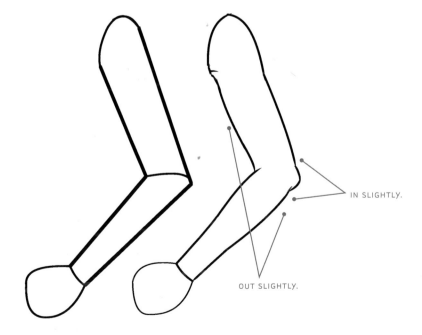

IN SLIGHTLY.

OUT SLIGHTLY.

ARMS

The arms aren't symmetrical tubes. The asymmetrical nature of the placement of the muscles gives the arms a lifelike appearance.

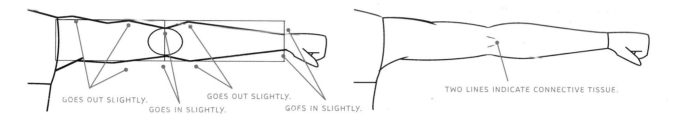

GOES OUT SLIGHTLY.
GOES IN SLIGHTLY.
GOES OUT SLIGHTLY.
GOES IN SLIGHTLY.

TWO LINES INDICATE CONNECTIVE TISSUE.

Front View

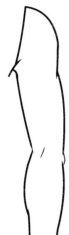

Side View

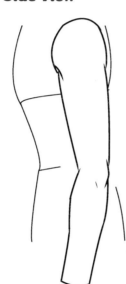

Rear View

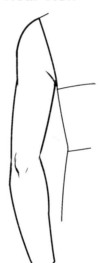

Note the contours of the elbow, which protrudes in both the front and side views. A definition line in the rear view indicates this protrusions there. You can also see that the natural "sweep" of the forearm is slightly forward when the arm hangs down in a relaxed manner.

When the arm hangs down at the side of the body, the elbow falls just above the level of the waistline, at the bottom of the rib cage.

Hands and feet are some of the most asymmetrical parts of the body. That's where reference drawings like this come in handy for familiarizing yourself with the contours and curves—the "ins and outs." We'll cover the hands here and then get to the feet later (on page 99) after we take a look at the legs.

Also, don't be hesitant to look to your own hands for reference. Still, since it's sometimes difficult to objectify ourselves, these examples are helpful. Think of drawing hands as creating *expressions* and *gestures* rather than as just drawing various hand positions.

By studying the skeleton of the hand, you can gain an understanding of precisely how many joints there are per finger and where they appear. Note that each finger has three joints. The thumb also has three joints. (Many beginners erroneously assume the thumb has only two joints.) When begin sketching the hand, it's most effective to start by dividing the fingers into their various joints and also to indicate the knuckles along the crest of the hand mass. The finished hand is then the result of cleaning up the previous construction sketch and adding detail. You can go straight to the last step if you're advanced enough as an artist or once you get comfortable drawing hands.

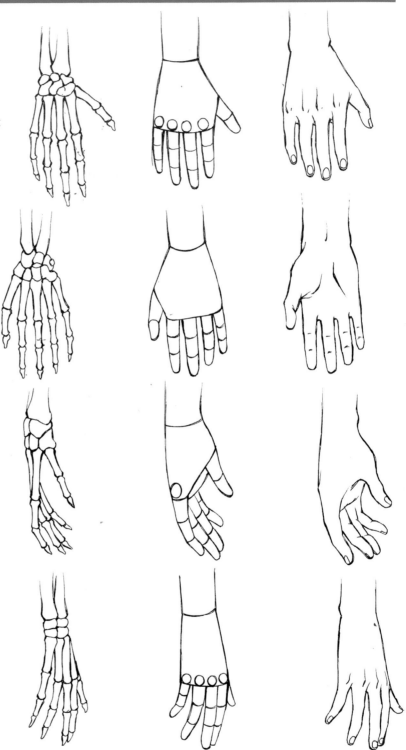

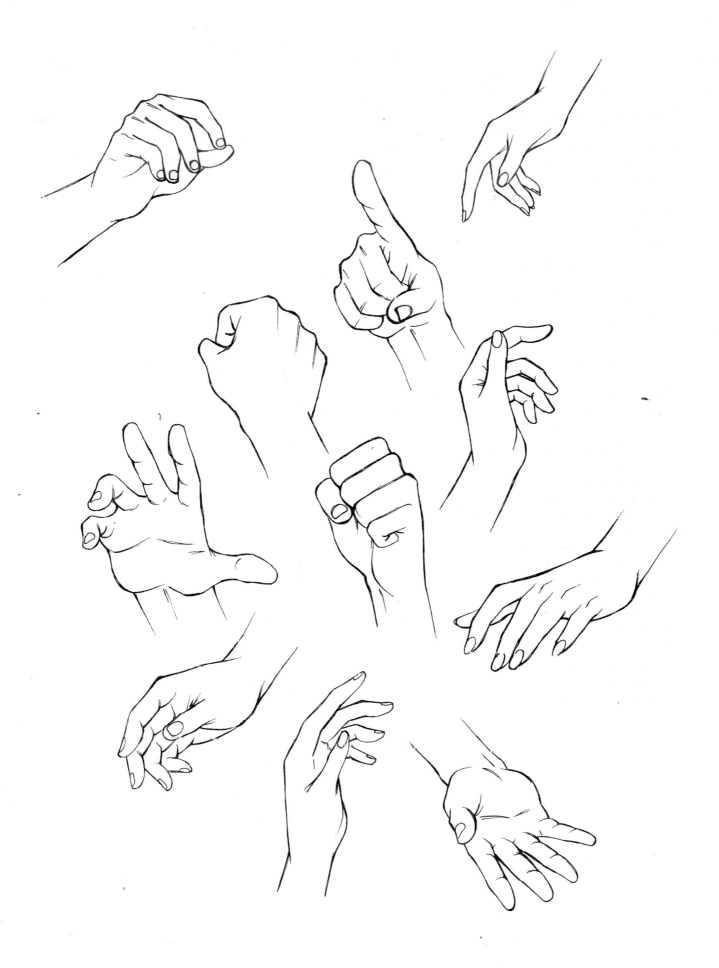

With just a little forethought, you can draw the leg in a very convincing manner. These are concepts that, once put into practice, quickly become second nature.

As a guide, start with a cylinder for the leg and an oval for the knee joint.

When you add width to the upper and lower legs, add more to the outer side and slightly less to the inner side. The muscles are not totally symmetrical on both sides of the bone.

Round off the outline for a more natural look.

Erase the inner guidelines.

MALE KNEECAPS VS. FEMALE KNEECAPS

The kneecap stands out more (is slightly more defined) on male legs. The shinbone is also articulated, and male legs are more muscular than female legs, in general, which are softer.

Male

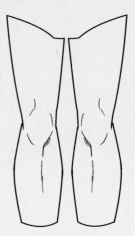

Female

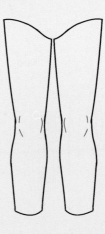

The Back of the Knees

To indicate the back of the knee, where there's a slight depression, use three definition lines. Keep it simple. Nothing fancy.

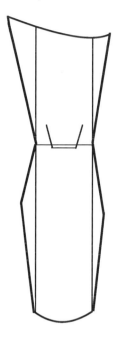

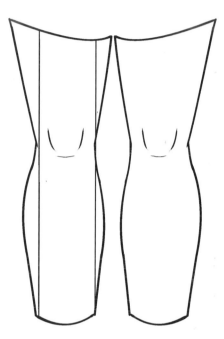

As with the front view, start with a column as your guide, and add width using straight lines that travel diagonally outward (more on the outer side than on the inner).

To finish, round off the outlines and remove the guidelines.

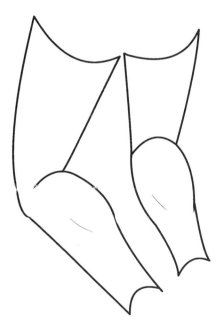

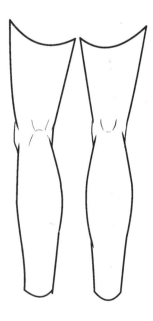

When a kneeling figure is seen from behind, the calf muscle overlaps a bit with the upper leg. Use an upward curving line to indicate this.

Even though this is the back of the knee, you can still indicate a little bit of the kneecap on this side of each leg.

3/4 View and Bending

This is a common angle for standing poses. In this view, you can get a good look at the knees in a locked position—something not as clearly seen from other angles. Note that the upper legs and knees "overhang" the lower legs just a bit.

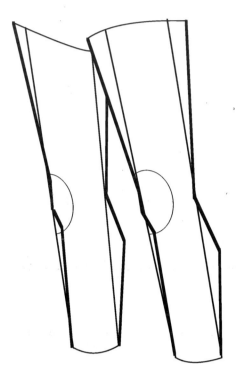

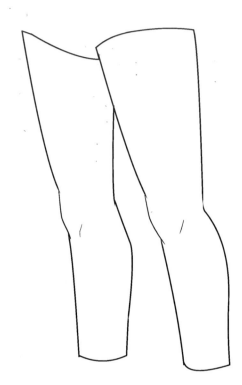

Just as with the other angles, start with a column and ovals for the guidelines. Then start to add the shape first with straight lines.

Once the basic structure is established, round out the form. Note the contours around the kneecap. Be sparing with your use of definition lines in the knee in the standing pose.

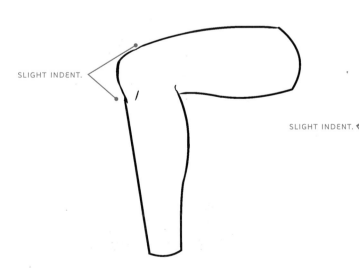

SLIGHT INDENT.

Even when the knee is bent, the contours of the kneecap, though subtle, are still visible.

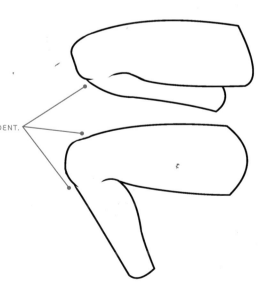

SLIGHT INDENT.

The foot is a little more interesting in profile, so we'll start with the side view here and then move on to other angles. The foot can look really wrong if you try to fake it. Don't wreck a perfectly good drawing simply because you lack info on how to draw the feet. Here are the tips:

As with the leg, start with straight lines and basic shapes—such as an oval for the ankle—as a guide. The ankle is centered in the leg and appears at the same level as the bridge of the foot.

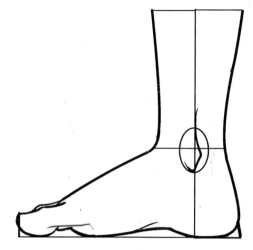

Round out the outlines as you progress, and indicate the contours of the sole of the foot around the big toe, arch, and heel. Also add detail to the ankle bone.

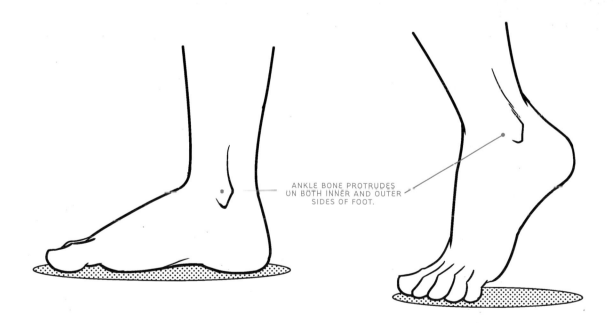

ANKLE BONE PROTRUDES ON BOTH INNER AND OUTER SIDES OF FOOT.

The Foot in Perspective

Sometimes you're going to have to draw the foot from the front, which usually gives people headaches. It's actually easy to do—if you simplify and truncate the form, showing the foot in perspective.

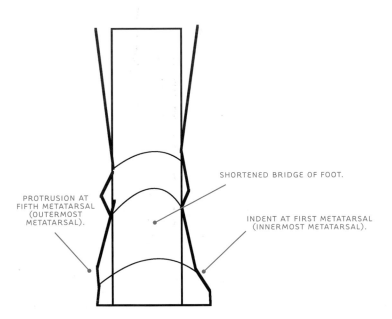

PROTRUSION AT FIFTH METATARSAL (OUTERMOST METATARSAL).

SHORTENED BRIDGE OF FOOT.

INDENT AT FIRST METATARSAL (INNERMOST METATARSAL).

The leg muscles angle in as they meet the ankle, and the outer ankle is slightly lower and larger than the inner ankle. To show the perspective, the bridge section of the foot is shortened.

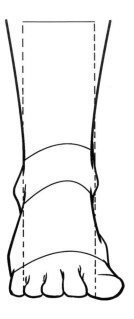

Just as with the elbows, the ankles display many "ins and outs."

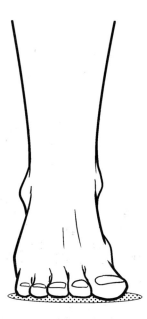

Use just a few definition lines on the top of the foot to indicate the underlying ligaments and bony structure.

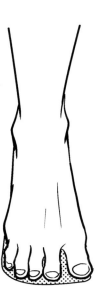

When comparing the version to the left to the view here looking down on the foot from above, you can really see the difference the foreshortening makes.

Walking Away

In case you have to draw a "walking away" shot, here are some hints for the back view of the foot.

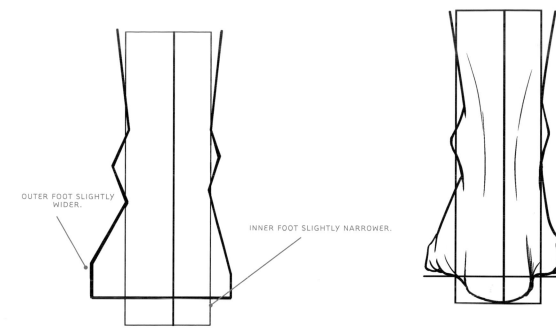

OUTER FOOT SLIGHTLY WIDER.

INNER FOOT SLIGHTLY NARROWER.

This is the back view of a left foot. How do we know this? The outer ankle is slightly lower and larger than the inner one. Note also that foot expands more on the outer edge than on the inner one.

Two definition lines give shape to the Achilles tendon. Indicating a bit of perspective, the heel falls at a slightly lower level than the rest of the sole of the foot.

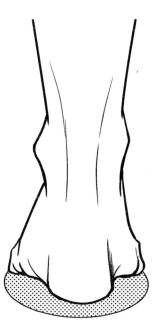

Even from the back, the in-and-out contours around the ankle are prominent.

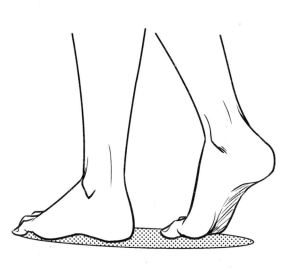

When the foot lifts off the ground in preparation to take a step, use a little shading to indicate the sole and give form to the arch. In a normal walk, only one foot leaves the ground at a time, of course, otherwise we'd all fall over.

Feet, like hands, are very asymmetrical. But by looking at the skeletal structure of the foot, you can see why the overall shape is formed the way that it is. The toes are all different lengths, just as the fingers are. And like the fingers, they all have three joints—except for the big toe, which only has two joints.

In the front view, the bridge of the foot should be truncated—i.e., foreshortened—due to the effects of seeing it in perspective. This gives the appearance that the bridge of the foot is rising high up into the calf.

In the 3/4 rear view, you can clearly see that the heel has a separate, distinct bone (the calcaneus) that rises up into the Achilles-tendon area.

In the side view, the heel protrudes slightly past the calf. This is important, because beginners tend to draw the heel flush with the calf, which makes the foot look awkward—as if something is "just not right" with the image, but you can't say why. This could be the reason. Practice drawing feet from a variety of angles to gain a solid grasp of the subject matter.

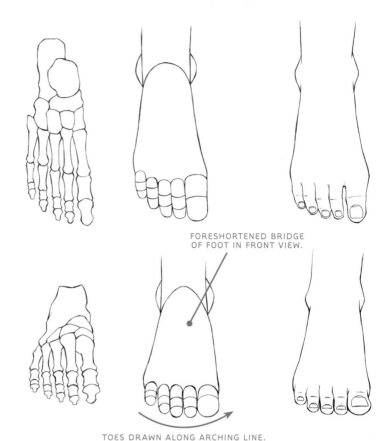

FORESHORTENED BRIDGE OF FOOT IN FRONT VIEW.

TOES DRAWN ALONG ARCHING LINE.

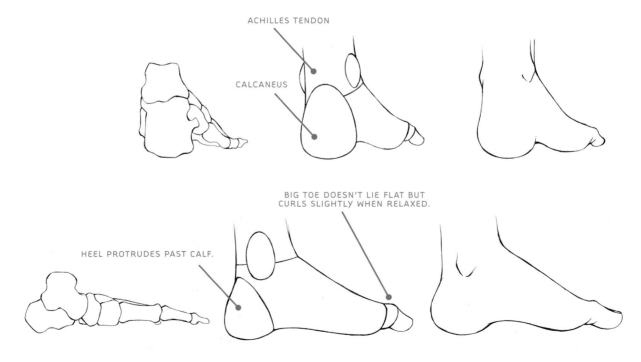

ACHILLES TENDON

CALCANEUS

BIG TOE DOESN'T LIE FLAT BUT CURLS SLIGHTLY WHEN RELAXED.

HEEL PROTRUDES PAST CALF.

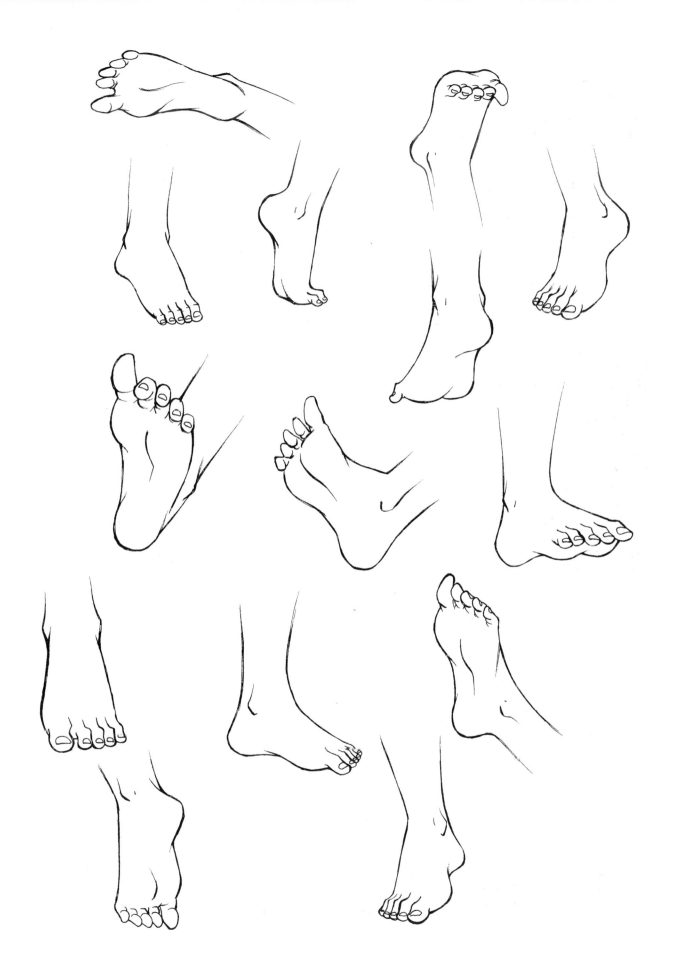

5: HOW MOVEMENT, LIGHT & PERSPECTIVE AFFECT THE BODY

The goal, of course, is to move beyond anatomy charts so that you can draw the body in a variety of cool poses. To achieve this goal, it helps to also have a simplified method for drawing the human figure. To this end, we're going to start thinking about the body in sections, similar to a wooden artist's mannequin. No professional artist draws the foundation of the body by first building a complete skeleton, with its attendant muscles. It would be too time-consuming. It's quicker and more effective to think of the body in sections as a first step toward learning to visualize the figure as a three-dimensional form moving in space. The limbs, therefore, are represented by cylinders and the major areas of the body are solid blocks. Using this type of mannequin as your foundation, you can proceed to round out the outline of the figure.

STANDING

There are classic arm poses—such as arms on hips, hands over the heart, waving, and even patting down one's hair—that make a character look active while standing. Avoid drawing a character with the arms straight down by the sides of the body. It shows a lack of inventiveness.

Front View

Here's a "must-know" for when you're drawing standing figures: If most of a figure's body weight is on one leg, the heel of that leg will usually be placed directly under the neck to maintain balance. You can see that in the pose below.

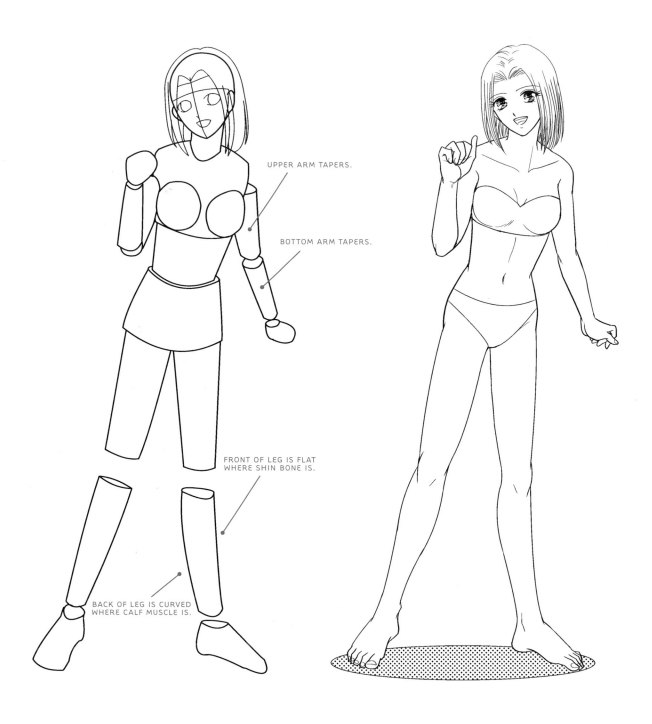

UPPER ARM TAPERS.

BOTTOM ARM TAPERS.

FRONT OF LEG IS FLAT WHERE SHIN BONE IS.

BACK OF LEG IS CURVED WHERE CALF MUSCLE IS.

PROPER FOOT POSITIONING

Beginners often try to avoid drawing the feet in the 3/4 view, as it requires foreshortening. So they turn the feet outward into a complete side view. This is wrong and makes the character look as if she were waddling like a duck. Feet don't aim out like this in a natural stance. It appears as though the character is balancing on a tightrope! Instead, the feet should point outward at a 45-degree angle. And here's a little-known fact to go along with this info: The knees likewise should point out at the same 45-degree angle.

No

Yes

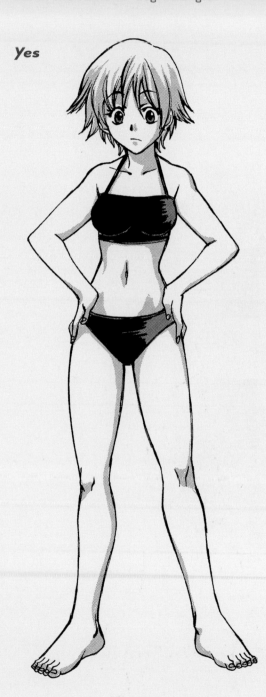

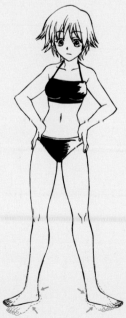

FEET AT 45-DEGREE ANGLE.

Side View

In a strict side view, you wouldn't see the far arm or leg. They would be hidden from view. But for our purposes, this would look odd—as if her limbs just disappeared. So to rectify the situation, use what's called an artist's "cheat."

Turn the character ever so slightly toward you—not in a 3/4 view, not nearly that much, but just enough to see a touch of the rear arm and leg. The figure will look less like a two-dimensional image and more like a real body.

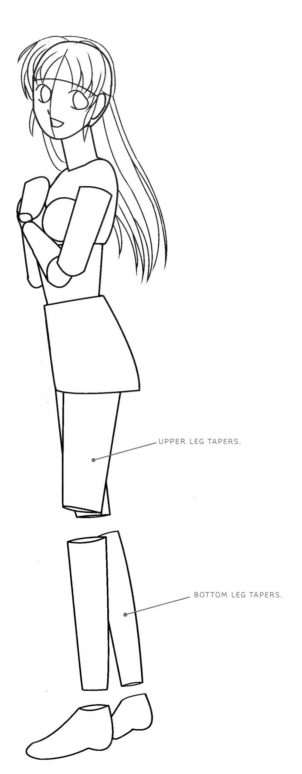

UPPER LEG TAPERS.

BOTTOM LEG TAPERS.

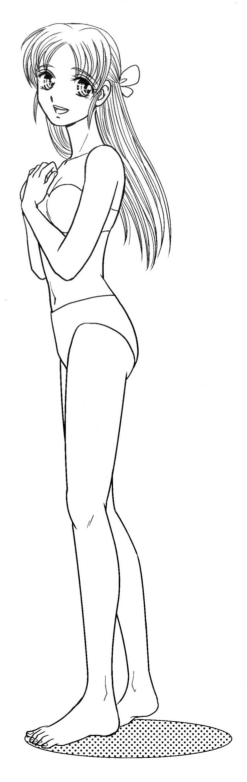

FLAT-BACK SYNDROME

Many artists give short shrift to the curviness of the back. It's an easy thing to miss—and an even easier thing to fix! The back is the curviest area of the female form. It's a long line possessed of several in-and-out curves. This serpentine line travels all the way from the upper back down to the buttocks. It creates a slinky, attractive appearance.

No

Yes

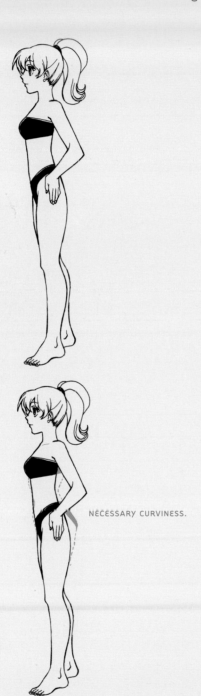

NECESSARY CURVINESS.

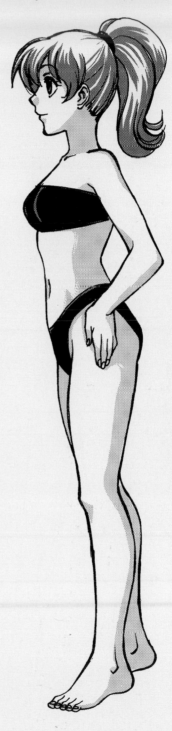

3/4 View

When you use the mannequin construction to think of the body in distinct sections (below, left), you can see that the top mass overlaps the midsection. This overlapping line will ultimately transition into the bottom of the pectoralis major. The examples in this section leave spaces for the joints, such as the shoulders, elbows, knees, and ankles, but some artists like to draw circles to represent them.

Also note that the ends of the cylinders here are not circles but ovals. This is because we are seeing the effects of perspective on them, and a circle that's "squashed" to be shown in perspective (rather then in a front view) will appear as an oval.

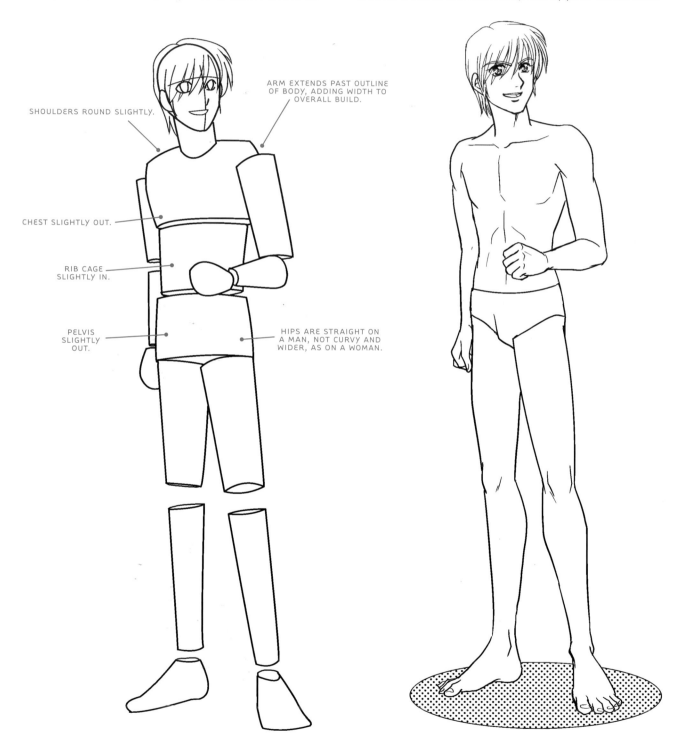

SHOULDERS ROUND SLIGHTLY.

ARM EXTENDS PAST OUTLINE OF BODY, ADDING WIDTH TO OVERALL BUILD.

CHEST SLIGHTLY OUT.

RIB CAGE SLIGHTLY IN.

PELVIS SLIGHTLY OUT.

HIPS ARE STRAIGHT ON A MAN, NOT CURVY AND WIDER, AS ON A WOMAN.

CORRECT ARM LENGTH

The fingertips should appear to hang about halfway down the thigh, and in this picture, it appears that they do. But wait . . . the arms still look too long. So what's the problem? Actually, this is a common error. The fingertips should dangle at the halfway point of the upper leg *when the arm is hanging straight*.

But these arms are *bent*. If you were to straighten them out, you'd add extra length, and then, the fingertips would fall well *below* the halfway point on the thigh. That means that the arms in the left-hand drawings are too long. They need to be shortened to the right length.

No

Yes

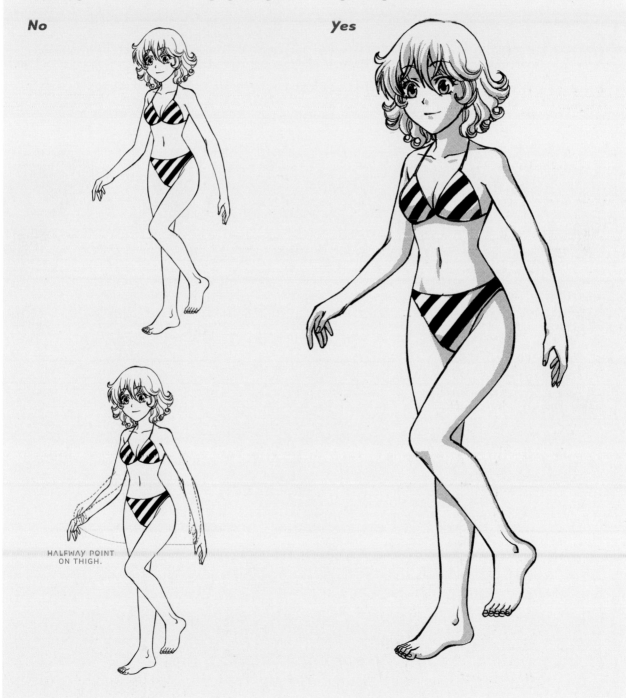

HALFWAY POINT
ON THIGH.

There are a variety of sitting poses, so we'll look at three popular ones on these next few pages. Note that regardless of pose, the figures hold our interest because they all are asymmetrical, even if it's only in subtle ways.

On a Stool

The stool isn't represented here, but you don't need it, because it's clearly implied by the pose and the circular areas under the hips and beneath the feet. The torso here displays a dynamic posture. Each section of the upper body is positioned at a slightly different angle. By looking at the figure's back, you can see that the rib cage angles up, the midsection remains straight, and the pelvis tilts slightly forward. In addition, the technique of overlapping one shape in front of another creates a sense of depth: The torso overlaps the arm on the far side of the body, and the near leg overlaps the far one. It makes the figure look three-dimensional.

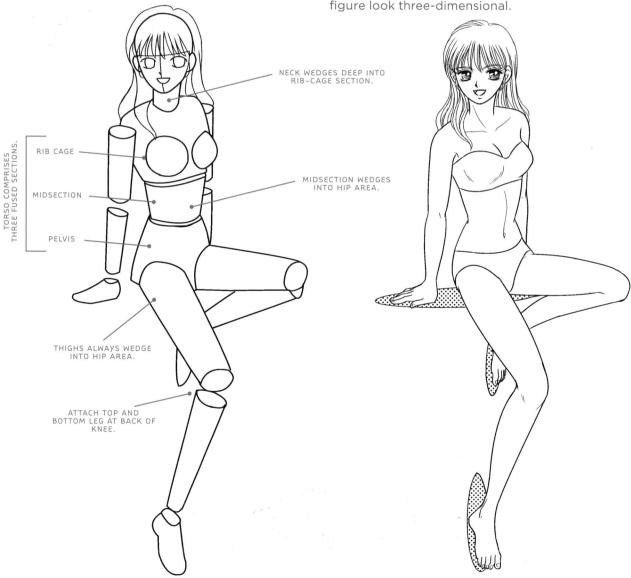

NECK WEDGES DEEP INTO RIB-CAGE SECTION.

TORSO COMPRISES THREE FUSED SECTIONS.

RIB CAGE

MIDSECTION

PELVIS

MIDSECTION WEDGES INTO HIP AREA.

THIGHS ALWAYS WEDGE INTO HIP AREA.

ATTACH TOP AND BOTTOM LEG AT BACK OF KNEE.

Cross-Leg Front View

To add asymmetry to this otherwise symmetrical pose, vary the arm placement. Adding asymmetry makes for a more interesting pose. Also, don't be fooled by the common misconception that male hips should be very small; they have sizable mass.

In addition, this pose uses foreshortening to make certain parts of the body appear to be coming at us. The upper legs are a good example of this. By drawing those, and all the limbs, as cylinders in the initial constructions, it's easy to map out foreshortened poses.

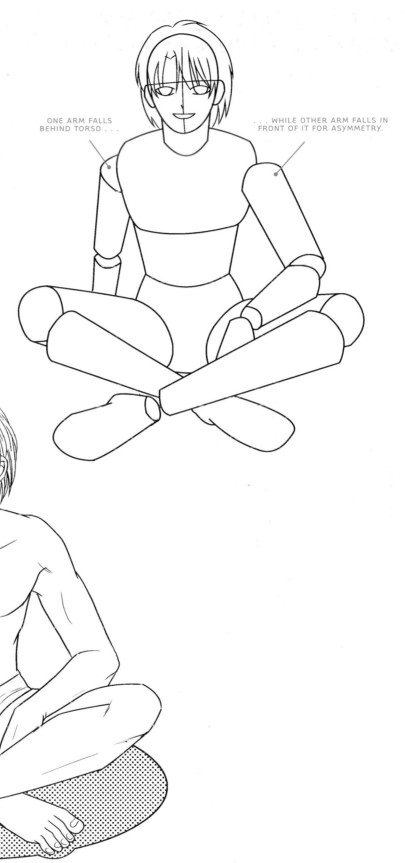

ONE ARM FALLS BEHIND TORSO . . .

. . . WHILE OTHER ARM FALLS IN FRONT OF IT FOR ASYMMETRY.

Bent-Leg Side View

There are a few important points that become clear when you analyze the figure in sections in this pose: First, even in the side view, the neck originates inside of the rib cage, not on top of it. Second, even though it's in sections, the back aligns along a single, curved line. And third, the far leg shouldn't be hidden behind the near one, otherwise the figure will look flat and stiff.

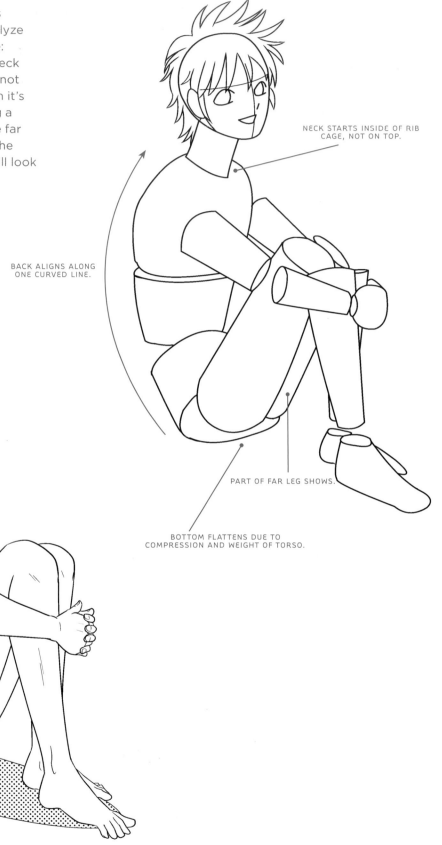

NECK STARTS INSIDE OF RIB CAGE, NOT ON TOP.

BACK ALIGNS ALONG ONE CURVED LINE.

PART OF FAR LEG SHOWS.

BOTTOM FLATTENS DUE TO COMPRESSION AND WEIGHT OF TORSO.

CORRECT MANGA HEAD SIZE FOR OLDER TEENS

Youthful teens, or "tweens," are generally drawn in the shoujo style, with giant eyes and large heads. Older teens, including the bishounen- and bishoujo-style characters, are drawn with smaller heads on long bodies— even when sitting! This makes the characters look more mature. But often, artists reduce the head size a bit too much. Tiny head sizes on regular bodies make characters look giant. It also looks wrong on a gut level. Be careful to avoid this error in judgment, and adjust if it occurs. Note the difference in the two examples given, and use the guide of four head lengths to make up the torso and head section.

No (Head Too Small) *Yes*

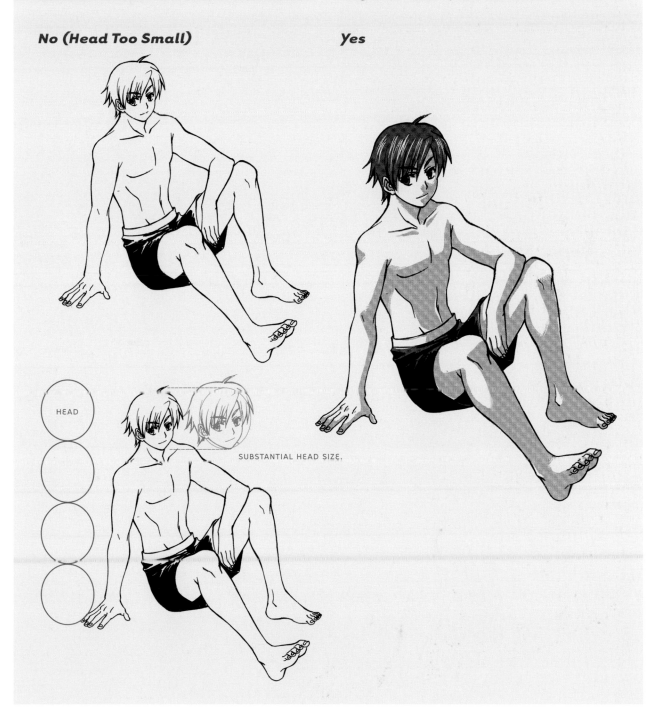

HEAD

SUBSTANTIAL HEAD SIZE.

"Just add some shading," some artists will advise you (as if it were only that simple), to which I respond, "Just add it *where*?" Yes, to fully bring the human form to life, you need to add a few hints of shadow, even if it's just a few touches here and there. But there needs to be a method to your madness. Shadows should not occur randomly (except in a few extreme cases, which we'll discuss at the end of this section). Light and shadows are logical. Light *causes* shadows to occur. Shadows do not just appear out of nowhere because they happen to look good. Things that block the light will cast shadows onto other things. Let's look at a few examples to see how it works.

Overhead Light

Since all bodies are built in more or less the same way, light hits us all in a similar fashion, creating the same types of shadows. Most often, we're affected by overhead lighting, which takes the form of either indoor ceiling lights, sunlight, or moonlight. So once you familiarize yourself with the cast shadows caused by overhead light, you can use it effectively in pose after pose, on any character, as your general form of lighting.

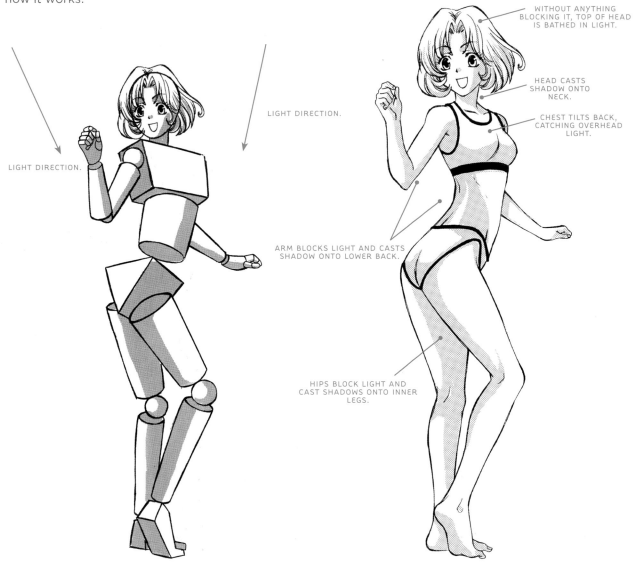

LIGHT DIRECTION.

LIGHT DIRECTION.

WITHOUT ANYTHING BLOCKING IT, TOP OF HEAD IS BATHED IN LIGHT.

HEAD CASTS SHADOW ONTO NECK.

CHEST TILTS BACK, CATCHING OVERHEAD LIGHT.

ARM BLOCKS LIGHT AND CASTS SHADOW ONTO LOWER BACK.

HIPS BLOCK LIGHT AND CAST SHADOWS ONTO INNER LEGS.

Sidelight

Sidelight hits the subject from the side, rather than from above. Outdoors, sidelight most commonly occurs in early morning or late afternoon, when the sun is low in the sky. Sidelight creates a different set of shadows than overhead light. An indoor lamp on an end table can also create sidelighting and side shadows.

To create shadows from sidelight, first consider the human form. Think of the torso as having not just a front and a back but also sides. In other words, the body is sort of a rectangle—a box. When one side of the box is hit by light, the other side of the box will fall into shadow. This side shading brings out the depth in a figure, making

the form look three-dimensional. Also note that when one body part touches or overlaps another, a cast shadow falls on the underlying body part. Similarly, when a small area that's farther back is framed by a nearer element, the framed area appears entirely in shadow. (This happens with the legs in this pose.)

Most commonly, a figure is rarely seen in overhead light alone; the effects of sidelight are also usually in evidence, even if it takes the form of ambient lighting. So in this section, we'll cover a variety of poses and actions in sidelight to get a comprehensive idea of how the shadows work on the body.

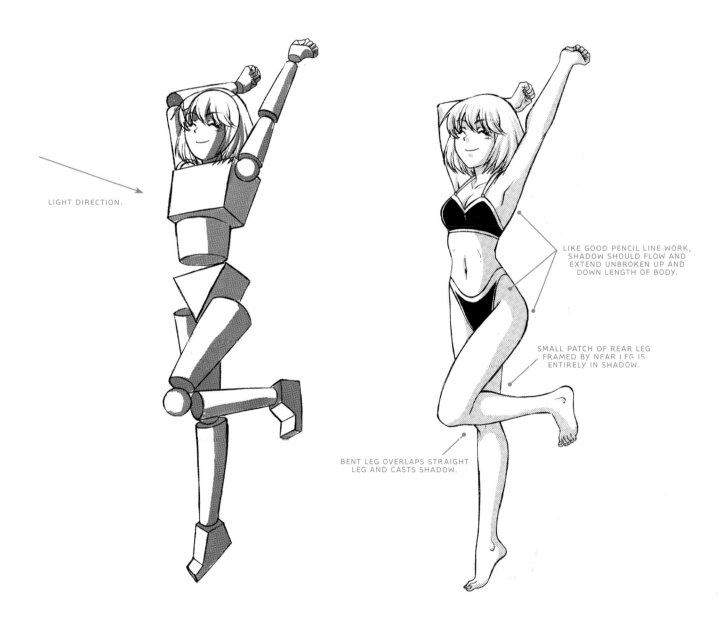

LIGHT DIRECTION.

LIKE GOOD PENCIL LINE WORK, SHADOW SHOULD FLOW AND EXTEND UNBROKEN UP AND DOWN LENGTH OF BODY.

SMALL PATCH OF REAR LEG FRAMED BY NEAR LEG IS ENTIRELY IN SHADOW.

BENT LEG OVERLAPS STRAIGHT LEG AND CASTS SHADOW.

Walking in Sidelight

The 3/4 view of a walking pose works well in sidelighting, because as you've just learned, the shading on the side of the figure gives the form depth. And the 3/4 view, when drawn properly, reveals the side plane of the body in a prominent way. Many beginning artists leave out the shaded side area when drawing this 3/4 walking pose, which results in a flat-looking character.

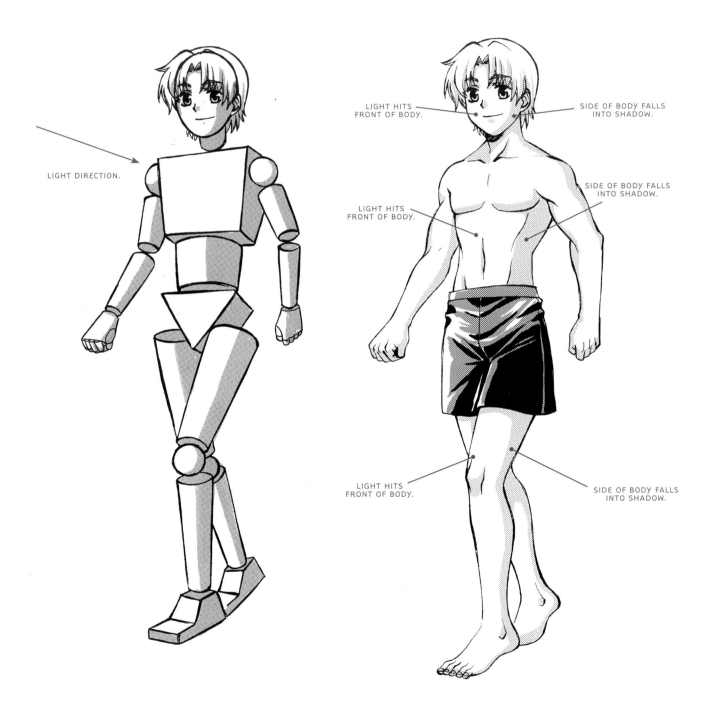

LIGHT DIRECTION.

LIGHT HITS FRONT OF BODY.

SIDE OF BODY FALLS INTO SHADOW.

LIGHT HITS FRONT OF BODY.

SIDE OF BODY FALLS INTO SHADOW.

LIGHT HITS FRONT OF BODY.

SIDE OF BODY FALLS INTO SHADOW.

KEEPING CORRECT MANGA PROPORTIONS

If you measure the average person from the top of the head to the bottom of the foot, the crotch would mark the halfway point of the body. It's an easy way to eyeball the proportions and, if they're off, make an adjustment.

However, *manga* characters are not average. They're often drawn slightly taller to create an idealized look. But be careful how you add the extra height. You don't do this by "growing" the figure slightly taller all over. In fact, the head/neck/torso unit should remain the same proportion as on an average person. You only add extra length to the legs. So the average manga character's crotch ends up as the halfway point between the top of the head and the *ankles*.

Too much additional height has been piled on. Clearly, her legs are oversized, which occurs sometimes when adding height. Don't go overboard and throw the proportions out of whack.

The ideal leg size is a much more comfortable fit and the overall manga proportions remain correct.

Let's recalibrate and see how that suits the overall look of the character.

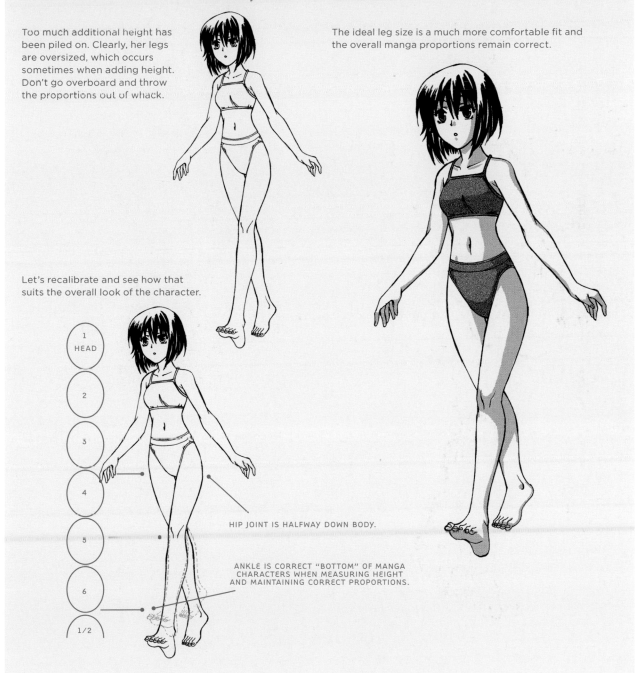

1 HEAD
2
3
4
5
6
1/2

HIP JOINT IS HALFWAY DOWN BODY.

ANKLE IS CORRECT "BOTTOM" OF MANGA CHARACTERS WHEN MEASURING HEIGHT AND MAINTAINING CORRECT PROPORTIONS.

Sitting and Kneeling in Sidelight

Notice how natural the shadows look on this figure. That's because they are logically planned and applied. In each instance, the direction of the light source has been considered before adding shadow. Therefore, all of the shadows fall in the same general direction. It looks right—because it is right.

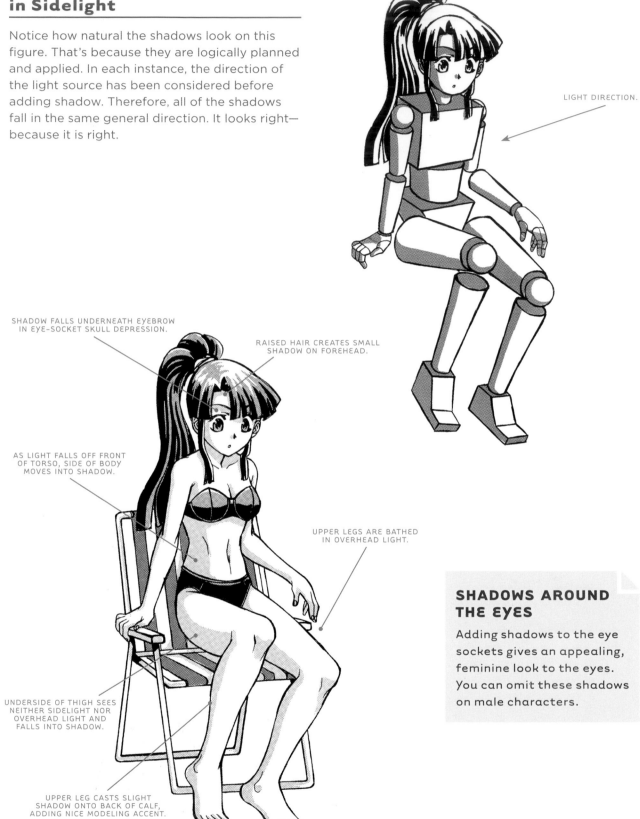

LIGHT DIRECTION.

SHADOW FALLS UNDERNEATH EYEBROW IN EYE-SOCKET SKULL DEPRESSION.

RAISED HAIR CREATES SMALL SHADOW ON FOREHEAD.

AS LIGHT FALLS OFF FRONT OF TORSO, SIDE OF BODY MOVES INTO SHADOW.

UPPER LEGS ARE BATHED IN OVERHEAD LIGHT.

UNDERSIDE OF THIGH SEES NEITHER SIDELIGHT NOR OVERHEAD LIGHT AND FALLS INTO SHADOW.

UPPER LEG CASTS SLIGHT SHADOW ONTO BACK OF CALF, ADDING NICE MODELING ACCENT.

SHADOWS AROUND THE EYES

Adding shadows to the eye sockets gives an appealing, feminine look to the eyes. You can omit these shadows on male characters.

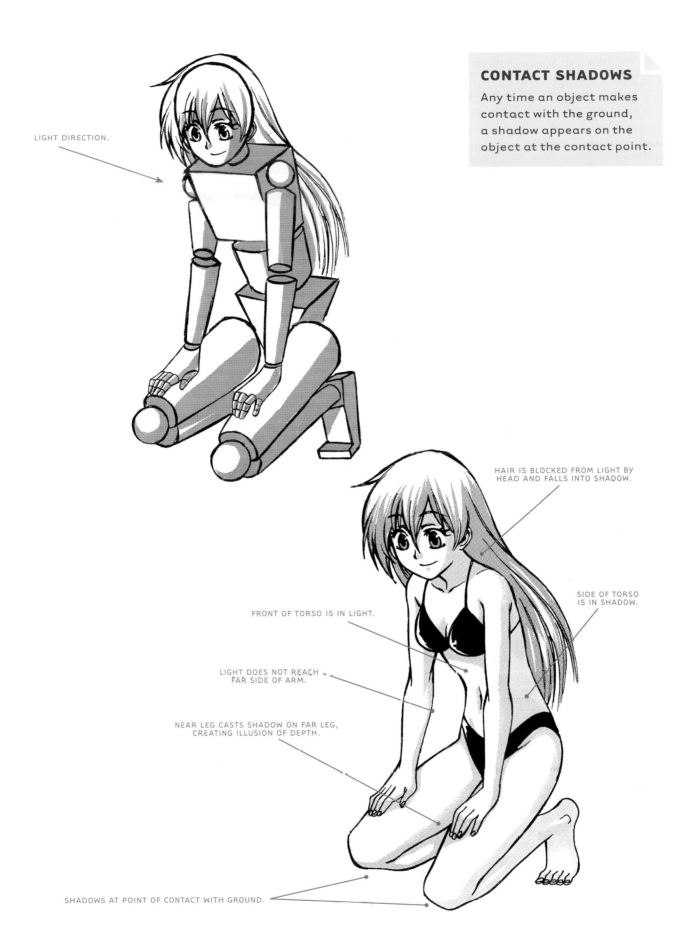

LIGHT DIRECTION.

HAIR IS BLOCKED FROM LIGHT BY HEAD AND FALLS INTO SHADOW.

SIDE OF TORSO IS IN SHADOW.

FRONT OF TORSO IS IN LIGHT.

LIGHT DOES NOT REACH FAR SIDE OF ARM.

NEAR LEG CASTS SHADOW ON FAR LEG, CREATING ILLUSION OF DEPTH.

SHADOWS AT POINT OF CONTACT WITH GROUND.

Fighting in Sidelight

Here's a creative 3/4-view action pose that puts the body through unique twists and turns. It shifts the shoulders and hips, creating unusual opportunities for shading. It will challenge you to think about the effects that light has on shadows on the figure. Remember, shadows aren't random; they are logically created as a result of the way light hits an object.

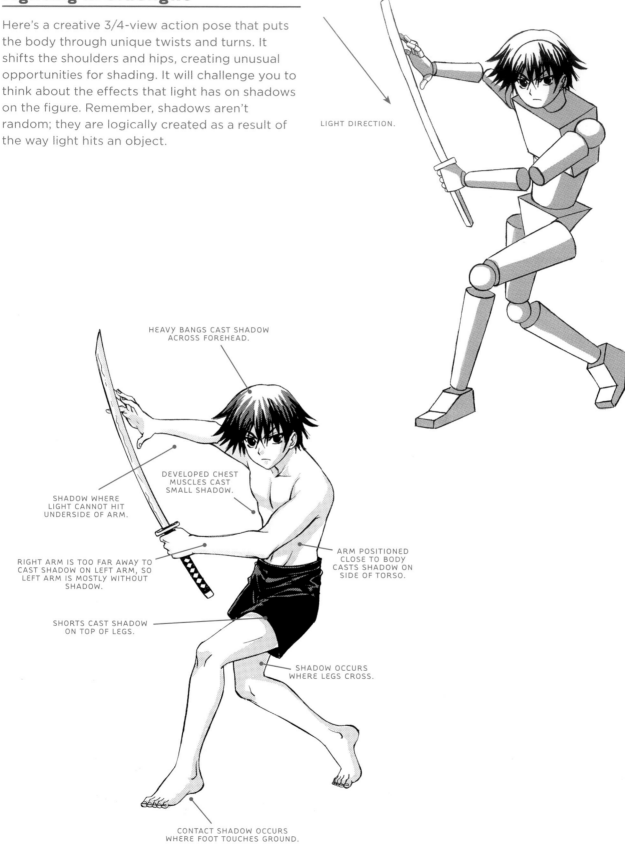

LIGHT DIRECTION.

HEAVY BANGS CAST SHADOW ACROSS FOREHEAD.

DEVELOPED CHEST MUSCLES CAST SMALL SHADOW.

SHADOW WHERE LIGHT CANNOT HIT UNDERSIDE OF ARM.

RIGHT ARM IS TOO FAR AWAY TO CAST SHADOW ON LEFT ARM, SO LEFT ARM IS MOSTLY WITHOUT SHADOW.

ARM POSITIONED CLOSE TO BODY CASTS SHADOW ON SIDE OF TORSO.

SHORTS CAST SHADOW ON TOP OF LEGS.

SHADOW OCCURS WHERE LEGS CROSS.

CONTACT SHADOW OCCURS WHERE FOOT TOUCHES GROUND.

INTERPRETIVE SHADING

Occasionally, you may have the opportunity to set aside the rules, using light and shadow solely for the purpose of creating mood. Perhaps it's a moonlit night in the woods, and the branches and leaves allow you to put shadows wherever you want them—without regard to realism. Or maybe you're setting the stage in a haunted castle, and light is pouring in through the cracks in the walls and broken windows. Then there are instances when shadows can be used to reflect a character's mental anguish. Here, the shadows serve to add intensity to the character's determination to fight.

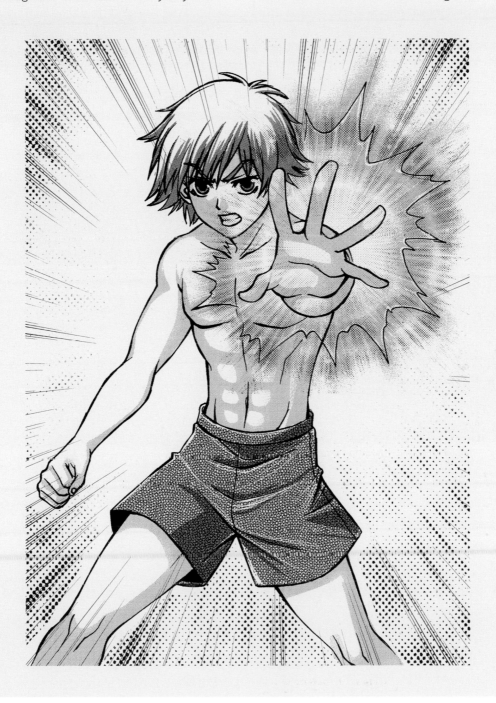

When you use foreshortening you compact or contract parts of the body depthwise so that you get the illusion of projection or extension in space. A foreshortened limb appears either enlarged as it comes toward you or reduced as it recedes from you.

Not every drawing of a figure requires perspective, but most have some. How much varies greatly. But usually, we're not even aware of the perspective in play—it's that subtle. Perspective can be used realistically to make the figure simply look real instead of flat and two-dimensional. Or perspective can be applied dramatically. This is called *forced perspective* and is a stylistic tool of exaggeration used to create impact. We'll examine several poses that display varying degrees of perspective, starting with mild perspective and working up to extreme perspective. But whatever degree perspective is used, keep in mind this general principle: Perspective only affects things that travel from the foreground to the background or from the background to the foreground—in other words, things that appear to have depth.

Minor Perspective

This character doesn't show much in the way of perspective; however, the arms present a good example of when perspective is called for and when it's not. The forearm on our right travels back in space, conveying some depth. Because of this, it will show the effects of perspective. And, indeed, to accomplish this, it has been compressed, or foreshortened slightly. In fact, it is drawn shorter than the forearm on the other side of the body, which is not traveling back or forward in space but rather is traveling left to right, parallel to the viewer. That forearm appears flat and, therefore, unaffected by perspective and should be drawn at its full length, as it is.

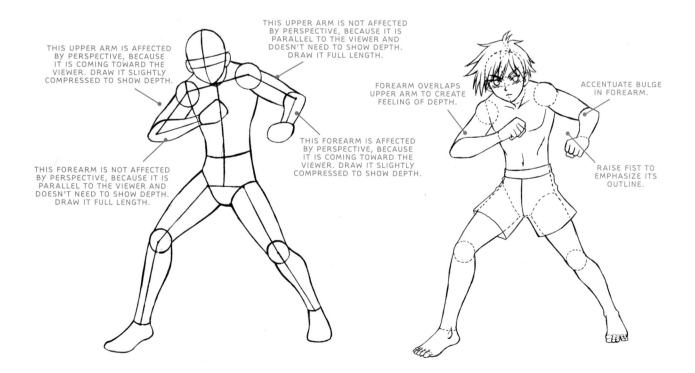

THIS UPPER ARM IS AFFECTED BY PERSPECTIVE, BECAUSE IT IS COMING TOWARD THE VIEWER. DRAW IT SLIGHTLY COMPRESSED TO SHOW DEPTH.

THIS UPPER ARM IS NOT AFFECTED BY PERSPECTIVE, BECAUSE IT IS PARALLEL TO THE VIEWER AND DOESN'T NEED TO SHOW DEPTH. DRAW IT FULL LENGTH.

THIS FOREARM IS NOT AFFECTED BY PERSPECTIVE, BECAUSE IT IS PARALLEL TO THE VIEWER AND DOESN'T NEED TO SHOW DEPTH. DRAW IT FULL LENGTH.

THIS FOREARM IS AFFECTED BY PERSPECTIVE, BECAUSE IT IS COMING TOWARD THE VIEWER. DRAW IT SLIGHTLY COMPRESSED TO SHOW DEPTH.

FOREARM OVERLAPS UPPER ARM TO CREATE FEELING OF DEPTH.

ACCENTUATE BULGE IN FOREARM.

RAISE FIST TO EMPHASIZE ITS OUTLINE.

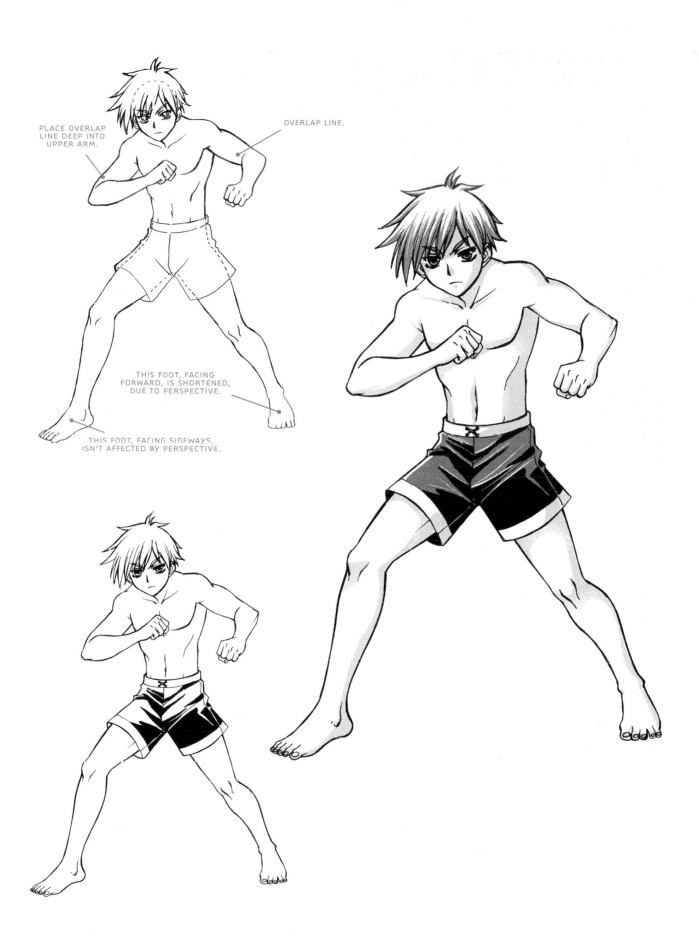

PLACE OVERLAP
LINE DEEP INTO
UPPER ARM.

OVERLAP LINE.

THIS FOOT, FACING
FORWARD, IS SHORTENED,
DUE TO PERSPECTIVE.

THIS FOOT, FACING SIDEWAYS,
ISN'T AFFECTED BY PERSPECTIVE.

Medium Perspective

The sitting pose is accented by crossed legs instead of two parallel legs, which would be symmetrical and repetitive. Note that only the crossed leg travels toward us. Therefore, that limb must be shown in perspective and, as a consequence, is foreshortened. The lower leg is not affected by perspective and is therefore drawn full length.

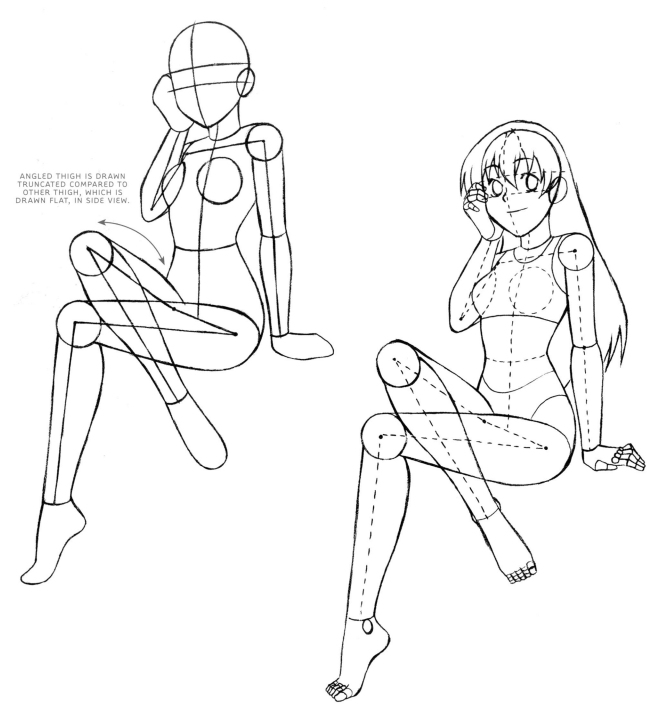

ANGLED THIGH IS DRAWN TRUNCATED COMPARED TO OTHER THIGH, WHICH IS DRAWN FLAT, IN SIDE VIEW.

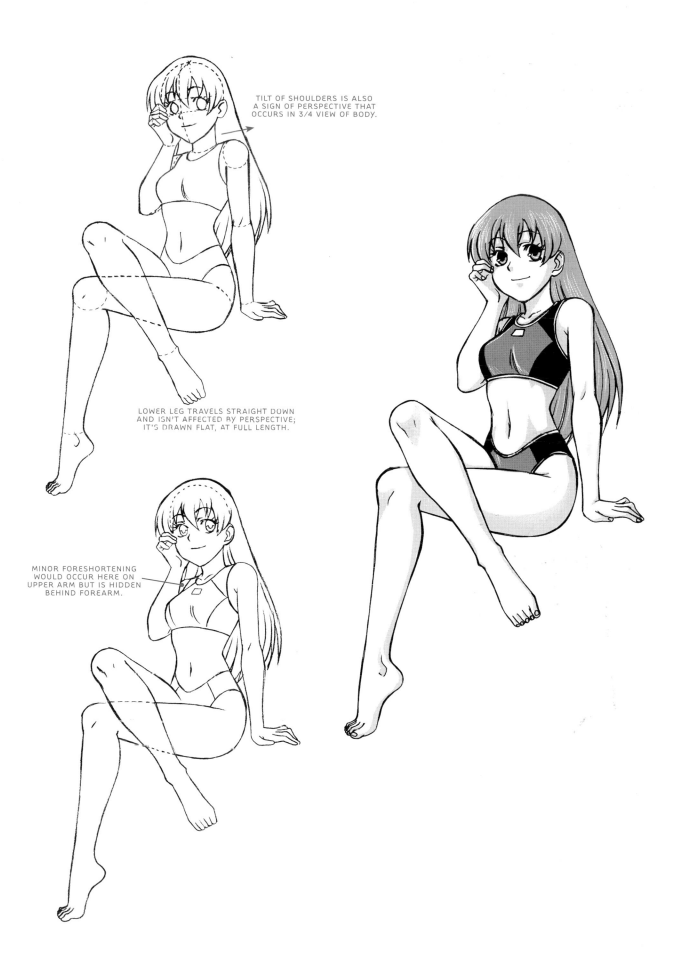

TILT OF SHOULDERS IS ALSO
A SIGN OF PERSPECTIVE THAT
OCCURS IN 3/4 VIEW OF BODY.

LOWER LEG TRAVELS STRAIGHT DOWN
AND ISN'T AFFECTED BY PERSPECTIVE;
IT'S DRAWN FLAT, AT FULL LENGTH.

MINOR FORESHORTENING
WOULD OCCUR HERE ON
UPPER ARM BUT IS HIDDEN
BEHIND FOREARM.

Maximum Perspective

Also called *forced perspective*, maximum perspective is a graphic-novel fan favorite. Just don't overuse it. It's like a spice. An occasional use adds zing. Too much causes what's known as "eye fatigue." Remember this rule: The closer the figure is to a front view, the more compressed the perspective will be. Conversely, the more the figure is in profile, the flatter the drawing will be. Here, we're getting awfully close to a full front view of that arm and fist, and consequently, the arm and fist are *severely compressed*.

How does one show significant compression? By flattening the object and using *overlapping shapes*. Dividing up the overlapping body parts into sections creates the illusion of depth. In this example, distinct areas of the fist, forearm, upper arm, and shoulder (to our right) are overlapped. In addition, for forced perspective, the mass that's closest to us should be the largest, followed by progressively smaller masses as parts recede sharply into the background. So that near fist is drawn large.

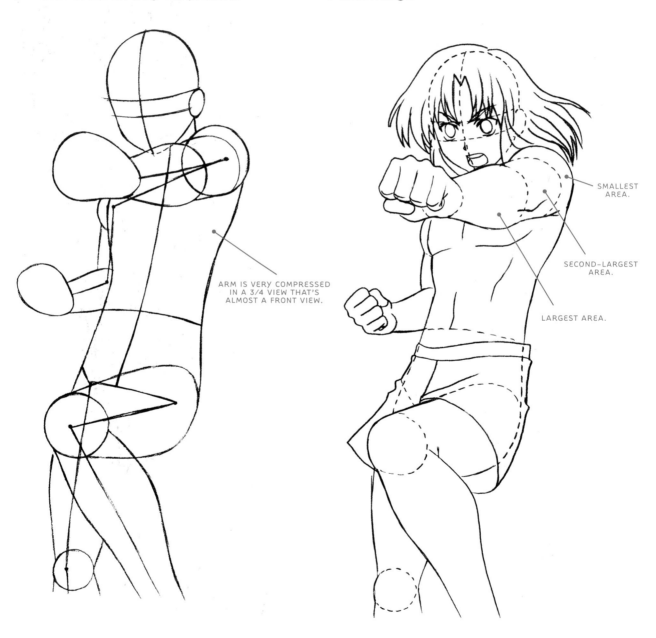

ARM IS VERY COMPRESSED IN A 3/4 VIEW THAT'S ALMOST A FRONT VIEW.

SMALLEST AREA.

SECOND-LARGEST AREA.

LARGEST AREA.

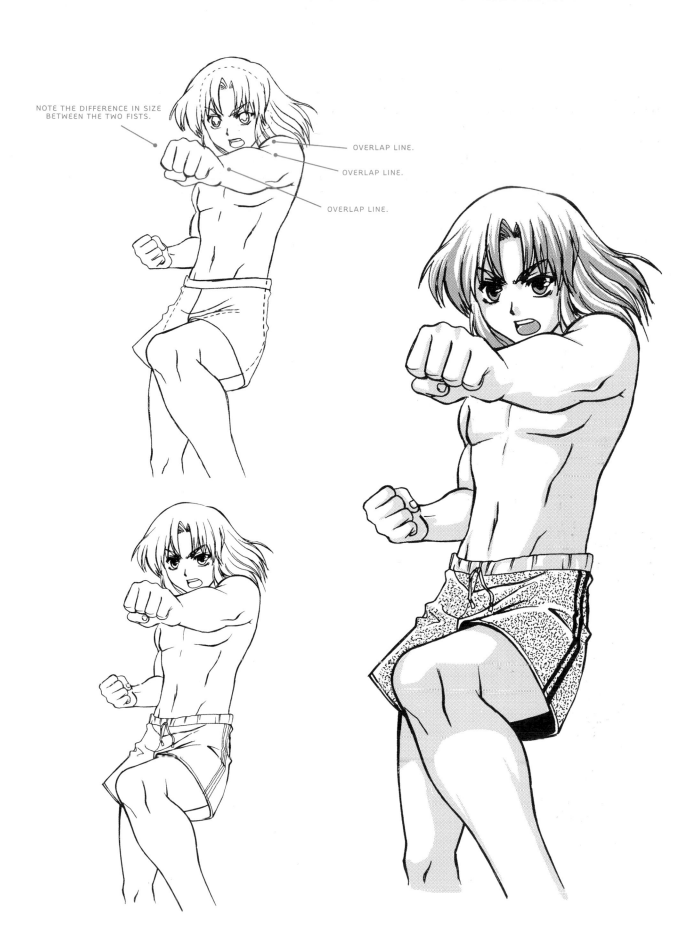

NOTE THE DIFFERENCE IN SIZE BETWEEN THE TWO FISTS.

OVERLAP LINE.

OVERLAP LINE.

OVERLAP LINE.

Perspective helps greatly in depicting a character running toward the viewer. The arms, in particular, are key in this type of pose. Note how both arms show the effects of perspective. One is coming at you and, therefore, increases in size, while the other travels away from you and, therefore, diminishes in size.

The gun-holding fist is virtually encircled by the outline of the forearm, due to the extreme foreshortening. Note that it is almost seen head-on, which is why it looks so compressed.

Remember, the closer the angle is to a front view, the more compressed the object will be. This makes the overlapping of sections of this arm very important in maintaining the arm's recognizability here. The other arm is angled more to the side than the gun-toting arm and displays a smaller amount of foreshortening, especially in the forearm.

The legs are both moving to the side, not toward us, therefore not much perspective is happening there.

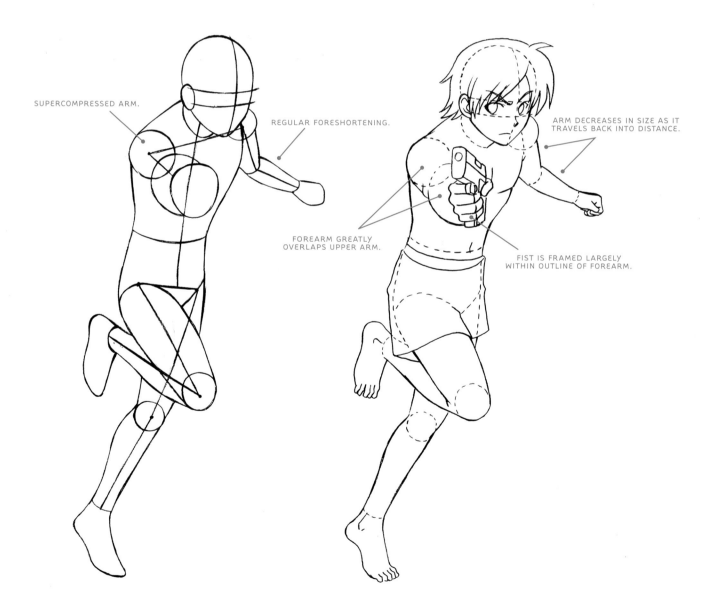

SUPERCOMPRESSED ARM.

REGULAR FORESHORTENING.

ARM DECREASES IN SIZE AS IT TRAVELS BACK INTO DISTANCE.

FOREARM GREATLY OVERLAPS UPPER ARM.

FIST IS FRAMED LARGELY WITHIN OUTLINE OF FOREARM.

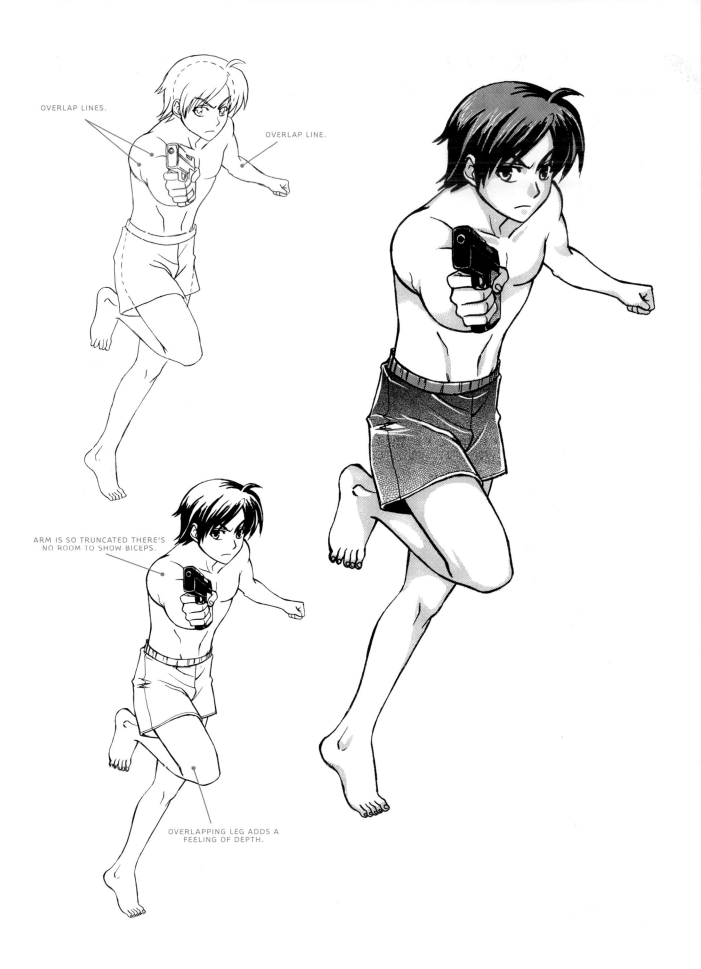

OVERLAP LINES.

OVERLAP LINE.

ARM IS SO TRUNCATED THERE'S
NO ROOM TO SHOW BICEPS.

OVERLAPPING LEG ADDS A
FEELING OF DEPTH.

Running in Extreme Perspective

When the entire figure appears to be coming straight at us, the entire torso, the hips, and both legs are all drawn to show the effects of perspective. This is extreme perspective at work. The head becomes the biggest element and leads the charge. It tilts down somewhat, showing more of its top than would otherwise be visible if the figure weren't drawn in perspective. In addition, the neck cannot be seen from this angle. This is due to the "down" angle in which the character is drawn. Remember to overlap: The head overlaps the torso, which overlaps the hips.

Also important to notice is what's not being affected so much by perspective: the arms. Instead of traveling toward or away from us, the arms travel sideways in a direction that's more parallel to us, with only slight advancing and receding. As such, they retain most of their true length.

The extended leg is a good example of forced perspective, a stylistic choice in which something increases or diminishes in size at an unusually rapid pace to enhance the drama of the moment. Here, that extended leg shrinks in size in an extreme way as it recedes into the distance.

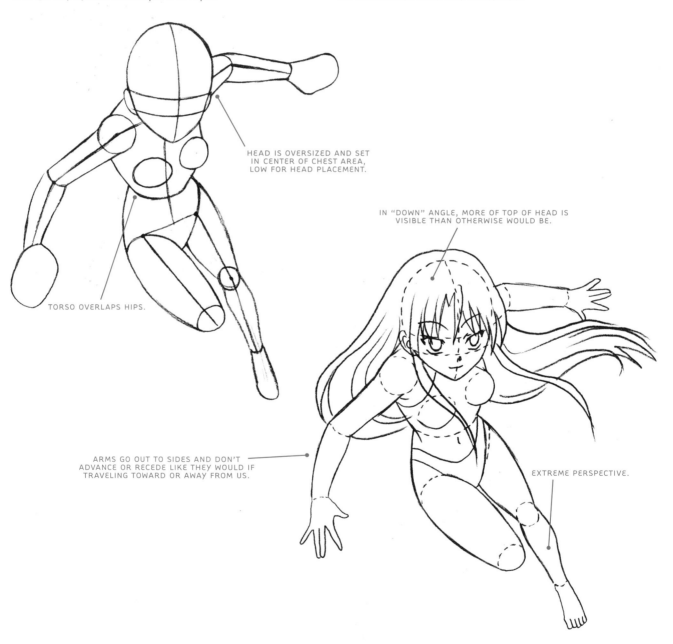

HEAD IS OVERSIZED AND SET IN CENTER OF CHEST AREA, LOW FOR HEAD PLACEMENT.

IN "DOWN" ANGLE, MORE OF TOP OF HEAD IS VISIBLE THAN OTHERWISE WOULD BE.

TORSO OVERLAPS HIPS.

ARMS GO OUT TO SIDES AND DON'T ADVANCE OR RECEDE LIKE THEY WOULD IF TRAVELING TOWARD OR AWAY FROM US.

EXTREME PERSPECTIVE.

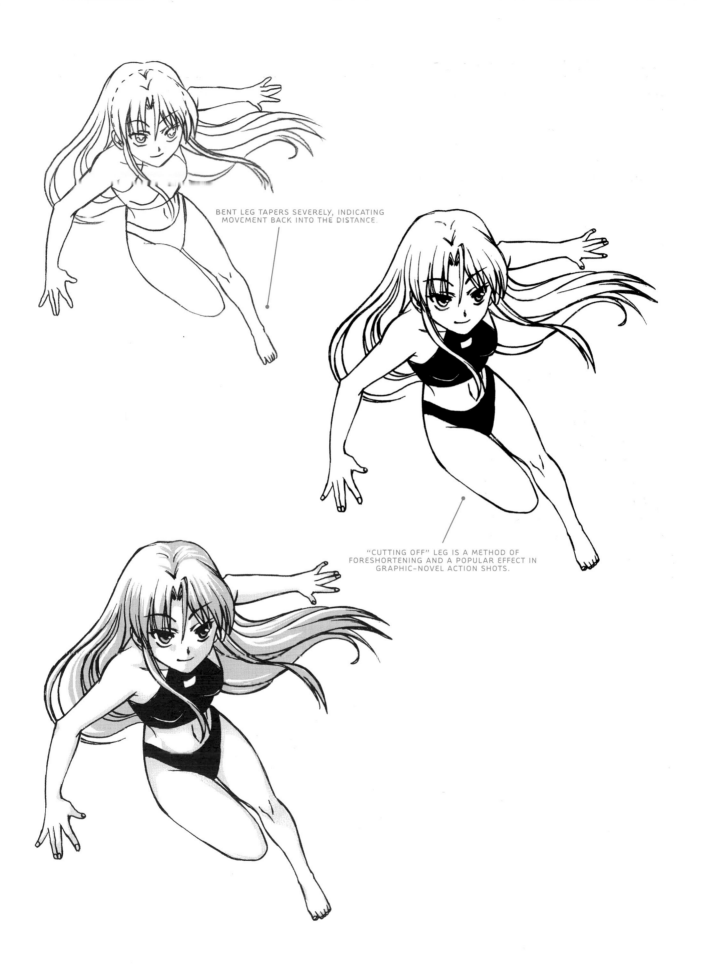

BENT LEG TAPERS SEVERELY, INDICATING MOVEMENT BACK INTO THE DISTANCE.

"CUTTING OFF" LEG IS A METHOD OF FORESHORTENING AND A POPULAR EFFECT IN GRAPHIC-NOVEL ACTION SHOTS.

Sitting poses are some of the more challenging for artists. So a few examples and hints for popular seated poses are included here. Just as the standing figure suffers when drawn in a stiff manner, so, too, should the seated figure avoid having a rigid posture. A seated figure can look natural and relaxed—and, for certain moods, even energetic. Simply because a character is seated doesn't mean that the torso becomes immobile, which is a common misconception; the torso remains dynamic due to the curve of the spine, just as in a good standing pose.

Feminine Pose

Placing both legs to one side makes for a popular, feminine, and decidedly attractive seated pose.

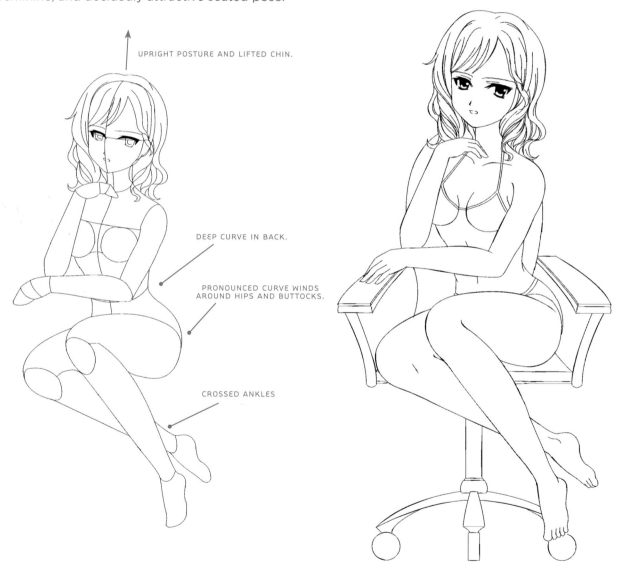

UPRIGHT POSTURE AND LIFTED CHIN.

DEEP CURVE IN BACK.

PRONOUNCED CURVE WINDS AROUND HIPS AND BUTTOCKS.

CROSSED ANKLES

Business Pose

Crossed legs create a popular, casual pose. Note that even though the head and upper torso are in a 3/4 view, the legs are in a front view and, therefore, are foreshortened, due to the effects of perspective.

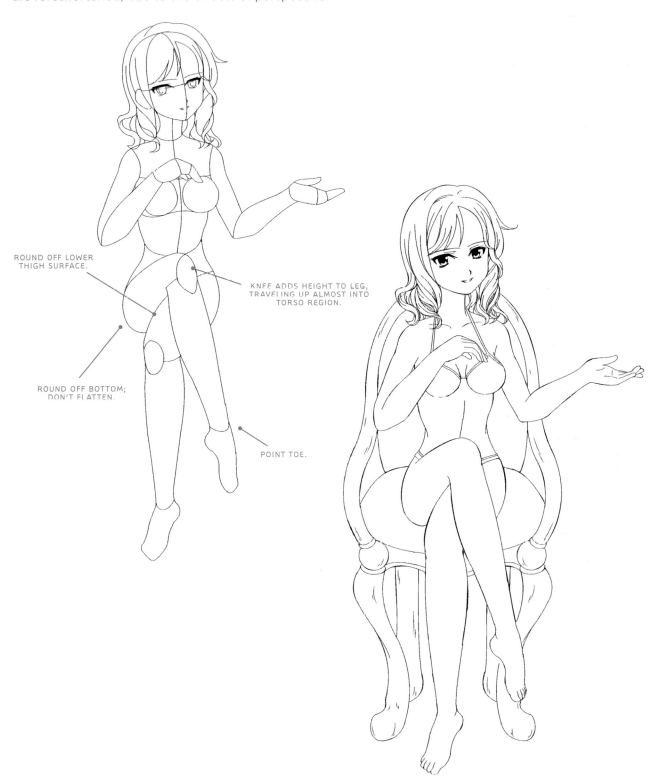

ROUND OFF LOWER THIGH SURFACE.

KNEE ADDS HEIGHT TO LEG, TRAVELING UP ALMOST INTO TORSO REGION.

ROUND OFF BOTTOM; DON'T FLATTEN.

POINT TOE.

Casual Pose

This is a popular, informal pose with the knees slightly apart and the hands gripping the edge of the chair between them.

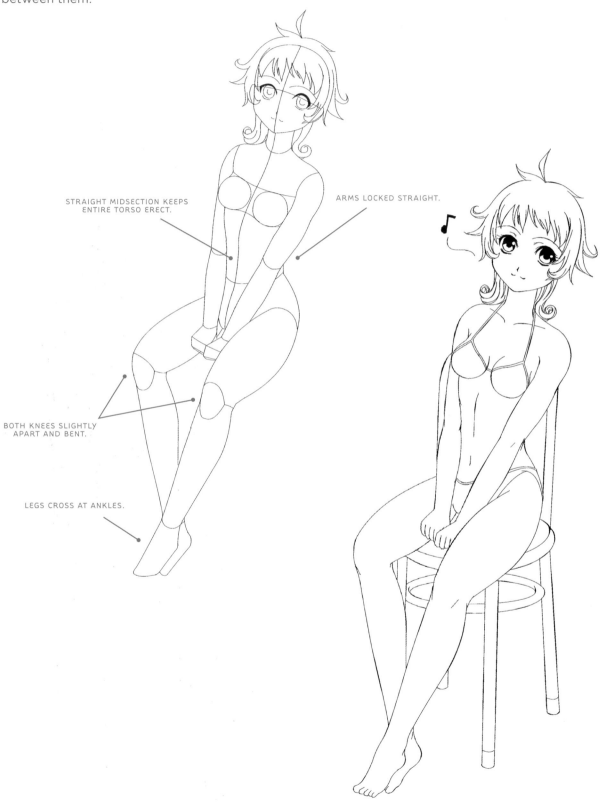

STRAIGHT MIDSECTION KEEPS ENTIRE TORSO ERECT.

ARMS LOCKED STRAIGHT.

BOTH KNEES SLIGHTLY APART AND BENT.

LEGS CROSS AT ANKLES.

Playful Pose

Tucking one leg under the body, in any position, is a playful pose. It's a typical "high school" or "college roommate" look. It appears easy to draw but can be tricky; plot it out first with a simplified construction.

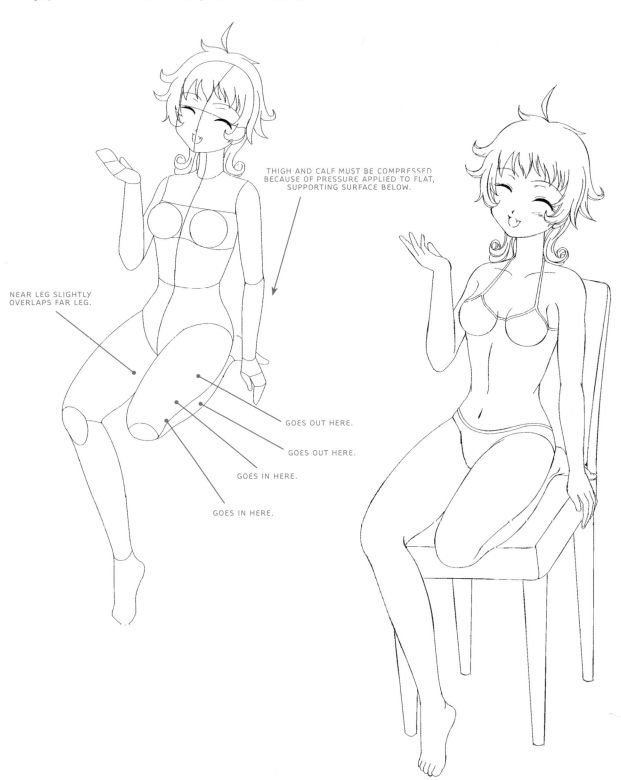

THIGH AND CALF MUST BE COMPRESSED BECAUSE OF PRESSURE APPLIED TO FLAT, SUPPORTING SURFACE BELOW.

NEAR LEG SLIGHTLY OVERLAPS FAR LEG.

GOES OUT HERE.

GOES OUT HERE.

GOES IN HERE.

GOES IN HERE.

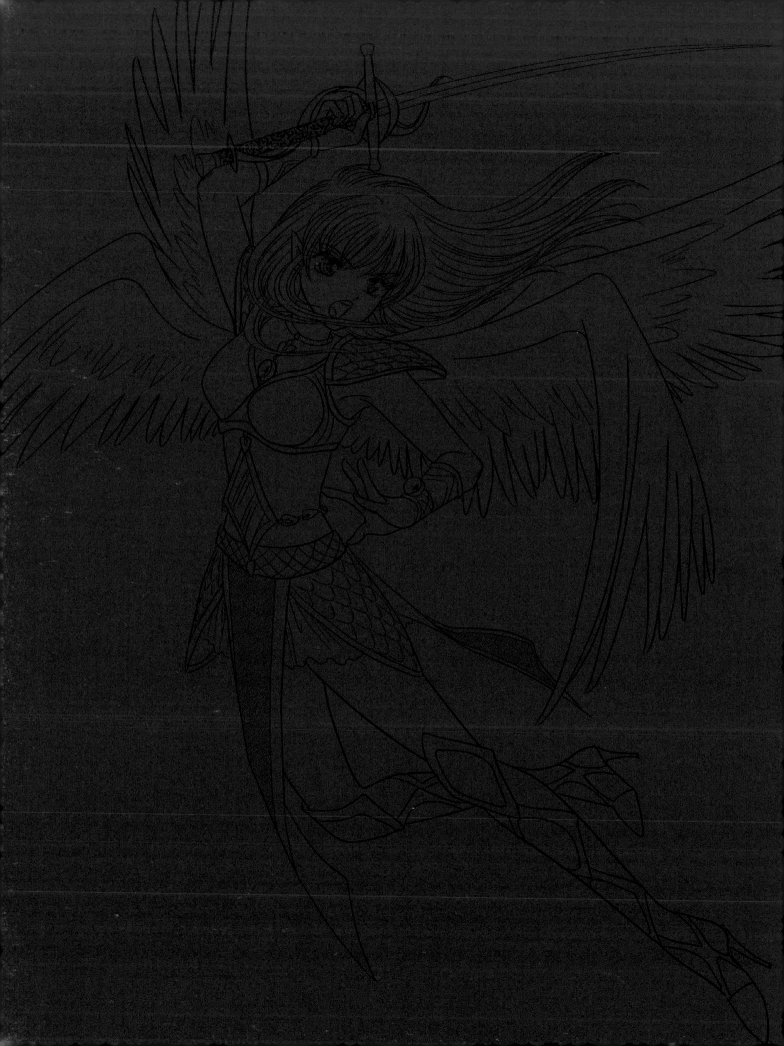

6: PUTTING IT ALL INTO PRACTICE

Most books on anatomy stop at showing the muscles and bones and never encourage you to really utilize what you've learned in actual character sketching. But character sketching is what it's all about for the manga artist. So we're going to take what we've learned so far about the basics of drawing the head and body and put it to use drawing a variety of personality-packed characters—and adding finishing details, such as appealing clothing. Now you can start paying attention to style and aesthetics.

ROMANTIC DRESS

Anatomy books always end before the clothed figure comes into play. Why? Don't they know that we also intend to draw dressed people? The basics—such as proportion, poses, construction, and overlapping shapes—will all come into play in drawing characters in costume.

Most professional artists usually begin at the foundation stage shown in the second steps of all these figures—and so should you. If artists get into difficulty with a pose, then they'll often revert to the simplified or realistic skeleton and reference the muscle charts to clarify the pose.

So the second step should always be kept general enough that it doesn't complicate the figure onto which the clothing will be sketched and yet provides a good framework on which to build the correct figure proportions.

Seated poses, although we often think of them as inert and static, can be involving, taking on a romantic tone if the body is positioned dramatically. The body dynamics at work in the foundation of this construction are as energetic as those of a figure in motion. Note the twisting and crunching angles. This adds energy to a pose.

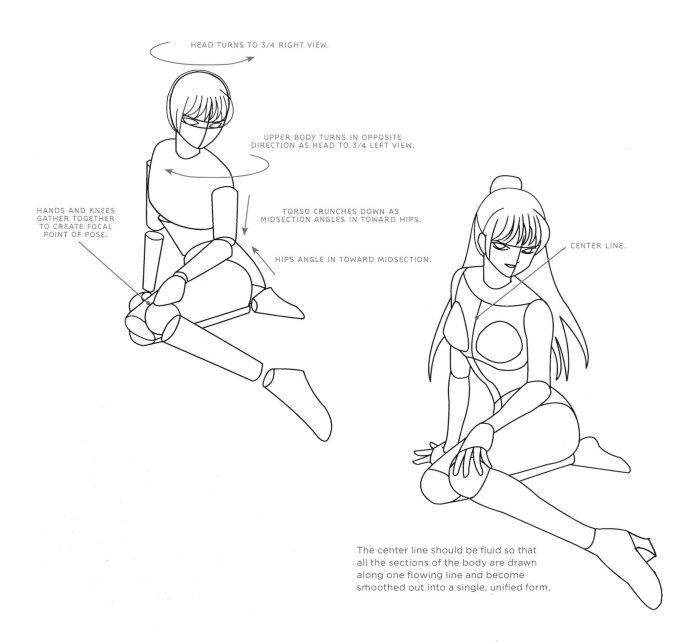

HEAD TURNS TO 3/4 RIGHT VIEW.

UPPER BODY TURNS IN OPPOSITE DIRECTION AS HEAD TO 3/4 LEFT VIEW.

HANDS AND KNEES GATHER TOGETHER TO CREATE FOCAL POINT OF POSE.

TORSO CRUNCHES DOWN AS MIDSECTION ANGLES IN TOWARD HIPS.

HIPS ANGLE IN TOWARD MIDSECTION.

CENTER LINE.

The center line should be fluid so that all the sections of the body are drawn along one flowing line and become smoothed out into a single, unified form.

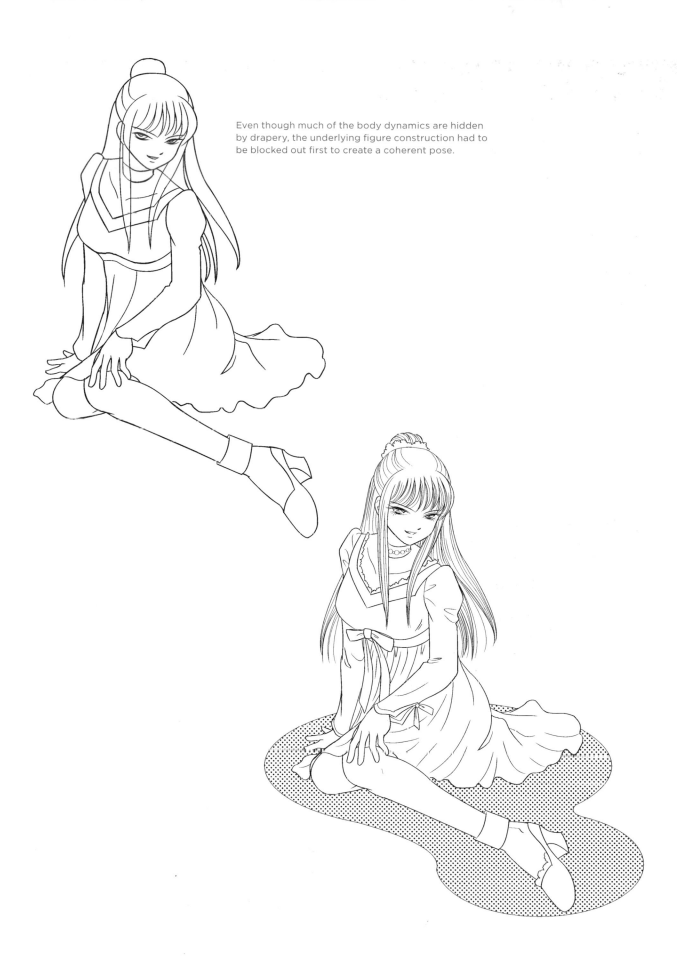

Even though much of the body dynamics are hidden
by drapery, the underlying figure construction had to
be blocked out first to create a coherent pose.

STYLISH SUIT

With his long hair and glamour-boy looks, this popular manga character is seen in many romance graphic novels. Called a "bishie" (short for bishounen and pronounced bee-show-nan), this popular character is lanky and often wears suits or trendy clothes. The teen-girl characters in these graphic novels typically have crushes on them, but the bishies are moody, distracted, and troubled, leading to unrequited love and, therefore, interesting stories.

Take a look at the stance and body dynamics here. Leaning against a countertop (or a wall, table, or chair) sets off a chain of body adjustments that make for a more interesting pose than one in which the character merely stands upright.

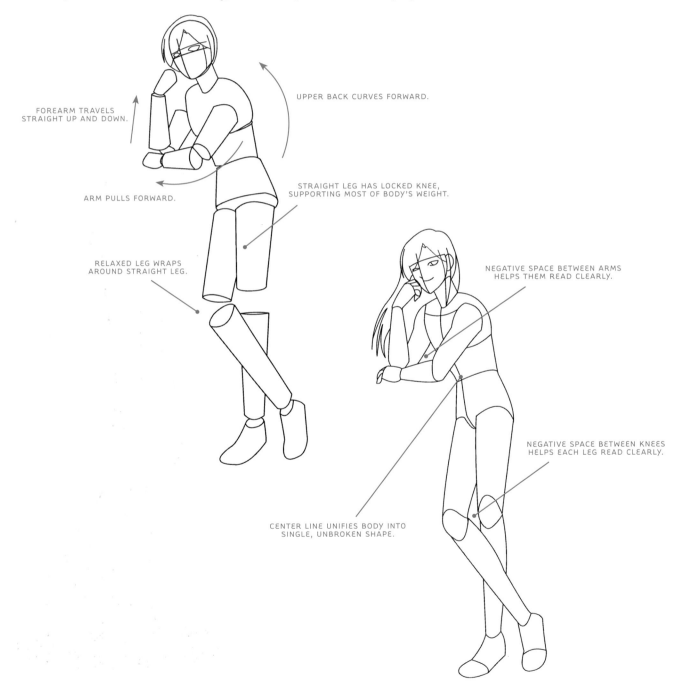

FOREARM TRAVELS STRAIGHT UP AND DOWN.

UPPER BACK CURVES FORWARD.

ARM PULLS FORWARD.

STRAIGHT LEG HAS LOCKED KNEE, SUPPORTING MOST OF BODY'S WEIGHT.

RELAXED LEG WRAPS AROUND STRAIGHT LEG.

NEGATIVE SPACE BETWEEN ARMS HELPS THEM READ CLEARLY.

NEGATIVE SPACE BETWEEN KNEES HELPS EACH LEG READ CLEARLY.

CENTER LINE UNIFIES BODY INTO SINGLE, UNBROKEN SHAPE.

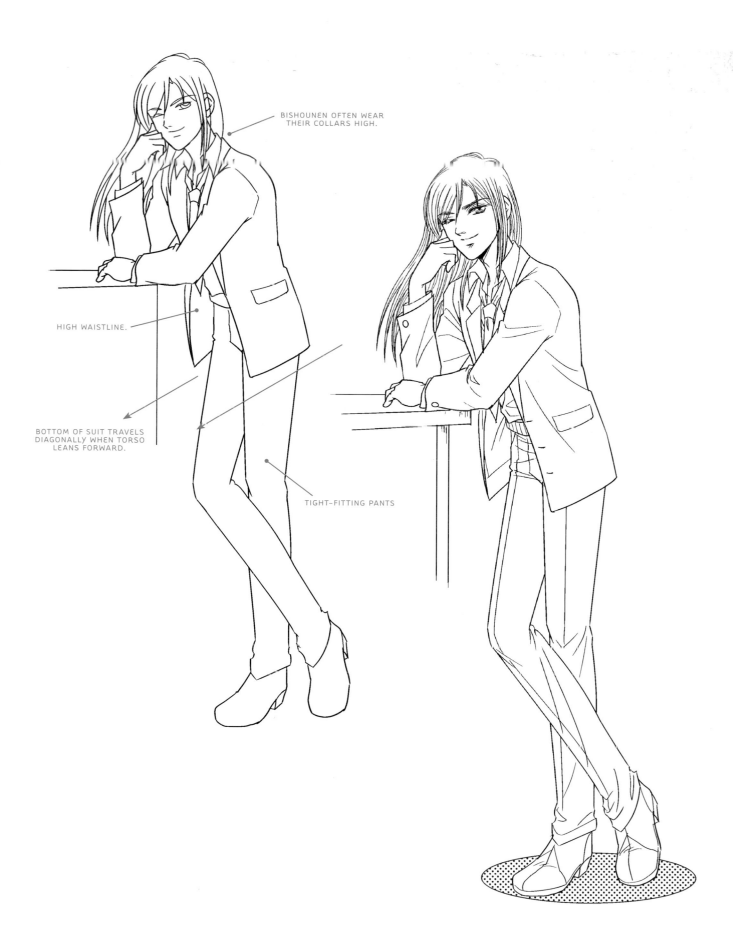

BISHOUNEN OFTEN WEAR
THEIR COLLARS HIGH.

HIGH WAISTLINE.

BOTTOM OF SUIT TRAVELS
DIAGONALLY WHEN TORSO
LEANS FORWARD.

TIGHT-FITTING PANTS

KIMONO JUMPSUIT

The kimono is a classic Japanese costume featured in graphic novels, most notably in the historical genre of manga.

Playful poses are fun to draw, because they're creative and random. They're typically most effective if the character looks caught in a moment between key poses, such as this half-step. This attitude shows a harmless flirtation, which makes the character appealing.

Note the body dynamics: In the first step, you can see that the weight-bearing leg pushes up the hip up on that same side. Therefore, the hips slant slightly and don't remain level. This gives the pose a little action, which makes it lively. If the hips were level, the pose would look static. Additionally, the arms are drawn with "opposing symmetry"—one up, the other down, mirroring each other. This is a pleasing technique, if not overused. You don't want to repeat this, pose after pose, as it gets self-conscious after a while.

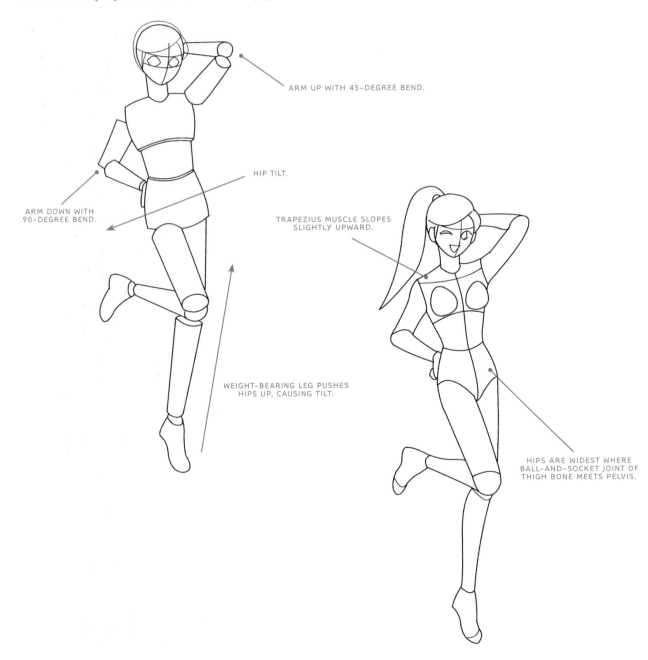

ARM UP WITH 45-DEGREE BEND.

HIP TILT.

ARM DOWN WITH
90-DEGREE BEND.

TRAPEZIUS MUSCLE SLOPES
SLIGHTLY UPWARD.

WEIGHT-BEARING LEG PUSHES
HIPS UP, CAUSING TILT.

HIPS ARE WIDEST WHERE
BALL-AND-SOCKET JOINT OF
THIGH BONE MEETS PELVIS.

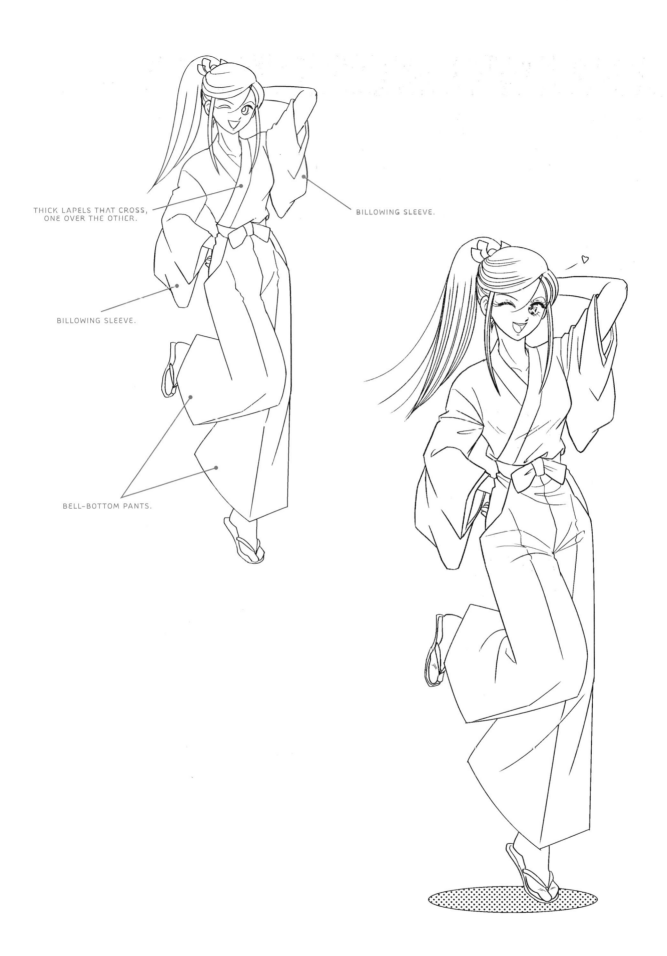

THICK LAPELS THAT CROSS,
ONE OVER THE OTHER.

BILLOWING SLEEVE.

BILLOWING SLEEVE.

BELL-BOTTOM PANTS.

MOD '60S COAT

Cat-boy male anthros (human-animal hybrids) are a subgenre of bishounen. Sporting the typical bishounen build, this character possesses a trim torso and long legs. His costume is pure fantasy manga. The coat has fur trim, with a belt and boot for a cool look. A staff, long wand, craggy walking stick, or pole serves as a good prop to enhance a standing pose. Here the character throws a portion of his weight onto the pole, resulting in an asymmetrical pose that creates interesting shifts within the body. Cat-boys appear in fantasy or shoujo stories.

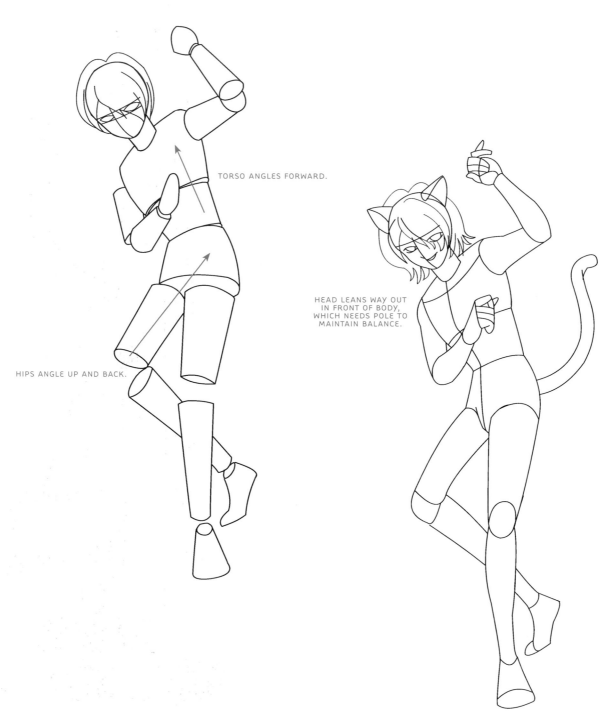

TORSO ANGLES FORWARD.

HIPS ANGLE UP AND BACK.

HEAD LEANS WAY OUT IN FRONT OF BODY, WHICH NEEDS POLE TO MAINTAIN BALANCE.

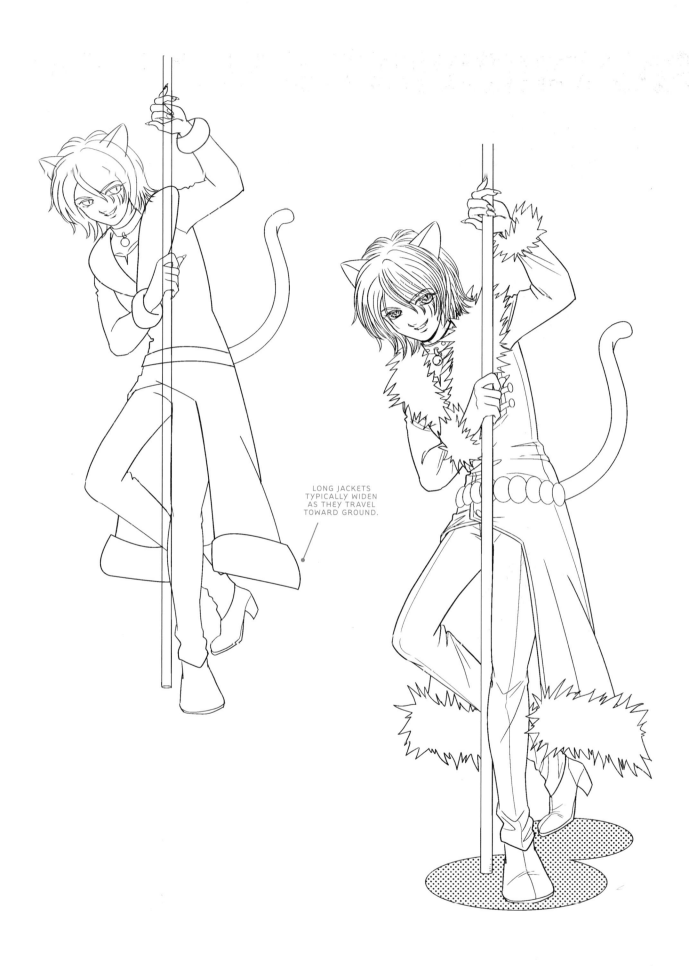

LONG JACKETS
TYPICALLY WIDEN
AS THEY TRAVEL
TOWARD GROUND.

PRETTY MAID

Frilly maids are extremely popular in graphic novels and anime, and they account for a large part of the dress-up "cos-play" at manga conventions. Like other heavily costumed characters, such as kimono girls and magical and miko girls, pretty maids are classic shoujo characters, sporting big eyes, round faces, and a youthful appearance and occupying the mid-teen age range. Their poses reflect a wide emotional range, from exuberance to shyness to embarrassment to jealousy and tearfulness. And their costumes should display lots of frills, which are quite popular in shoujo.

With so much clothing covering the figure, there's a temptation to start by drawing the clothes—skipping the underlying body structure, since it will be erased anyway. Resist this.

But, hey, we're not purists here. Let's be realistic—and practical—about this. You can skimp on drawing the torso if the figure is heavily clothed. But by *skimp*, I mean just rough it in. You don't have to belabor the musculature of a torso that will be heavily clothed. However, since the arm is partially seen through the drapery, it's essential that you draw the arm construction in the initial steps with some degree of care.

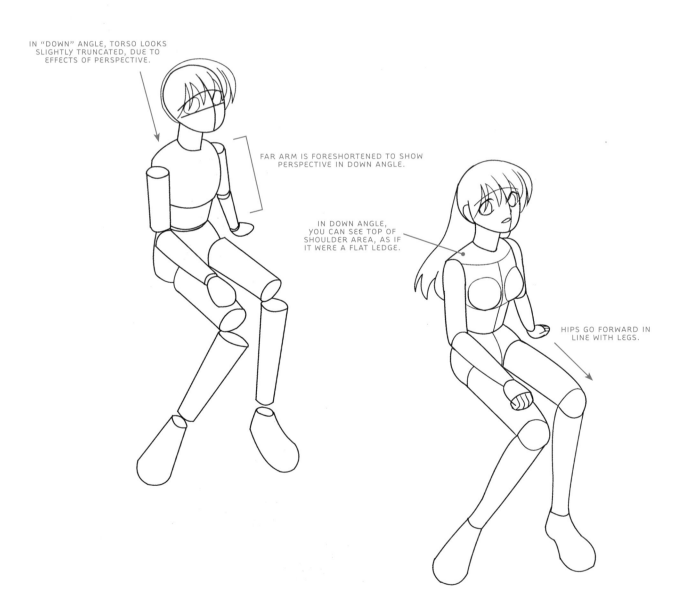

IN "DOWN" ANGLE, TORSO LOOKS SLIGHTLY TRUNCATED, DUE TO EFFECTS OF PERSPECTIVE.

FAR ARM IS FORESHORTENED TO SHOW PERSPECTIVE IN DOWN ANGLE.

IN DOWN ANGLE, YOU CAN SEE TOP OF SHOULDER AREA, AS IF IT WERE A FLAT LEDGE.

HIPS GO FORWARD IN LINE WITH LEGS.

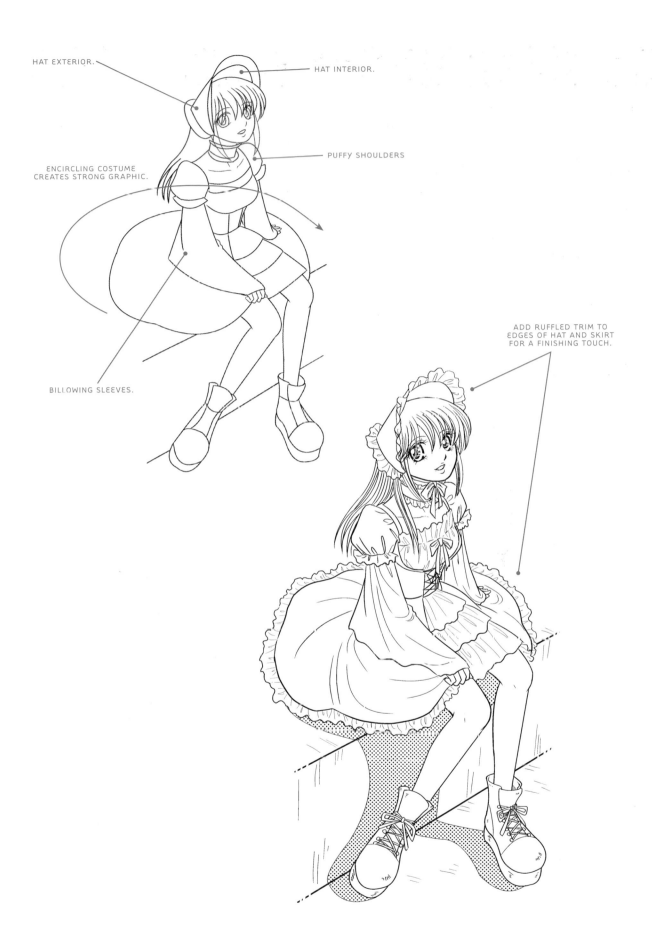

HAT EXTERIOR.

HAT INTERIOR.

PUFFY SHOULDERS

ENCIRCLING COSTUME
CREATES STRONG GRAPHIC.

BILLOWING SLEEVES.

ADD RUFFLED TRIM TO
EDGES OF HAT AND SKIRT
FOR A FINISHING TOUCH.

FANTASY VILLAIN

Charismatic male villains are often drawn with rock-star good looks. Note the exaggerated proportions of his superidealized physique: extralong legs on a regular-size torso and a small head. These dark personalities are sociopaths of the first order—power-driven, mad, and proud of it. The cape adds a dashing touch. The high collar adds an underworld element. Straps and buckles make the outfit look like warrior gear. It's the poor man's equivalent of modern armor.

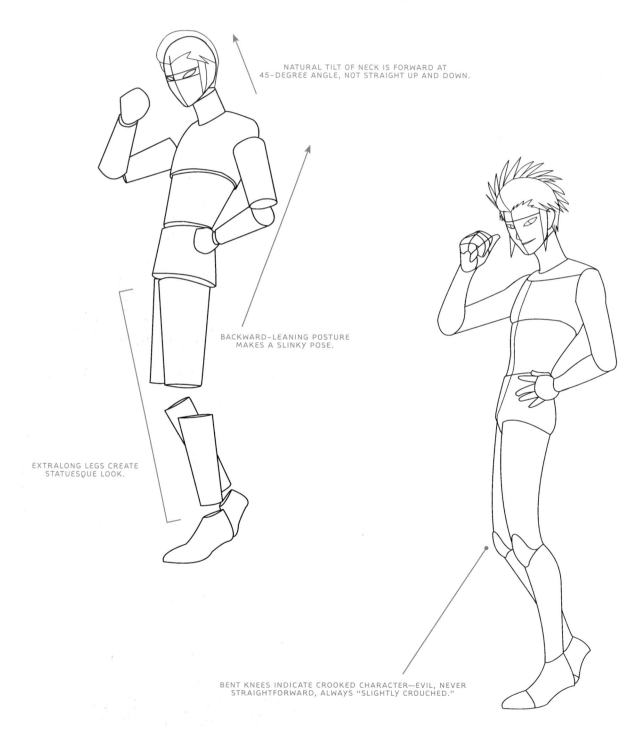

NATURAL TILT OF NECK IS FORWARD AT 45-DEGREE ANGLE, NOT STRAIGHT UP AND DOWN.

BACKWARD-LEANING POSTURE MAKES A SLINKY POSE.

EXTRALONG LEGS CREATE STATUESQUE LOOK.

BENT KNEES INDICATE CROOKED CHARACTER—EVIL, NEVER STRAIGHTFORWARD, ALWAYS "SLIGHTLY CROUCHED."

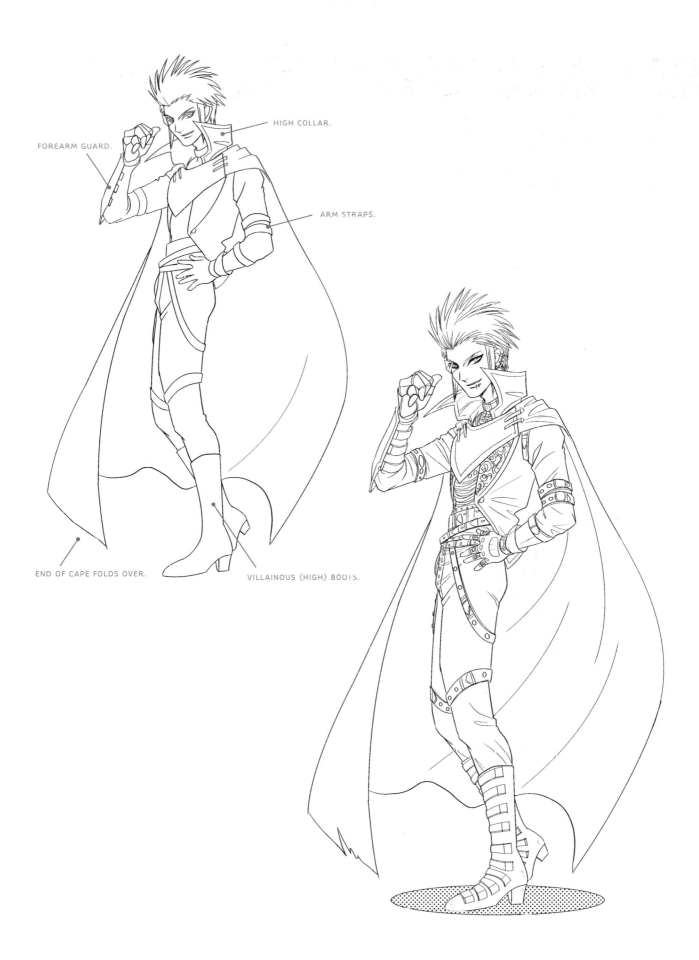

FOREARM GUARD.

HIGH COLLAR.

ARM STRAPS.

END OF CAPE FOLDS OVER.

VILLAINOUS (HIGH) BOOTS.

WINGED FANTASY FIGHTER

What manga book would be complete without showing how to draw the superpopular magical-girl character? Magical girls are teenage hero fighters, imbued with special powers, who fight to save the world from the forces of darkness.

The wings are the most dramatic design element here, not only because they are huge but because they are horizontal when the rest of the character is laid out vertically on the page. Therefore you have to place the character carefully on the page so that you don't run out of room for the wing tips as you complete your drawing.

The type of wing defines the type of character. Butterfly or dragonfly wings appear on faerie fighters. Batlike wings indicate occult characters. Batlike wings made out of sharp metal are often found on pretty cyborgs. Feathered wings are emblematic of angelic beings and magical girls. Double wings like those here are routine for butterfly and dragonfly faerie wings but are unusual for feathered "avenging fighter" wings. But as manga artists, we're always looking for ways to introduce a new angle to our characters. The costume here has a medieval flair.

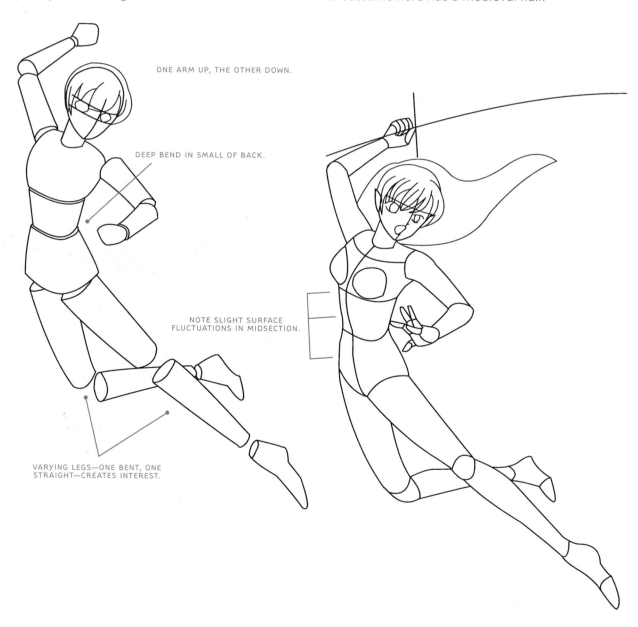

ONE ARM UP, THE OTHER DOWN.

DEEP BEND IN SMALL OF BACK.

NOTE SLIGHT SURFACE FLUCTUATIONS IN MIDSECTION.

VARYING LEGS—ONE BENT, ONE STRAIGHT—CREATES INTEREST.

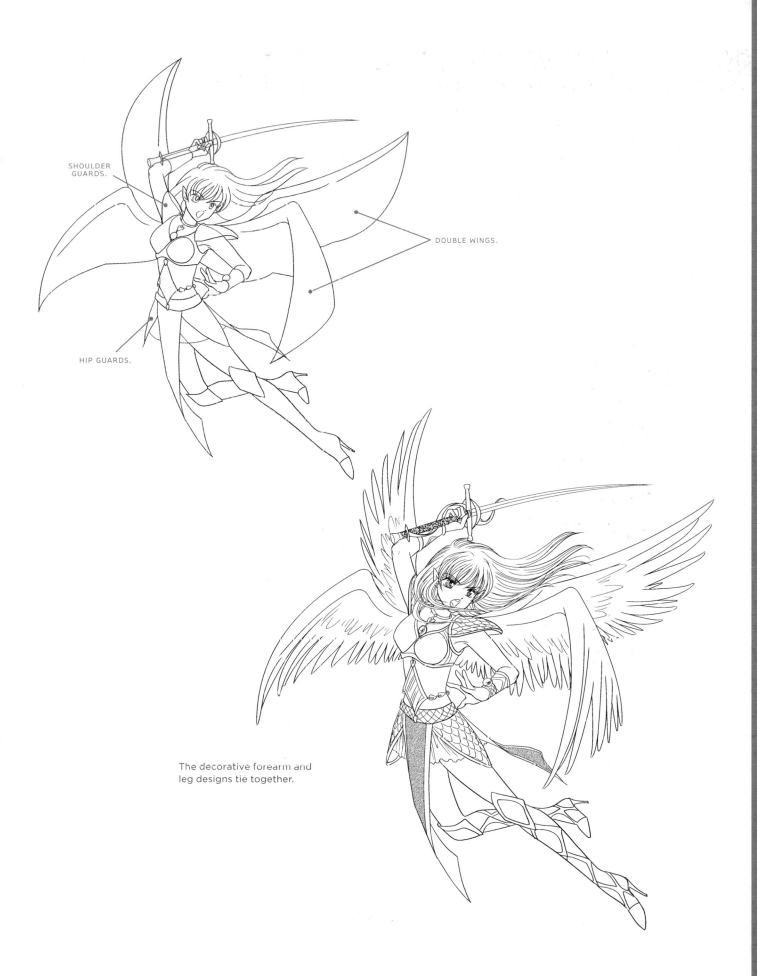

SHOULDER GUARDS.

DOUBLE WINGS.

HIP GUARDS.

The decorative forearm and leg designs tie together.

FANTASY KNIGHT

A symmetrical pose can look poetic and romantic if the lines are long and graceful. The symmetry in this pose gives a sense of serenity. The shoulders are rounded and level, not tilting one direction or the other. The arms are both evenly placed and positioned the same way. The torso consists of three main sections—chest, midsection, and hips—that are basically stacked evenly.

But not everything is symmetrical, is it? A few areas of the body add a much needed accent to the pose. The head is bowed, with the neck tilted at a 45-degree angle. Additionally, the one leg crosses slightly in front of the other, in a balletic manner, which also results in an asymmetry of foot positions—and a more interesting and elegant pose.

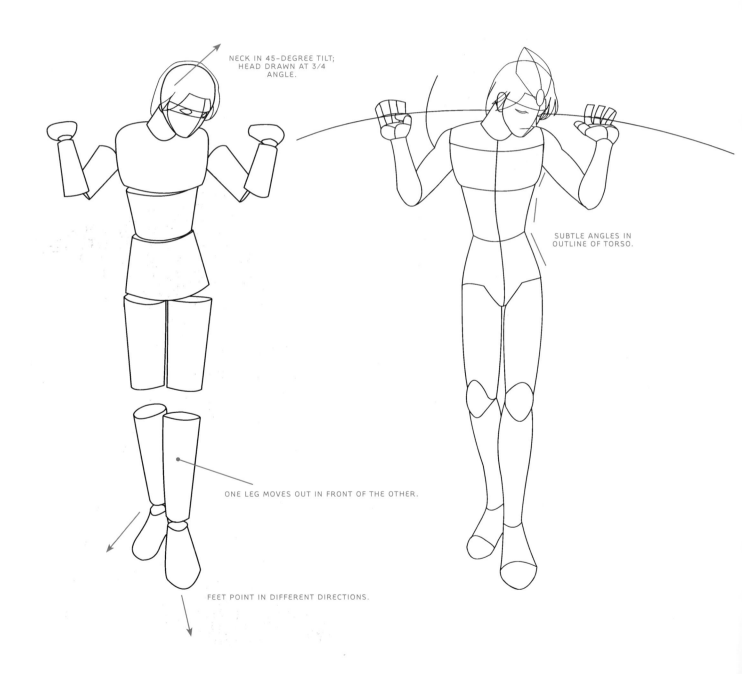

NECK IN 45-DEGREE TILT; HEAD DRAWN AT 3/4 ANGLE.

SUBTLE ANGLES IN OUTLINE OF TORSO.

ONE LEG MOVES OUT IN FRONT OF THE OTHER.

FEET POINT IN DIFFERENT DIRECTIONS.

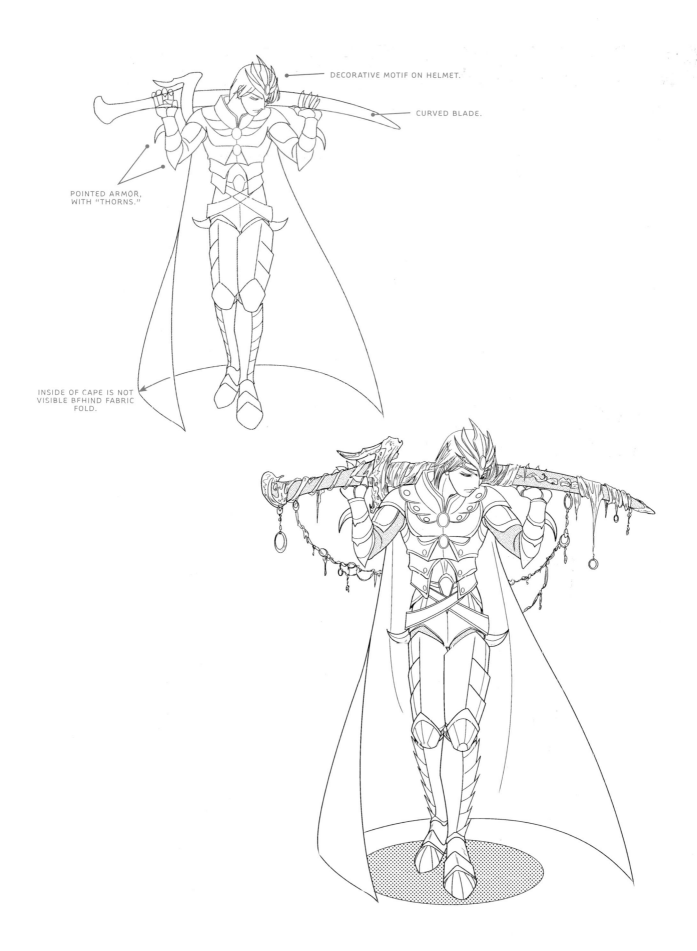

DECORATIVE MOTIF ON HELMET.

CURVED BLADE.

POINTED ARMOR,
WITH "THORNS."

INSIDE OF CAPE IS NOT
VISIBLE BEHIND FABRIC
FOLD.

SAMURAI

Samurai are often depicted with their weapons drawn. This makes them dramatic characters and favorites of otaku (manga fans) everywhere. But it's not just the long blade that makes the image exciting—it's the pose. The blade is held at a diagonal, which is much more dynamic than if the character held it straight up and down or horizontally. Then, to wield the blade, the samurai has to be ready, and that means bending at his knees, turning his head forward, and moving his body sideways so that it's less of a target for an opponent.

This is a classic martial arts "back stance." The back leg is bent, and the body leans back, with the sword pulled back and ready for action. The front foot always points forward, at the opponent.

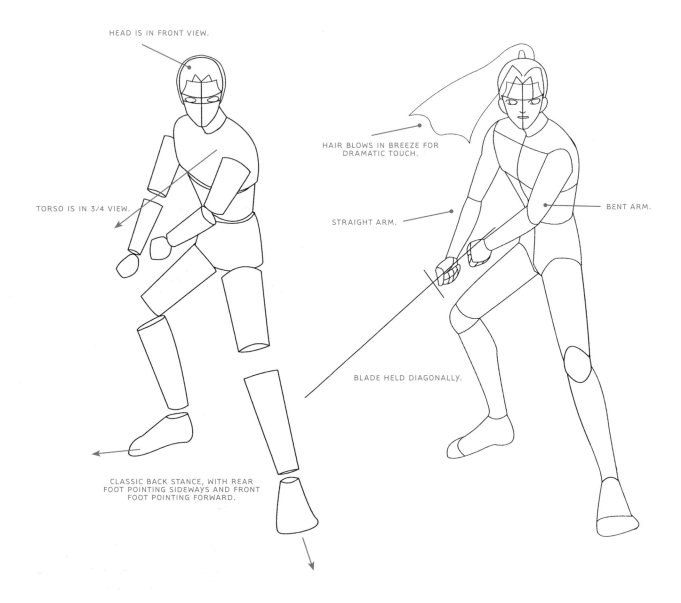

HEAD IS IN FRONT VIEW.

TORSO IS IN 3/4 VIEW.

HAIR BLOWS IN BREEZE FOR DRAMATIC TOUCH.

STRAIGHT ARM.

BENT ARM.

BLADE HELD DIAGONALLY.

CLASSIC BACK STANCE, WITH REAR FOOT POINTING SIDEWAYS AND FRONT FOOT POINTING FORWARD.

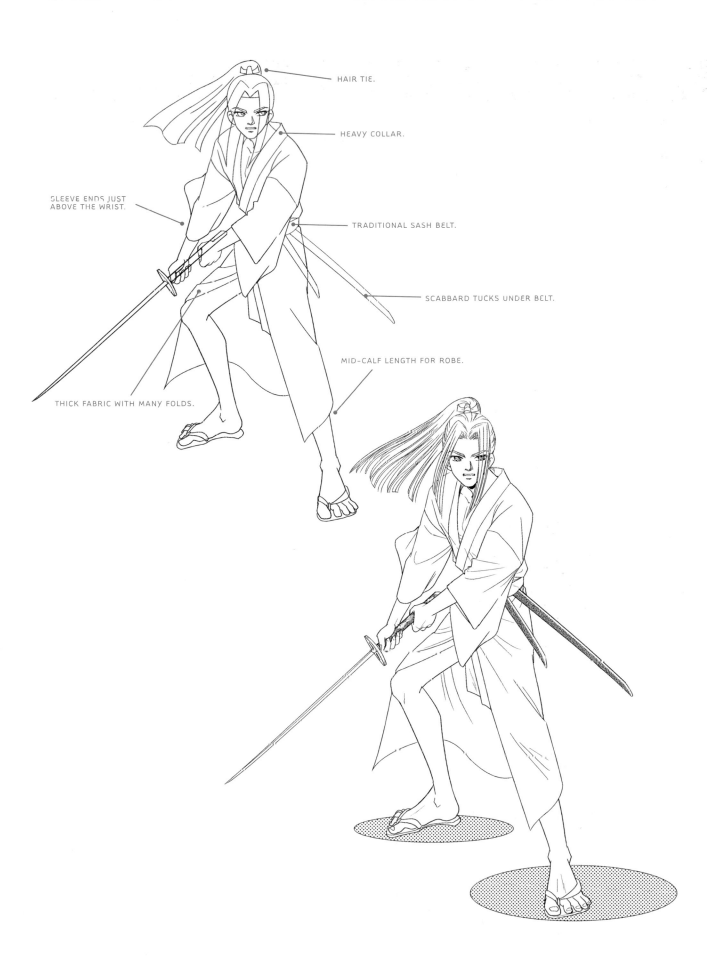

HAIR TIE.

HEAVY COLLAR.

SLEEVE ENDS JUST
ABOVE THE WRIST.

TRADITIONAL SASH BELT.

SCABBARD TUCKS UNDER BELT.

MID-CALF LENGTH FOR ROBE.

THICK FABRIC WITH MANY FOLDS.

MUSCLES THROUGH CLOTHING

When working with a muscular character—such as a hero, jock, or powerful villain—you'll probably want to indicate the muscles even though they are covered by clothing. It's no problem to draw "bumpy" muscles along the outline of the figure, but how do you convey a muscular look within that outline so that the interior of the body looks muscular, as well? How do you highlight the muscles? By emphasizing the white areas. And to do that you first have to add dark areas.

You make an area look white, or lighter, by first darkening the area surrounding it. These lighter areas need to have smooth outlines, not sketchy ones. Sometimes, the light areas can retain an oval shape. This technique gives the illusion that the lighter patches are bulging forth. The surrounding dark, shaded areas will look as though they are receding—in other words, they will look like the flat parts of the body, and the white parts will look like the bumpy, muscular areas.

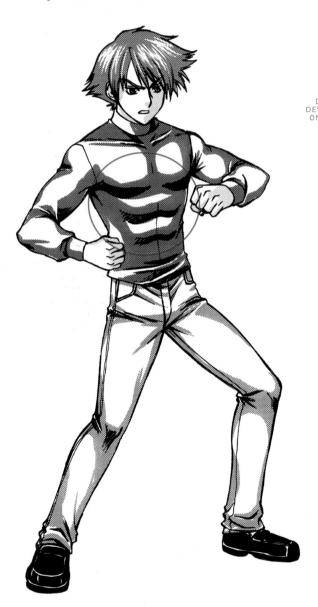

The pectoralis major of the chest and the rectus abdominis of the stomach are the muscles to highlight on the front of the torso.

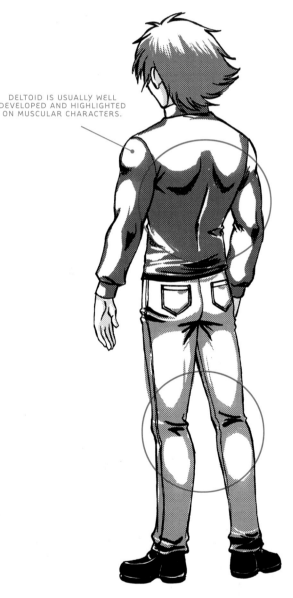

DELTOID IS USUALLY WELL DEVELOPED AND HIGHLIGHTED ON MUSCULAR CHARACTERS.

The shoulder blades are the two most prominent areas of the developed back, and on athletic characters, the gastrocnemius in each calf should be compact and rounded.

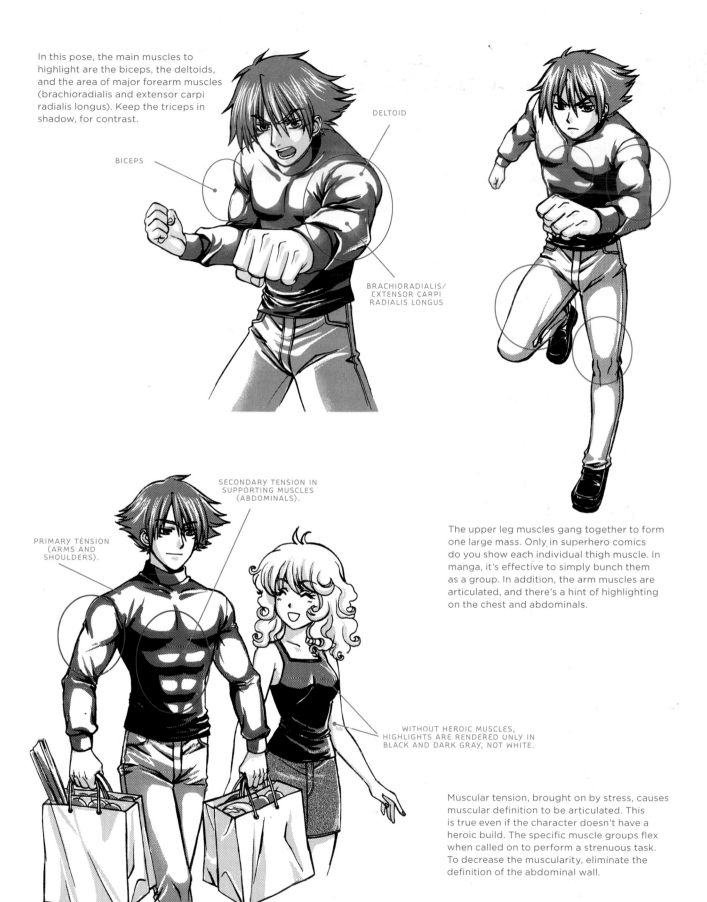

In this pose, the main muscles to highlight are the biceps, the deltoids, and the area of major forearm muscles (brachioradialis and extensor carpi radialis longus). Keep the triceps in shadow, for contrast.

DELTOID

BICEPS

BRACHIORADIALIS/ EXTENSOR CARPI RADIALIS LONGUS

SECONDARY TENSION IN SUPPORTING MUSCLES (ABDOMINALS).

PRIMARY TENSION (ARMS AND SHOULDERS).

WITHOUT HEROIC MUSCLES, HIGHLIGHTS ARE RENDERED ONLY IN BLACK AND DARK GRAY, NOT WHITE.

The upper leg muscles gang together to form one large mass. Only in superhero comics do you show each individual thigh muscle. In manga, it's effective to simply bunch them as a group. In addition, the arm muscles are articulated, and there's a hint of highlighting on the chest and abdominals.

Muscular tension, brought on by stress, causes muscular definition to be articulated. This is true even if the character doesn't have a heroic build. The specific muscle groups flex when called on to perform a strenuous task. To decrease the muscularity, eliminate the definition of the abdominal wall.